Bird Love Leila Jeffreys

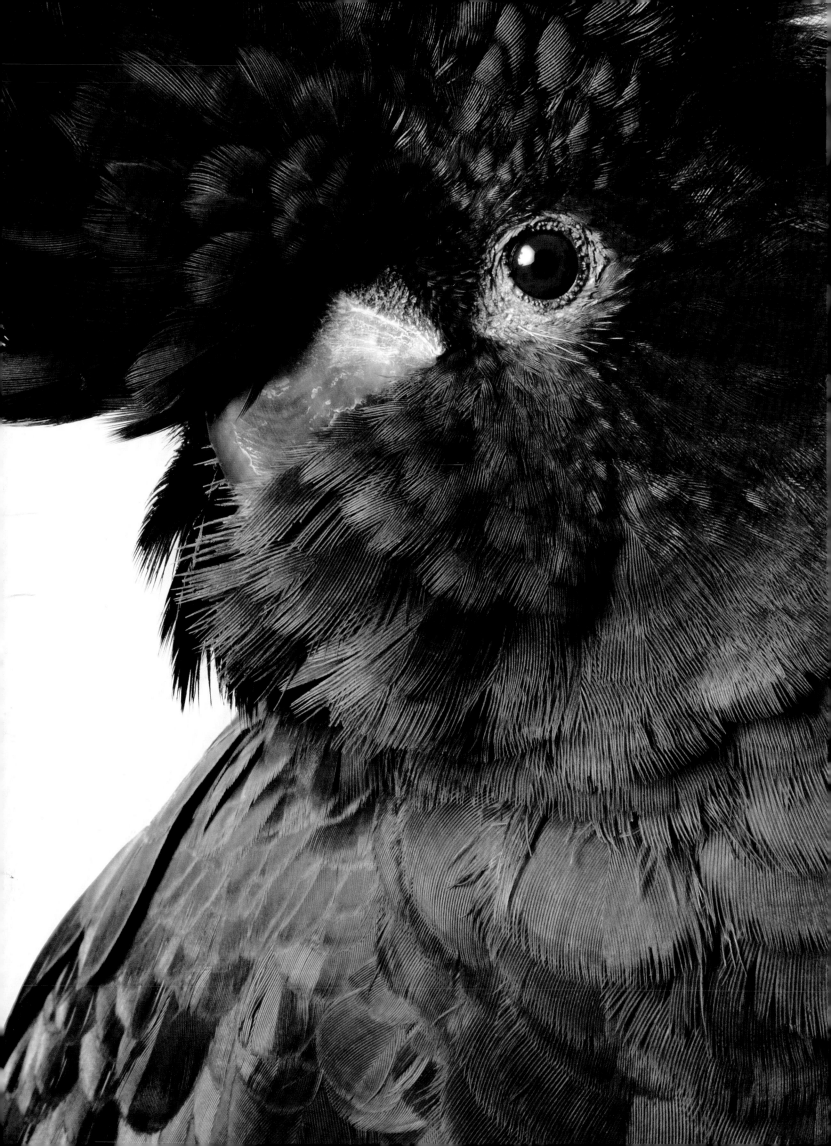

Bird Love

Leila Jeffreys

Abrams, New York
in association with PQ Blackwell

To my dad, who as a child was so shy he would cross the road to avoid having to speak to a passerby, and yet went on to quietly achieve so much in his lifetime. He was always there to help me and listen to me and embarrass me in public by breaking into song. I miss his songs every day.

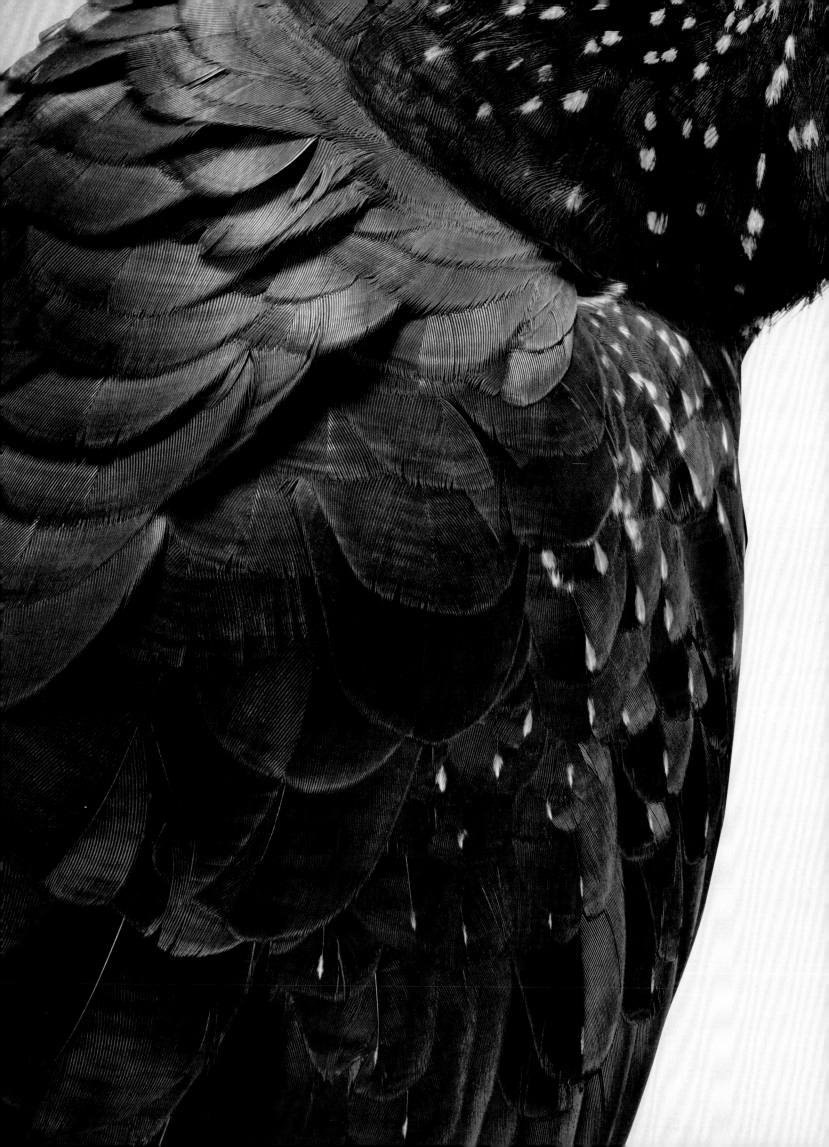

Contents

Preface Leila Jeffreys

Some time ago, my life was changed by an amazing place: Christmas Island, a tiny Australian territory hidden away in the tropical Indian Ocean 1,600 miles (2,600 kilometers) northwest of Perth, Western Australia. Flying in on a small plane, I looked down on imposing cliffs, dark, lush rain forests, and thousands of pterodactyl-like birds circling on the air currents above the jungle. It looked like a scene out of *Jurassic Park,* and it was exhilarating.

I had by this time become consumed by a love of bird photography. The garden bird-watcher I began as had morphed into a serious bird-watcher. I'd started off helping ornithologists tag birds, and taking photos of them had come after that. The island had drawn me, along with assorted biologists, ecologists, and ornithologists, to partake in the annual Christmas Island Bird 'n' Nature Week. One of our guides was Australian biologist and author Tim Low. Tim—whose books have had a huge effect on me—brought us to a small beach backed by cliffs and asked us to scavenge along the shoreline for seeds and flotsam that had traveled in on the tide. Along with seeds, we found various plastic toys that looked like something you might pull out of a cereal box. At Tim's urging, a closer look at these toys revealed that they came from Indonesia. This told us something about the island's ecology, and indicated that the seeds we had found probably came from Java and other islands to the north. Ocean currents bearing seeds from these places had given the rain forest its Asian flavor. I was suddenly transported from *Jurassic Park* to a David Attenborough documentary. I saw the world through a naturalist's eyes as my mind was opened up to the magnificent world of ecology and how plants and animals come to be where they are.

The experience of visiting the island had reawakened a connection to nature that I felt I had lost. I felt joyful. Rather than this awareness of the incredible beauty of bird life being a secret only shared by bird-watchers, I wanted everyone to feel this sense of amazement. The trip changed the way that I see and photograph birds.

Now, when I look back, I also realize that my experience on Christmas Island tapped into fond memories of my own childhood. My brother and I spent much of our childhood in the outdoors. My dad was born in the picturesque Isle of Man in the British Isles and wasn't a fan of cities. His adventurous spirit was much more at home within the natural world, and because of this, he took our family to some wondrous places. I was born in Papua New Guinea, and as a child I was completely obsessed with animals. If you look at our family photos, it's hard to find one where I'm not with an animal. To me, animals were individuals, living their own lives, with their own stories to tell, and I felt at home among them and sought out their company whenever I could.

Because we traveled a lot, many of my early memories are attached to the natural environments we visited—the plants and ultimately the animals that were so intrinsically linked to them. I remember the lush rain forest that surrounded our house in Papua New Guinea. In this environment the modestly dressed female birds of paradise raise their young as single parents, leaving the males to obsess over their extraordinary courtship moves and preen their luscious feathers.

I think of India, where my mother was born, and a particular banyan tree in Nasrapur that I used to climb, along with the insects, birds, bats, monkeys, and the chameleon I met high up on a branch one day. I think of the Isle of Man and the woodlands where pretty songbirds would dart in and out of view from where I watched them in my "secret garden." I think of Australia, where my brother was born, and the bushland that we inherited from our paternal grandfather near the town of Collie in Western Australia. There stands a hundred-year-old, 230-foot-high (70-meter-high) eucalyptus tree that died long ago, leaving a mass of sculptural, silvery branches that form a perfect deer head, complete with antlers and beautiful big eyes. The tree is known in my family as "Lee's tree," and in it still nest the endangered Carnaby's and Baudin's black cockatoos.

I'm as enamored with these birds as I was as a child, and I have brought this fascination with the natural world to my art practice. Because we don't often get to see birds up close, and because they are so small compared to us, we don't realize how extraordinary they are. With this book and the exhibition work that I do, I want people to have the opportunity to view wildlife in detail. I had an overwhelming desire to see a bird photographed with all the attention and skill we give human subjects. I decided to photograph them as you would a person for a studio portrait, also removing any surrounding natural elements and printing the images at human size. This allows the viewer to focus entirely on the bird and to get a sense of it as an individual with a personality.

I've now photographed more than one hundred different bird species. When I have an exhibition, rather than viewers being confronted by a random series of images, I like to focus on a particular type of bird or bird family. By doing this, I want viewers to think about the similarities and differences that can exist within a bird family or group. For example, many people don't realize that there are twenty-one different species of cockatoo, all in different colors and sizes. I'm not a wildlife photographer in the formal sense, as I generally don't photograph animals in the wild. Instead, I approach organizations such as bird rescue centers and ask if I can photograph their birds. Generally it takes about two years to photograph a new series of images, and I greatly value the relationships I've developed with these important organizations and the opportunities I've had to bond with the birds. By photographing the birds, I feel that I'm increasing awareness of them and also the work that their dedicated carers do.

People tend to think that "the wilderness" or "nature" is somewhere else, somewhere remote, but most of the birds I photograph live or are rescued in urban areas—people just don't notice they're there. But while some bird species have triumphed in urban environments, others are declining. By learning about the species in our region that are struggling, and working toward giving them a better future—perhaps by joining a conservation group or raising general awareness of their plight—we can help wildlife survive while at the same time enriching our lives.

Introduction Sarah Engledow

Knowing even a bit about birds, we know they don't get dressed. What they've got on, they don't put on. In this book, every creature's naked—and entirely comfortable with it. Yet, as I look at Leila Jeffreys's photographs, I keep thinking of words like "raiment" and "livery." Look at the black silk attire of the red-tailed black cockatoos, their hairpins of glass and amber beads, gorgets spangled with gold, scalloped and tiered satin opera capes; the tiny, fluffy trousers on the boobook owl, a creature from a fable; the gannet's breast plumage, like the furled, curled petals of a Chinese white chrysanthemum; the sheath over the miniscule silvereye, filaments of mythological metals—silver, gold, and gamboge—wrought by fairies.

Leila Jeffreys herself fancies Tani (p. 125), the Australian masked owl, in a crocheted cape. To me, Tani's feathers recall log-borne fungus in the tree fern shadows of a creekbed where lyrebirds lived when I was young. Twice, my brother found their feathers; one was long, narrow, exquisitely curved, color-blocked cream and chocolate. Now, on daily walks through the bush, I squint under gum trees for a certain type of feather that I'll bring home if it's clean. Over a half lifetime, I've treasured feathers, up to a point. But until I looked at Leila's photographs, I think, I never really *saw* feathers. Why? First, in her portraits there's nothing to compete with the birds' own texture; in contrast to their cousins in wildlife photographs, Leila's subjects aren't peeking from under grevilleas or between grass blades, standing on porous rocks, flying against serried clouds. Secondly, for the very brief, strange period of their lives that they're being photographed, they inhabit a shadowless place. Thirdly, for exhibition, Leila's works are printed to a huge scale, enabling us to see and conceive of birds in a way that even the greatest illustrators couldn't and can't offer us.

Perhaps what I mean about the feathers is that I never really saw the way they fitted around a bird. The precious little gang-gang cockatoos in my garden creak like squeaky gates, and it's a joy to see one nibbling at a pinecone, turning it

this and that way in its claw; but I never noticed the way the dense, short feathers, gray or red, on the gang-gangs' foreheads meet their beaks as neatly as a velvet turban met the brow of Edith Sitwell. In Sydney's Olsen Irwin gallery, I lingered over Leila's photograph of Soren (p. 136), a wedge-tailed eagle, the selvages of his wings blazing gold. He's almost as sleek as a snake, but not quite; a painter probably wouldn't include the skerrick of white down sticking up, errant, from his shoulders. Looking, I thought: How would it actually *feel* to be taken under a wing? I forgot metaphor and felt a strong physical sense of it: up against ribs and elbow, squeezed between struts of bone, in a space unyielding, dark, and warm at the same time. I felt the chest rising and falling; I heard the heartbeat. I moved along to study a brown falcon with his feathers slicked back from his forehead and his drumsticks in soft breeches. I pored over the dry scales on his hard shins. Note to self: moisturize calves and ankles.

Some people fear appearing ignorant or sentimental by attributing human emotions to animals. Some are uneasy with humans' entitlement to declare what other animals feel, while others insist that animals feel as much as, if not more than, we do. Most people, however, comfortably ascribe certain feelings to people they see depicted in painted or photographed portraits. It's an obvious point, but even *people* may not feel the way they look like they're feeling in a portrait at all. I've been honored to be painted by two accomplished artists myself. In the resulting portraits, the women pictured wear two quite different expressions, yet I can't remember feeling more or less morose or febrile during either session. (On neither occasion did I feel as fat in specific, though different, regions as I obviously was.) Furthermore, in the course of my career I've seen professional portrait photographers at work, and have observed how readily they're able to get a disempowered and self-conscious subject to stand a certain way and put her head at a certain angle to arrive at a particular expression. Appraising thousands of works for various

National Photographic Portrait Prizes, I've been disillusioned by the realization that if you want to depict people with a faraway look, you only need to persuade them to put their lips in neutral and stare at the far corner of the room (the higher they're looking between skirting board and cornice, the less melancholy they'll appear). I scrutinize portraits every day, with interest as much personal as professional, but the truth is, I'm as skeptical about the correspondence between expression, experience, and personality as any middle-aged woman with a resting or default bitch face—as it's now termed—is likely to be.

The great English portrait photographer Cecil Beaton said, "The camera is a mirror of actual facts. Hence if the photographer is also to be an artist, he must pose his sitters and prepare his decorations so as to place before the camera in physical reality those inward facts of life with which an artist is concerned." Leila Jeffreys uses no decoration, and looking through her viewfinder, she can't instruct an owl to bring her right foot forward a little, put her wings by her side, or raise her chin a fraction (the owl doesn't have a chin to raise, anyway). Maybe, I thought, Leila Jeffreys just goes through her proof sheets until she finds a photograph in which the bird *looks like it's feeling something*. That's what most portrait photographers do. A shocking experience, for me, was seeing proof sheets from Beaton's session with Marilyn Monroe in the Ambassador Hotel in New York in 1956. In most of his pictures, she looked entirely ordinary, like a woman standing in for Monroe while Beaton got the lighting right. Certain photographers, though, have a reputation for drawing the best out of their sitters through their own charm, seriousness, or air of integrity. I asked Leila if she could coax an expression out of a bird, or whether she takes a brace of photographs and then chooses the one that best reflects her understanding of that bird's characteristics. She told me that before she tries to bring into physical reality those inward facts of a bird's life, she tries to reveal to people what they habitually miss, either because they don't register the presence of a bird at all, or a bird they do notice is too small to see properly, or doesn't stay still for inspection. Sometimes, she says, she'll photograph a bird and it's not until afterward, when she's looking at the proofs, that she'll see an expression she didn't notice at the time. Other times, the combination of her specialization as a bird portraitist and the bonds she forms naturally with animals means she *can* coax a look out of a bird. When Leila works with birds, she talks to them. When she talked to the red-capped robin, her words appeared to fall on deaf ears; all she

can do with a subject like that is wait until he stares at her lens. Mostly, though, the creature will respond—with a head tilt, perhaps, a change of stance, or a shy glance. She finds that some birds—like Seisa (p. 21), the palm cockatoo—offer up a range of expressions that vary greatly as her relationship with them develops. The process isn't easy technically, but it's simple emotionally—it's honest. The moment you meet Leila, you see why the birds like her.

To humans, other living creatures appear more or less expressive depending on the mix of fixed and movable elements on and around their heads. Looking at the face of, say, a crab or a shark, we'd be hard put to judge whether the animal was contented or panicky at the time, let alone equable or irascible in general. In people, mobile eyebrows, eyelids, eyeballs, and mouth combine with wrinklable nose, twistable neck, tiltable, juttable chin, and static eye bags and teeth to comprise that complicated conceptual thing—expression. It's a fact that birds have half as many principal facial features as humans: where we have eyes, nose, mouth, and chin, they have eyes and beak. (As for secondary features, any expression lines birds may develop are concealed by facial feathers; this could well be the origin of the epithet "lucky duck.") In my estimation, notwithstanding the personality they may *have*, birds fall somewhere between lizards and cats in their equipment to *convey* a personality. It's no accident that the creators of the video game *Angry Birds* endowed its characters with eyebrows; the Angry Birds are only heads, and there simply wasn't enough for the animators to work with. A lot of the expression we read in any of Leila's bird subjects is down to its stance and glance (behold the princely mien of Darcy, p. 133, the brown falcon apparently cloaked for a state occasion). Neither bird nor person has any advantage over the other when it comes to conveying expression through the ears. There, cats and dogs command the field. However, birds have a great expressive advantage over fish, say, simply because they can tilt their heads. Reading Helen Macdonald's ravishing *H Is for Hawk*, I was beguiled by the passage in which the goshawk Mabel turned her head entirely upside down while playing. Nothing implies curiosity like a head tilt. Furthermore, a head tilt can indicate desire for meaningful communication between disparate entities. The miniscule silvereye (p. 63), who flew into focus while Leila was setting up a shot with a different bird, is irresistibly appealing, not only in the sense of being sweetly attractive, but also in the sense of seeming to request an answer or explanation. It seems thrillingly inquisitive *about us*.

A bird's beak acts like a mouth, but it sure does look like a nose. Emoticons characteristically have no nose, which, to me, explains why there is no emoticon to denote or express hauteur. Two of the haughtiest and sexiest portraits I know are by John Singer Sargent: of Madame X (now *there's* a stance and glance), in the collection of the Metropolitan Museum of Art, New York, and of Lord Ribblesdale, in the collection of the National Gallery, London. Each of these portrait subjects has a nose of very considerable substance. The nose of Thomas Lister, fourth Baron Ribblesdale, one-time Master of the Buckhounds, and regarded as the "face" of the Victorian and Edwardian aristocracy, is aquiline, meaning "eagle-like." The term reminds us that the profiles of some birds are regularly appropriated for the paraphernalia of the elite: crests, escutcheons, emblems, and the like. Far and away, the leaders in this field are the eagles, adopted as mascots by countries and organizations as various as the Nazis, the United States, Indonesia, Poland, Mexico, the Holy Roman Empire, and the Anglican Church. Stubby-beaked birds rarely appear in heraldic trappings, although two of the nicest national crests, of Saint Lucia and of Dominica, feature parrots, rendering both islands inviting from the outset. One of the pleasantest human snub-nosed portrait sitters is Jacques-Louis David's Madame David, in the National Gallery of Art, Washington, DC, who has more head feathers than some of Leila's sitters. Comtesse Daru, depicted by the same artist in a portrait now in the Frick Collection, New York, has always reminded me of a cockatoo, simply because she looks so perfectly composed, intelligent, and complacent at once. (To me, Matilda, p. 43, the Major Mitchell's cockatoo, looks like the gentlest, most contented of homemakers, pink and white cashmere twinset snug over her bosom.)

The variation in beak size and shape is so great that some birds don't have profiles at all. Imagine Leila's Duke (p. 129), the eastern grass owl, turned fully side-on to the viewer. He'd appear not to have a head, but a neck terminating abruptly in a flat plane like the end of a log. Mrs. Plume (p. 91), the budgerigar, could press her forehead, beak, chin, throat, and chest against a window all at once. As to full-figure silhouettes, some budgies, including Barnaby Rudge (p. 105), appear to carry what dressmakers call a dowager's hump—a pad of flesh between the shoulders, often seen on the mature female human, necessitating a couple of extra small darts at the back neckline. Even if it's only on account of puffed-out feathers, budgies are among the few birds that can look like they're lugging a few grams of extra weight. In fact, the creation of a flock of budgies would be a nice project for a kindergarten class, because they're little lumps of birds, improbably and quite tastelessly colored.

The nostrils have allowed many individuals, such as Vivien Leigh, the opportunity to show disgust or defiance by exposing them in a tilt-back of the head (some people, notably the late Kenneth Williams, the English comic actor, can dilate or draw up the nostrils to enhance reactive effects). It's an odd fact that while most birds have nostrils (or nares) in their beaks, some don't. I'd contend that they're the least-noticed features of birds. (The Angry Birds have no nares, though their nemeses, the pigs, have massive nostrils.) In mammals, the nostrils are invariably to be found at the terminus of the nose, but among birds, only kiwis— anomalous in other ways too—have them there. In birds, the position of the nares varies from species to species. The cockatoos have them up very high, level with the eye. They're visible in the female black cockatoos Nora (p. 27) and Rosie (p. 45), and enhance the attractiveness of the cockatiel Jarra (p. 47), but they're hidden under feathers fine as mouse fur in Queenie (p. 35), the galah, and who could see what's going on under the riotous crest of Pete (p. 31), the red-tailed black cockatoo? On budgerigars, the nares are set in their own distinctly colored section of fleshy tissue shaped like a Barbie's strapless bra, or a dormouse's padded sleep mask (ratifying the childish appeal of budgies—the cere, as it's called, really is pinkish for girls, blue for boys).

In his book *Modern Painters*, John Ruskin squandered a little of his brilliance on setting the mouths of animals on a scale of attractiveness. The nastiest mouths were those least capable of expression, or most capable of destruction— those of fish and crocodiles. From there, "we arrive at birds' beaks," before scaling the ladder of beauty to arrive at the lips of carnivores—attractive to Ruskin, except when they were snarling or biting. Thence, the critic progressed through the mouths of horses, camels, and fawns to arrive at those of man. Far be it from me to argue with Ruskin about art, but having looked at scores of pictures of fawns on the Internet, I'd contend that the lips are among the least of the beasts' adorable components. Furthermore, I contend that unlike people's mouths, and the mouths of, say, camels, birds' beaks usually look clean. Birds don't slobber; they lack teeth to graduate to brown and fall out; their lips don't sag,

twitch, or whiffle. Even in extreme old age their scratched and chipped beaks are firm. The slightest inaccuracy in the position, thickness, or line of the lips makes for a disaster in a painted representation of a person. The habitual mobility of the human mouth means that in paintings, people often look as if they've been affected by palsy or a stroke. In fact, Sargent is said to have defined a portrait as a likeness in which there is something wrong about the mouth. An alien mouth doesn't necessarily come down to an artist's mistake, though. Each of us has had the experience of being photographed with lips set in an unattractive manner that we fondly believe to be uncharacteristic—just *wrong*. Had we beaks, we wouldn't be so susceptible to misrepresentation. Providing it keeps its beak closed and its eyes open, each bird's facial expression is invariable. Cockatoos' beaks fit together as perfectly as the rounded shells they often resemble, interlocking as harmoniously as the parts of the symbol of yin and yang. Delightfully, the seam line along many cockatoos' beaks turns upward, imparting a permanent smile that conduces to their popularity as pets. Bob (p. 39), the long-billed corella, and Slim (p. 25), the sulphur-crested cockatoo, could be a pair of old vaudevillian comedians: interminably yarning Bob in his trademark orange tie and pince-nez, white hair in a high wedge; Slim raising his crest and squawking at an innuendo; both with their yellow-powdered cheeks. Though his head is no bigger than a snail's shell, who or what could wear a more benign expression than Jarra (p. 47), the cockatiel?

The gape of cockatoos doesn't extend beyond the bony part of the beak. Exult as I may over the perfection of the wedge-tail's beak—ivory yellow shading into dark gray, like a polished bangle on the arm of the heiress Nancy Cunard—I'm a little unsettled to observe the soft pink curve that extends its line: a flange of "lip" that cuts into the cheek like a frown. Roscoe (p. 79), one of the tawny frogmouths, is one of few of Jeffreys's subjects photographed with his beak ajar, or agape. Another frogmouth (p. 81), his slash of beak closed, tip pursed and distinctly downturned at the sides, is like a feathered sock puppet; he looks as alarmed and aghast as his namesake Beaker, the Muppet Labs assistant.

⸻

If you walk through a sulphur-crested cockatoo rookery at dusk, you'll see the birds clowning around, hanging upside down, shrieking insults resembling pocket Nazgûl. A few might be taking one last bowlegged trundle through the grass, crests erect. On Leila's gang-gang Commander Skyring (p. 23),

the wayward, wispy head feathers and the bald-rimmed eyes convey an appealing dishevelment (Mrs. Skyring, p. 22, apparently passing a piece of gossip over her shoulder, looks younger than her mate). A good guide to the age of humans is the amount of wrinklature and slack skin around the eye sockets. Apart from shabby feathers, a good guide to the age of cockatoos is the amount of featherless, thin flesh around the eyes. The older they get, the more sulphur-crested cockatoos look like they've been out all night, their bare eye bags teamed with their crests like yellow party hats. Every corella, even a young one like Little Stevie (p. 33), has an appealingly dissipated, even hungover look—a bit like Boris Johnson, the charismatic mayor of London.

Absurdly, humans have, over time, linked particular character traits to particular eye colors: we fancy that brown eyes are soulful, bright blue eyes are sharply appraising, and gray-blue eyes are divinely mild. How kindly we smile in response to the eyes on Goya's cockaded Countess Chinchón in the Prado, Madrid, one of the softest-looking women in the whole of Western art; they're just the same shade as those of Leila's beloved gannet (p. 175). Many birds' eyes change color as they age. Within the same species, males and females may have differently colored eyes. The eyes of Forrest (p. 153), the great horned owl, are yellow like a cat's; the budgies' eyes are as pale as wolves'. Beady-eyed birds, like the silvereye and the robin, look sharply alert because their eyes are as wide open as they could be. Birds like Pete (p. 31), the red-tailed black cockatoo, who seem to have little black glass pinheads for eyes, are revealed in Leila's shots to have brown eyes with pupils. I should have known they did—but I didn't.

I said earlier that Leila employs no decoration. That said, the grave aspect of the hunters in her *Prey* series is heightened by the backdrop against which they stand—a lowering gray as opposed to the lighter shade in her shots of cockatoos, for example. Some raptors' brow ridges, extending from the inner corner of the eye to the midpoint of the eyelid, make them look as if they have eyebrows, brought together in a frown. Soren (p. 136), the wedge-tailed eagle, has exactly the look that cartoonists go for in drawing eagles. The combination of frowny eye ridges and tucked-in, down-curved beak gives the adult Trinity (p. 147), the brown goshawk, an expression of disapproval, censoriousness even, that she lacked as a juvenile, when her face was bluer. While the bodies of the raptors are brown and gray, their faces are surprisingly colorful: the round brown eyeball of Leila's Ash (p. 127),

the gray falcon, is set in a yellow ground the shape of a human eye, and Fenrick (p. 143), the black kite, has yellow lips. The apparent irritability of the eagles and falcons doesn't diminish their personal magnetism. You'd think it would, but then consider Lucian Freud, a man with the permanently angry look of a small bird of prey, who was utterly irresistible to his female portrait sitters (there's a marvelous photograph, incidentally, of Freud holding a kestrel, taken by Clifford Coffin for *Vogue* in 1948). Set in the silky swirl of tickly fluffiness composing Pepper (p. 135), the southern boobook, are astounding yellow orbs, on the very front of the face. Those disproportionate eyes are the reason everyone loves owls. In this photograph, however, it's not just their size that draws us in; it's the bird's enlarged pupils, which humans read as symptomatic of interest, even love, from an interlocutor. Because of her smaller pupils, the owl Sooty (p. 131) looks more ferocious than Jeda (p. 141), her counterpart. Oddly appealing are birds with whiskers, or rictal bristles, like those on the face of the somnolent Yule (p. 149), the barking owl. Soren (p. 136), the wedge-tail, also has minute hair-like feathers on his face, arranged in a nebula spinning from the inner corner of the eye. One of the superabundance of cute aspects of Penguin (pp. 66–73), the magpie, is that she's lying on her back with her eyes open (another is her outstretched claws—hands up!).

In contemporary Australia, one rarely experiences the enjoyment of looking at an image of a vivacious person, effortlessly inhabiting well-fitted garments of rich cloth and intense color. Partly, that's because, at present, a fey look— even a nauseated and a dowdy look—is more fashionable than a zesty one. Scuffing around in this casual country, we can only yearn for one of the traditional pleasures of portraiture—the clothes. In Leila's portraits, I see the rich texture and elegant cut that I dream of in the covering we humans, bald for life, are constrained to adopt. Through a unique combination of technical skill, ingenuity, patience, and empathy, Leila creates objects of art that are luxurious visual pleasures in themselves. By abstracting her subjects from their accustomed context, she demands focus on form, composition, and color. Stark and warm, objective and celebratory at the same time, her photographs not only enhance our personal surroundings by their own decorative presence, but expand our joyous understanding of the world we inhabit, yet customarily see so incompletely in the short time allotted to us.

Color Plates

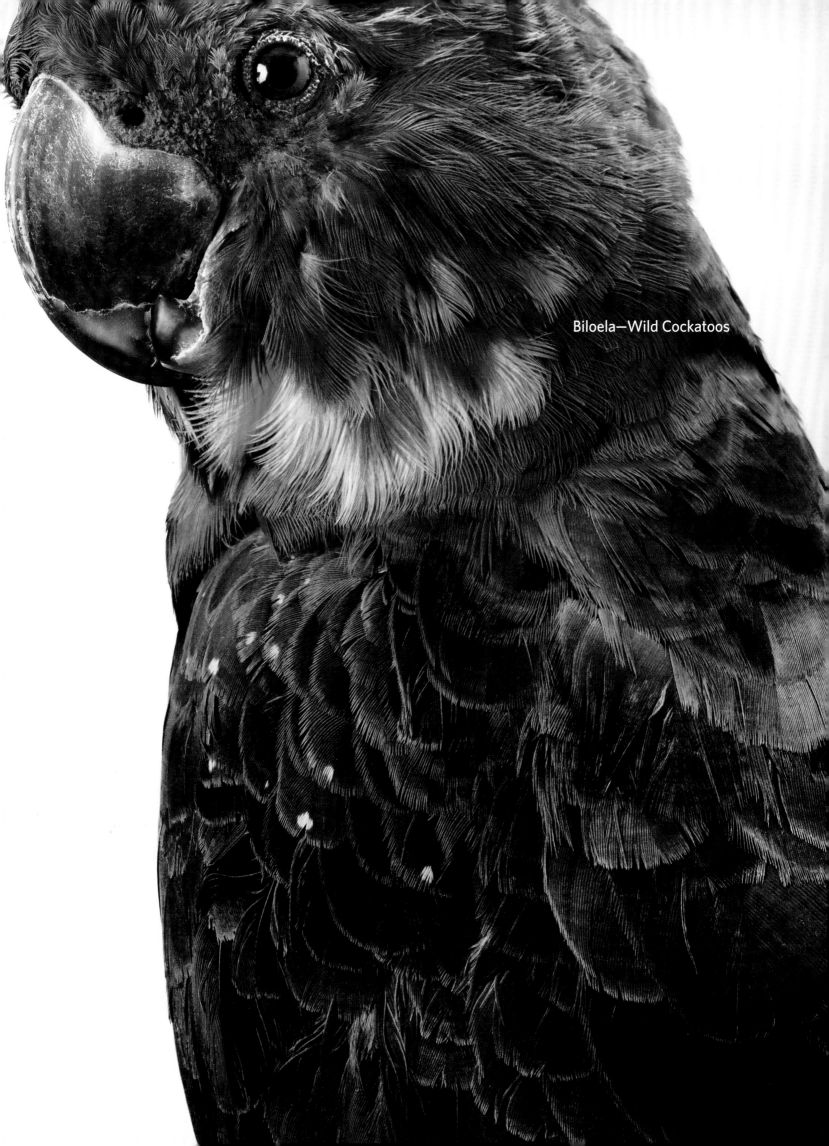

Biloela—Wild Cockatoos

Seisa
Palm cockatoo
Probosciger aterrimus

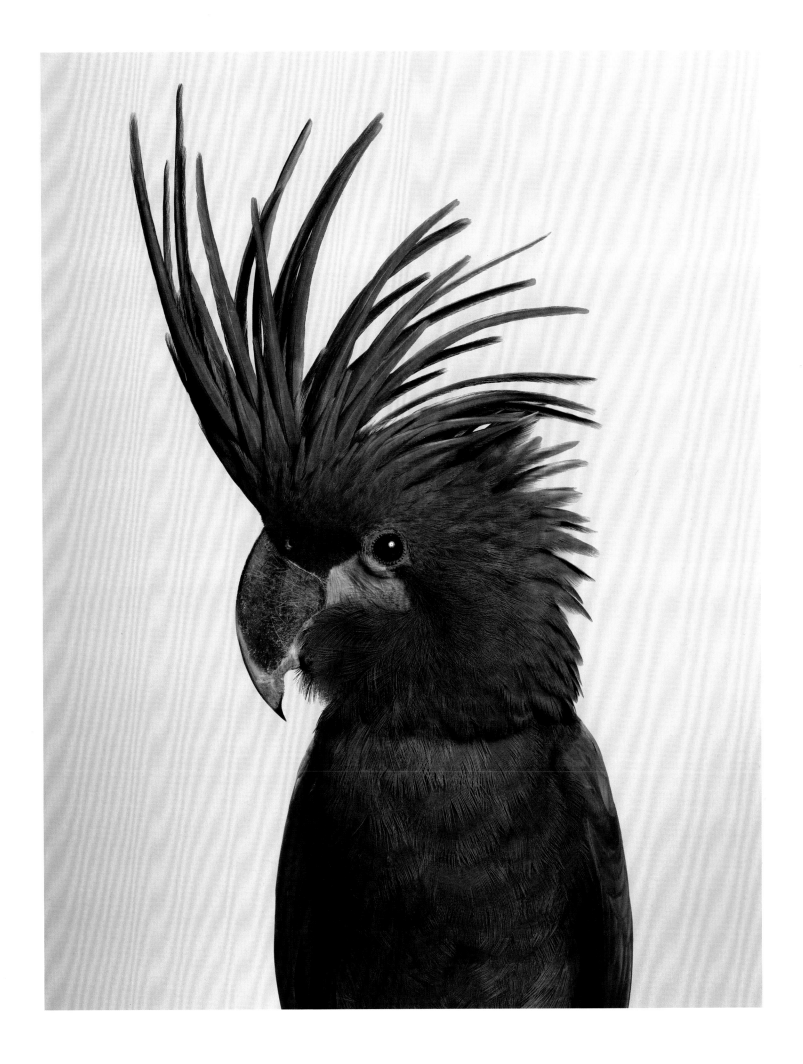

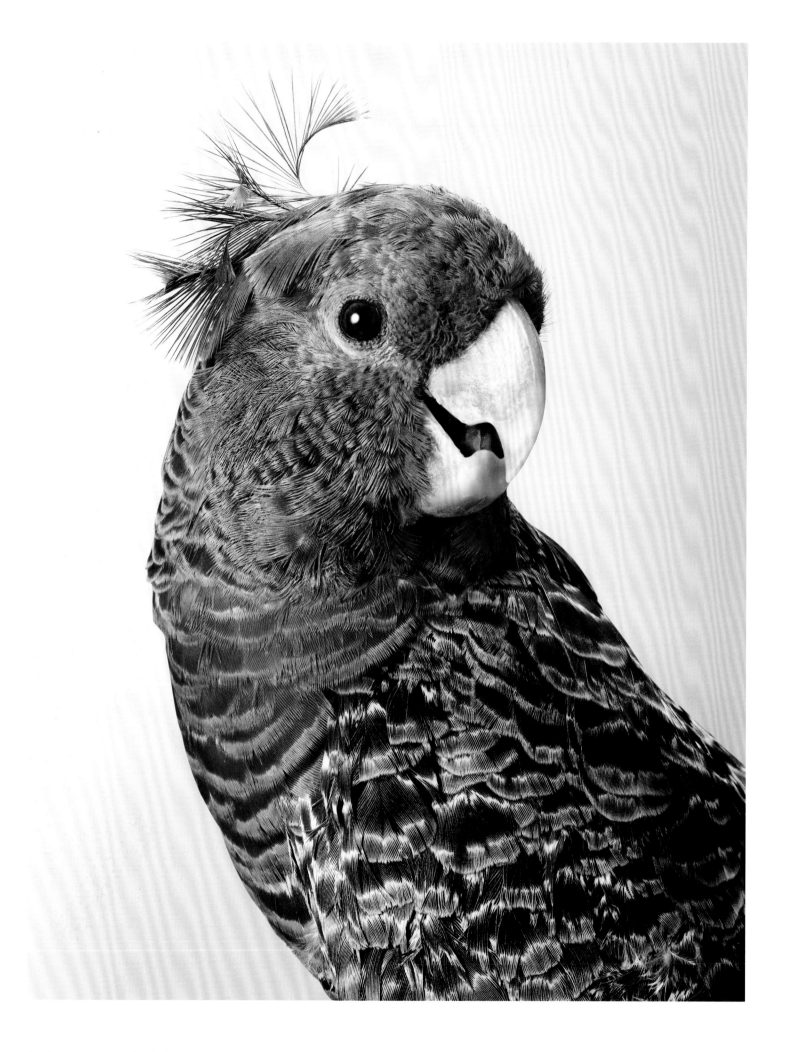

Biloela—Wild Cockatoos

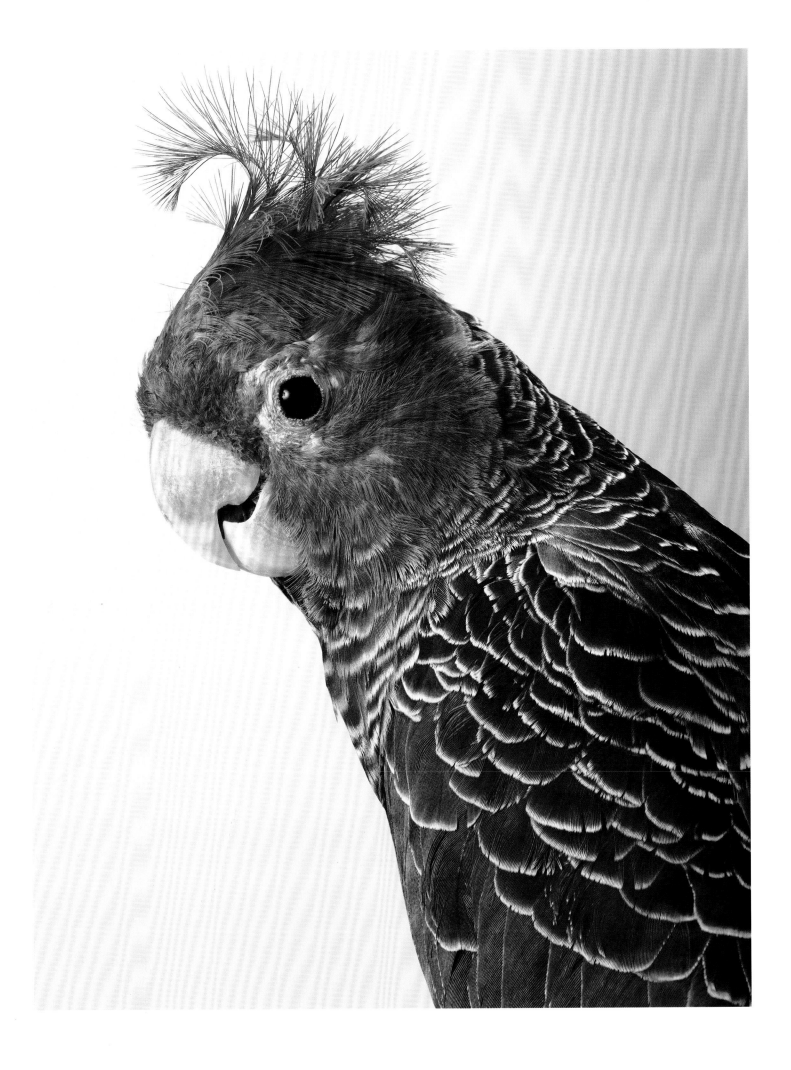

22
Mrs. Skyring
Gang-gang cockatoo
Callocephalon fimbriatum

23
Commander Skyring
Gang-gang cockatoo
Callocephalon fimbriatum

Slim
Sulphur-crested cockatoo
Cacatua galerita

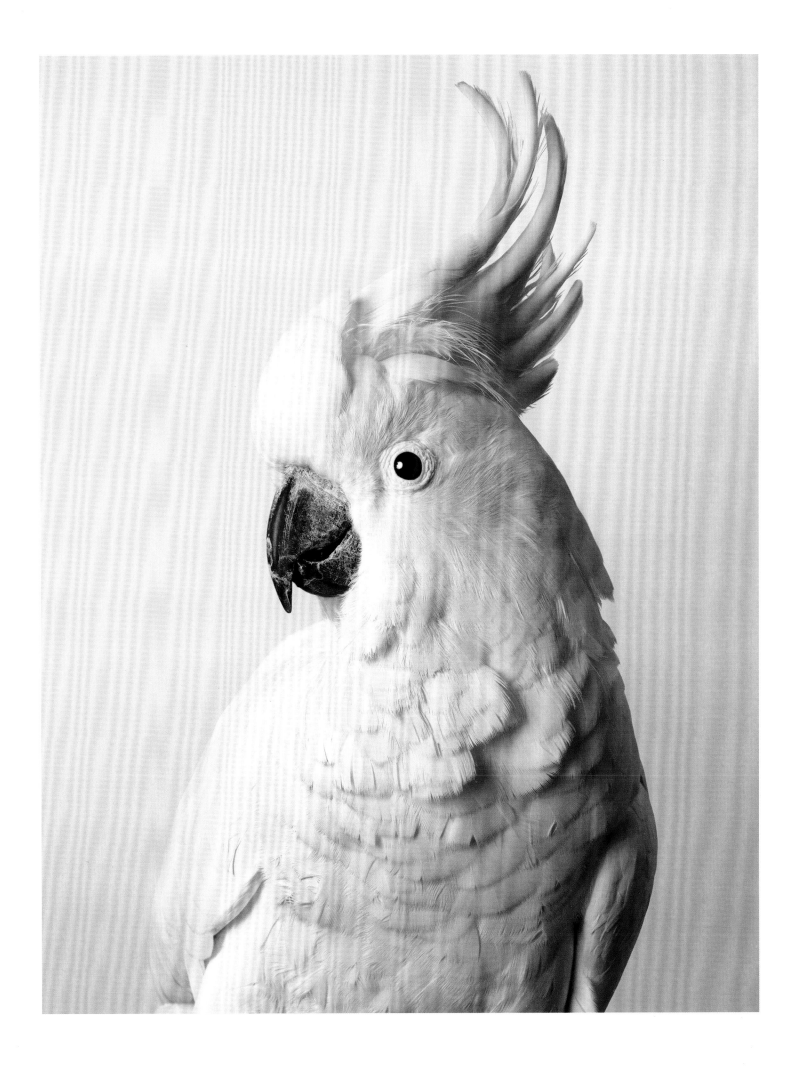

Nora
Red-tailed black cockatoo
Calyptorhynchus banksii

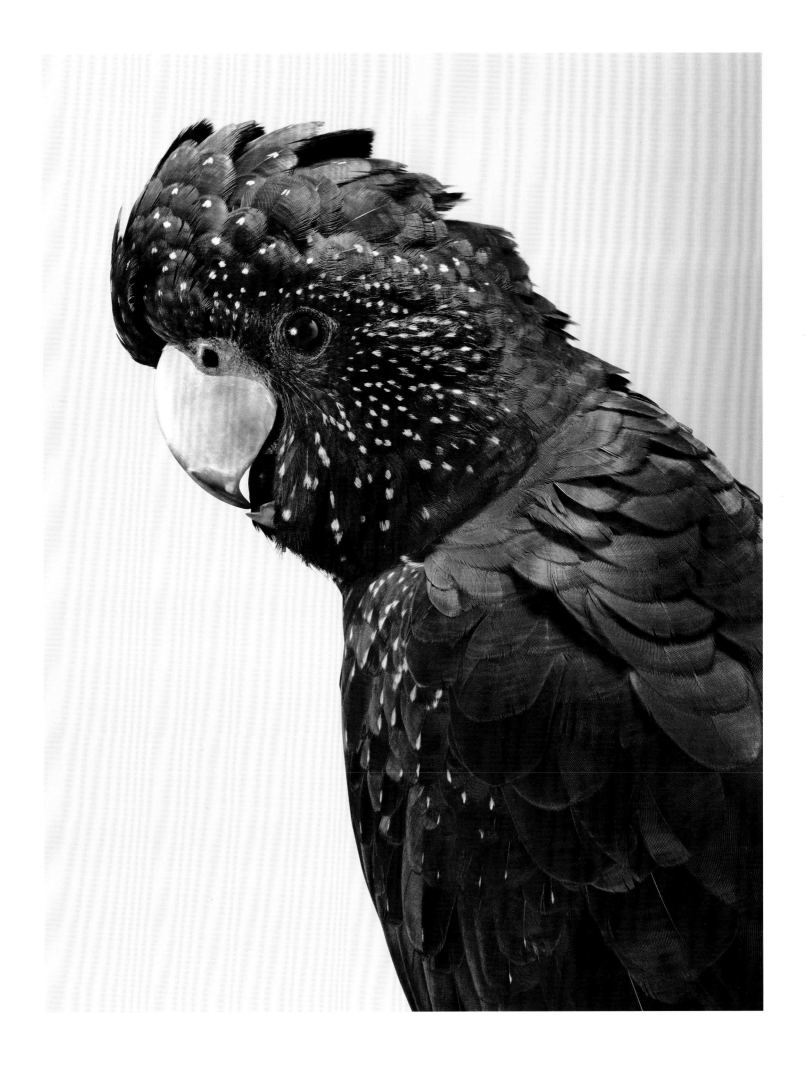

Neville
Major Mitchell's cockatoo
Lophochroa leadbeateri

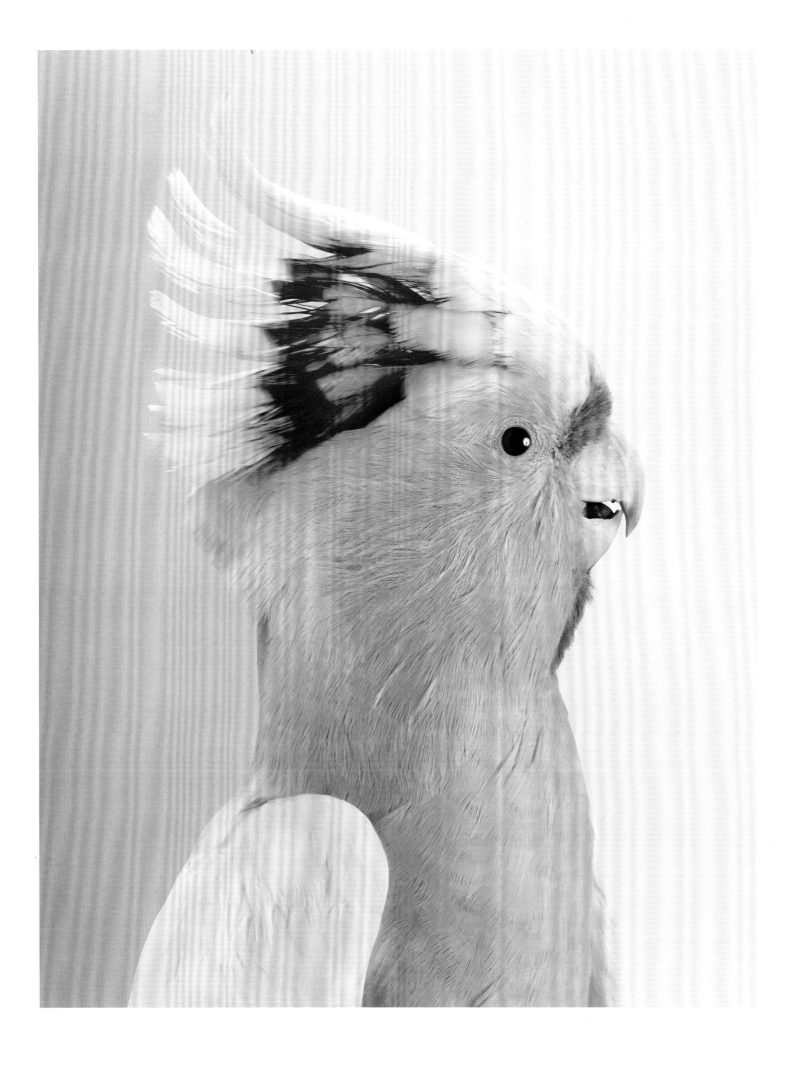

Pete
Red-tailed black cockatoo
Calyptorhynchus banksii

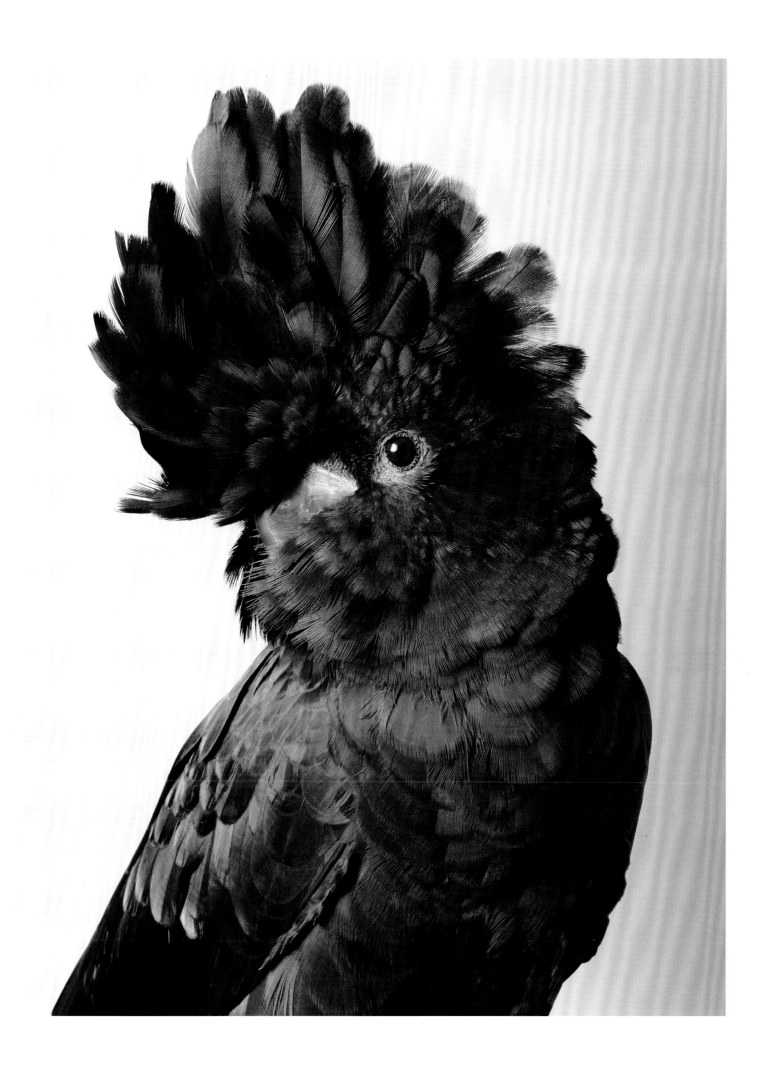

Little Stevie
Little corella
Cacatua sanguinea

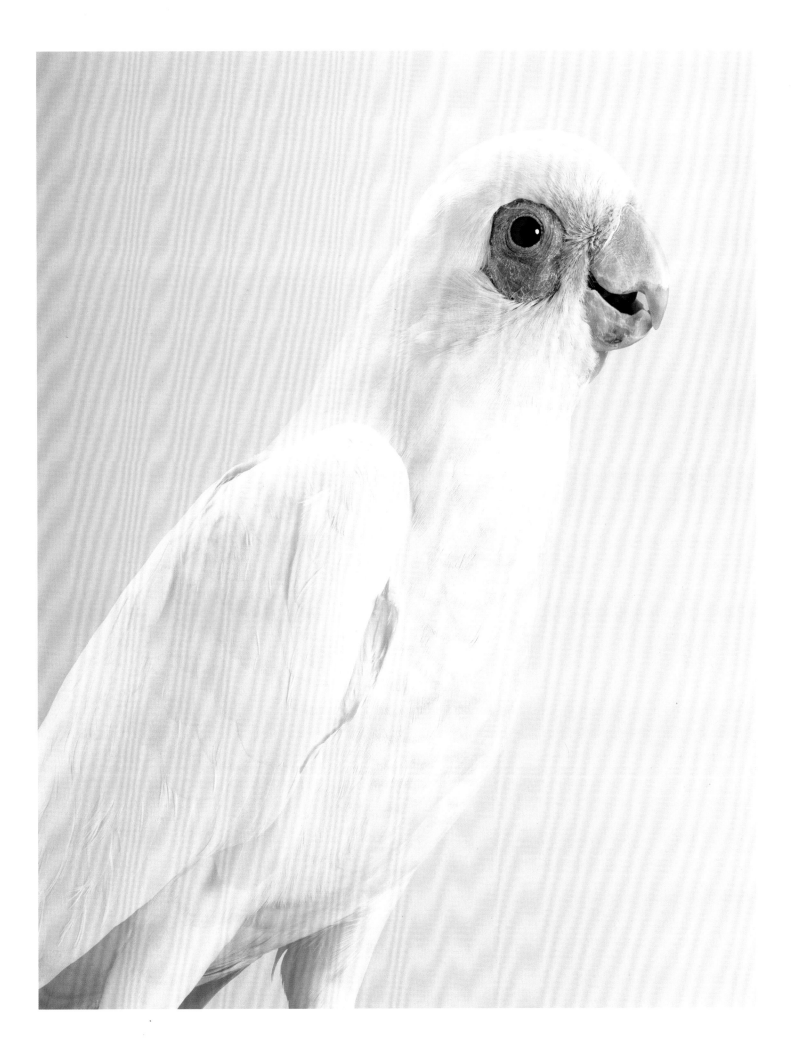

Queenie
Galah cockatoo
Eolophus roseicapilla

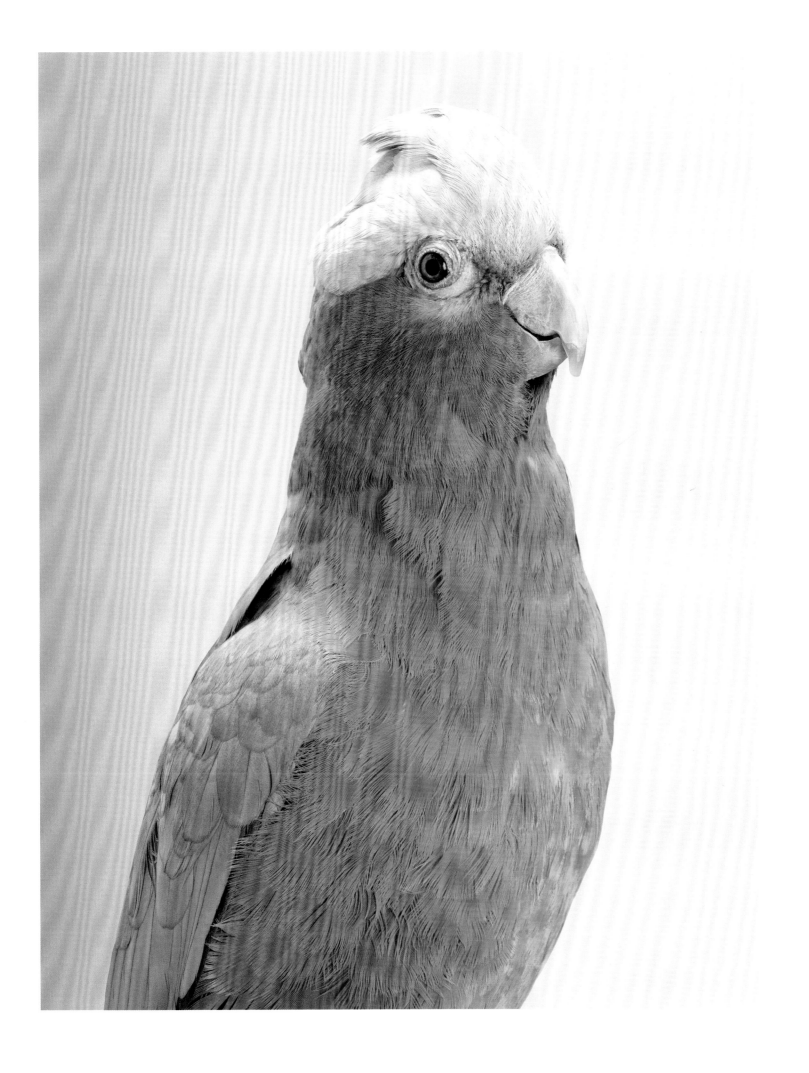

Melba
Yellow-tailed black cockatoo
Calyptorhynchus funereus

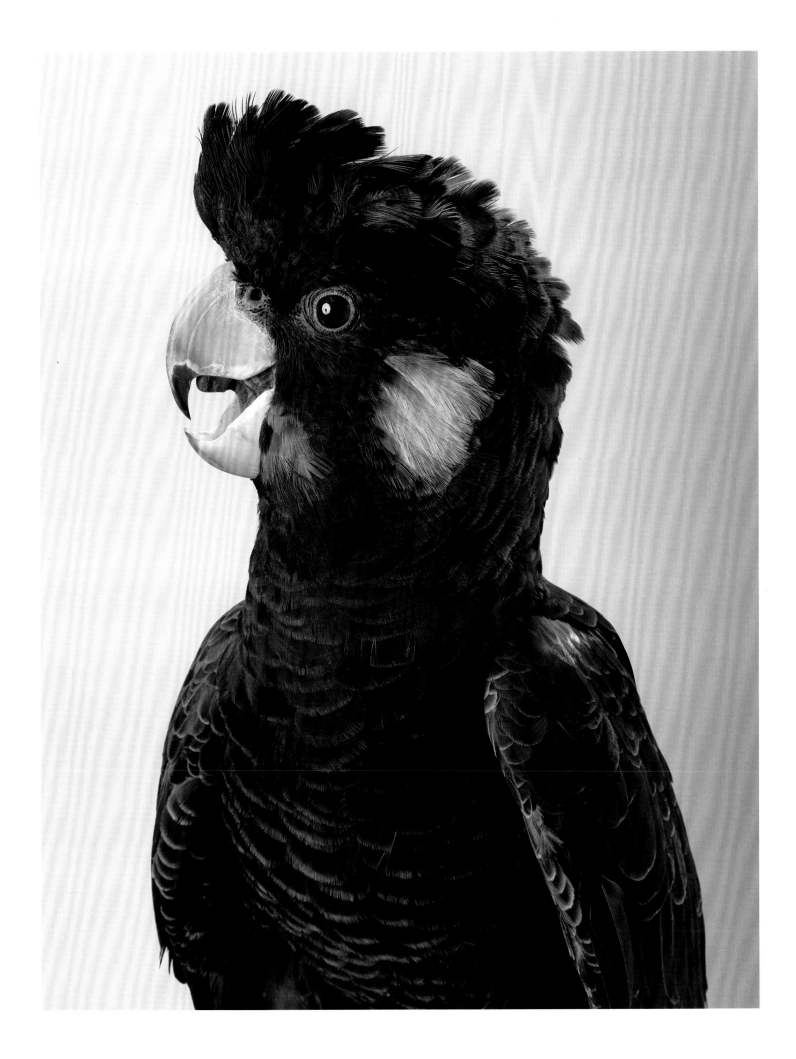

Bob
Long-billed corella
Cacatua tenuirostris

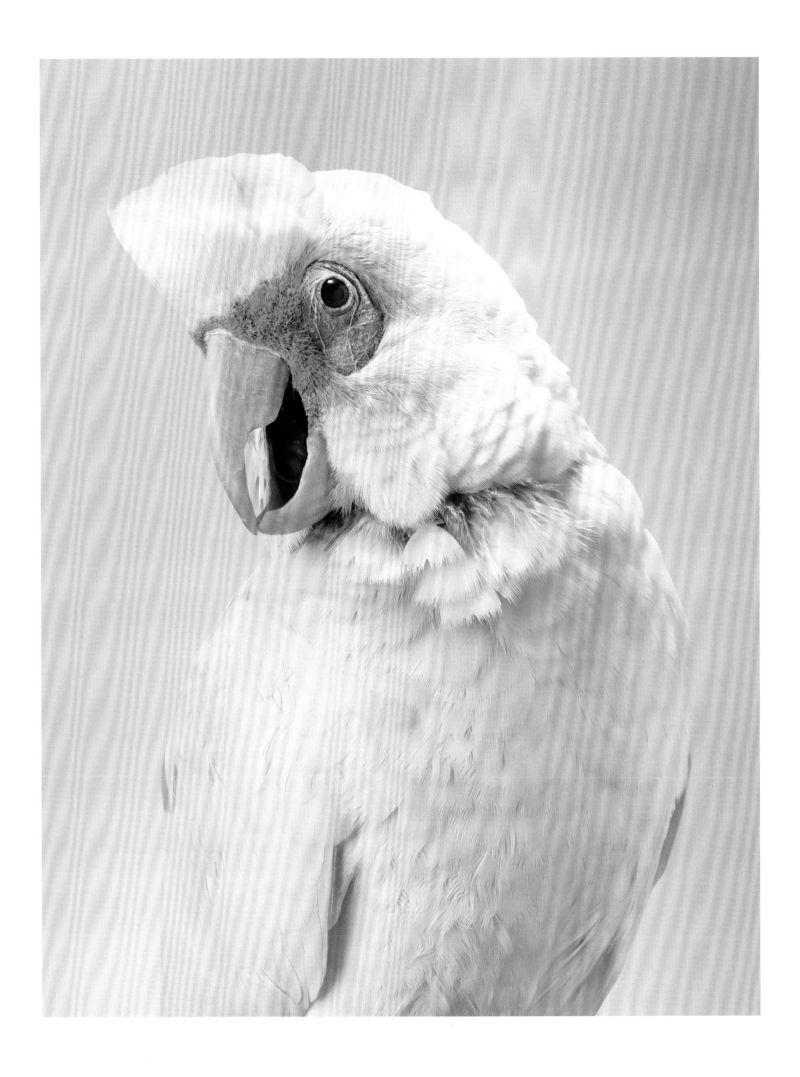

Kirra
Carnaby's black cockatoo
Calyptorhynchus latirostris

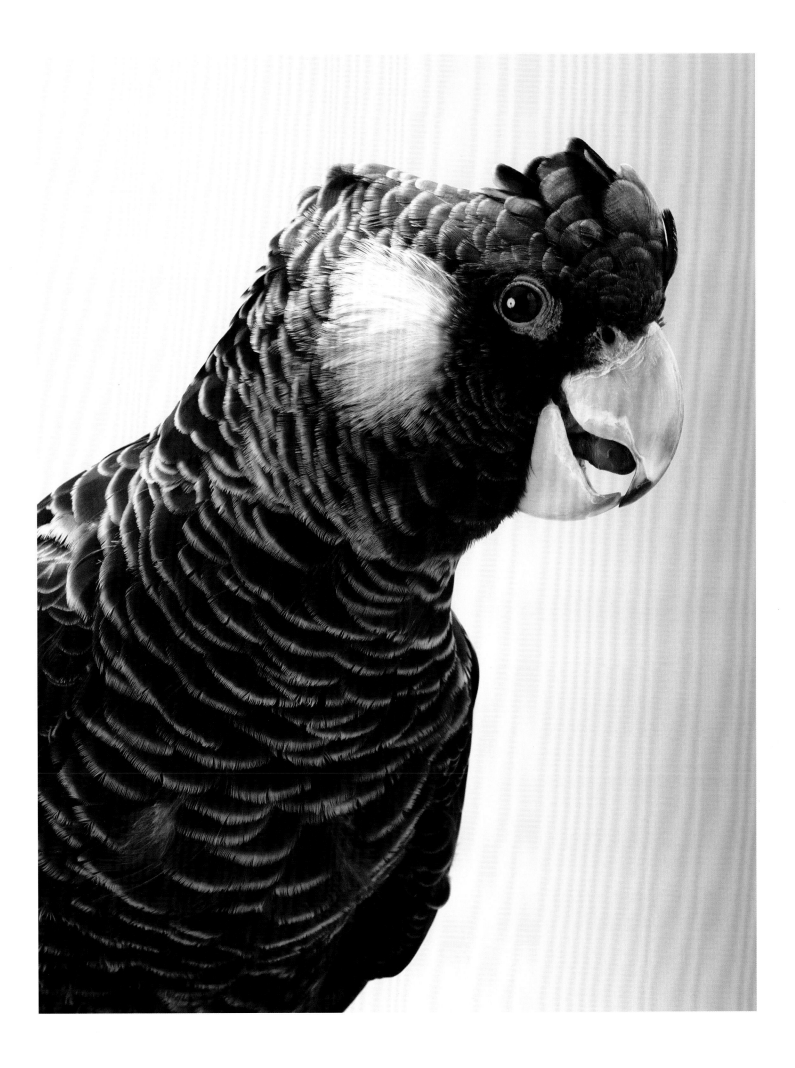

Matilda
Major Mitchell's cockatoo
Lophochroa leadbeateri

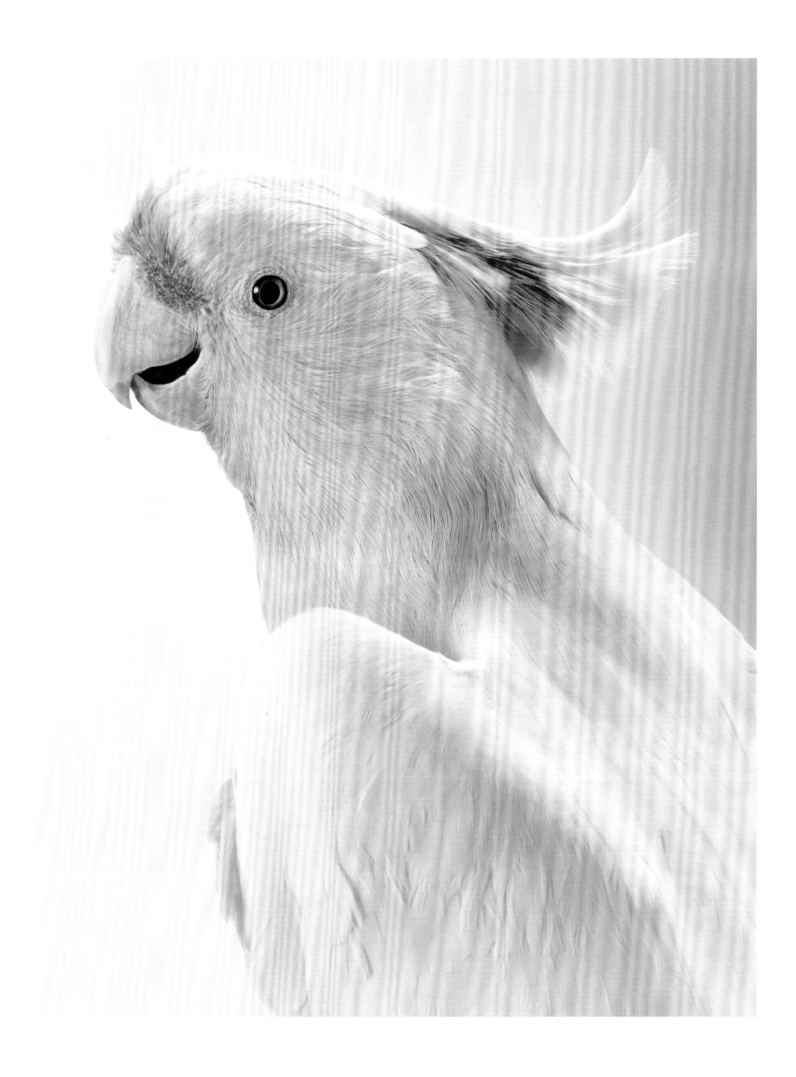

Rosie
Red-tailed black cockatoo
Calyptorhynchus banksii

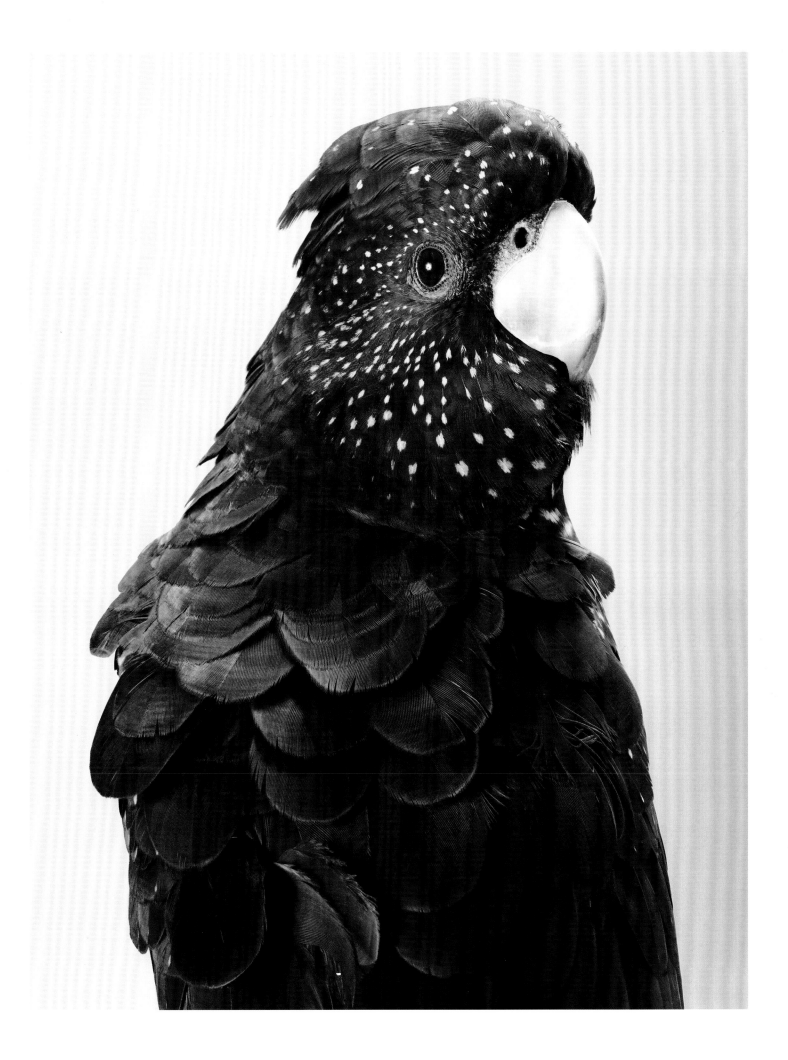

Jarra
Cockatiel
Nymphicus hollandicus

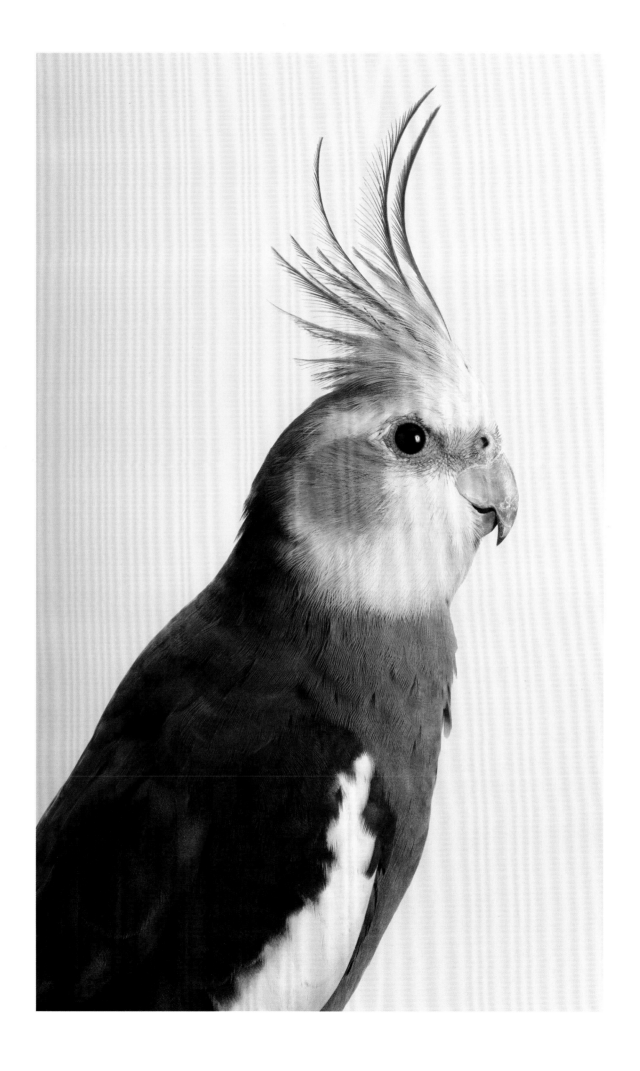

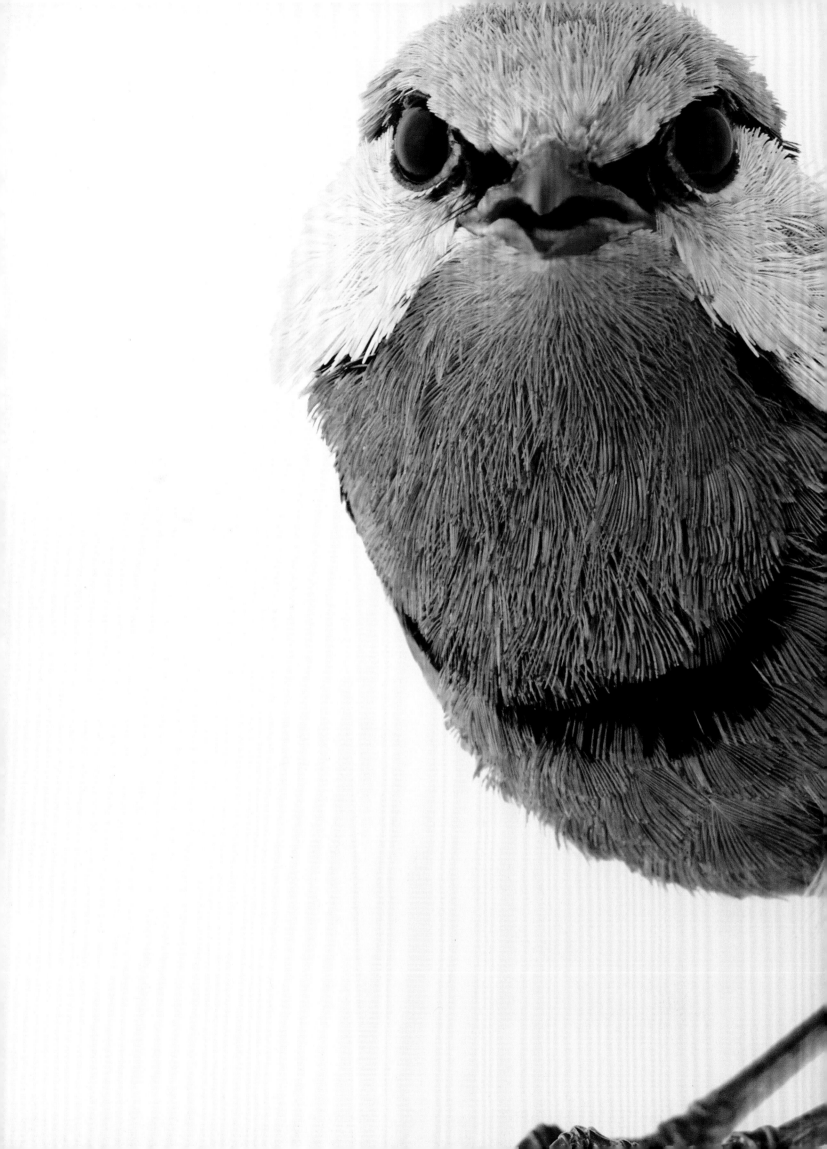

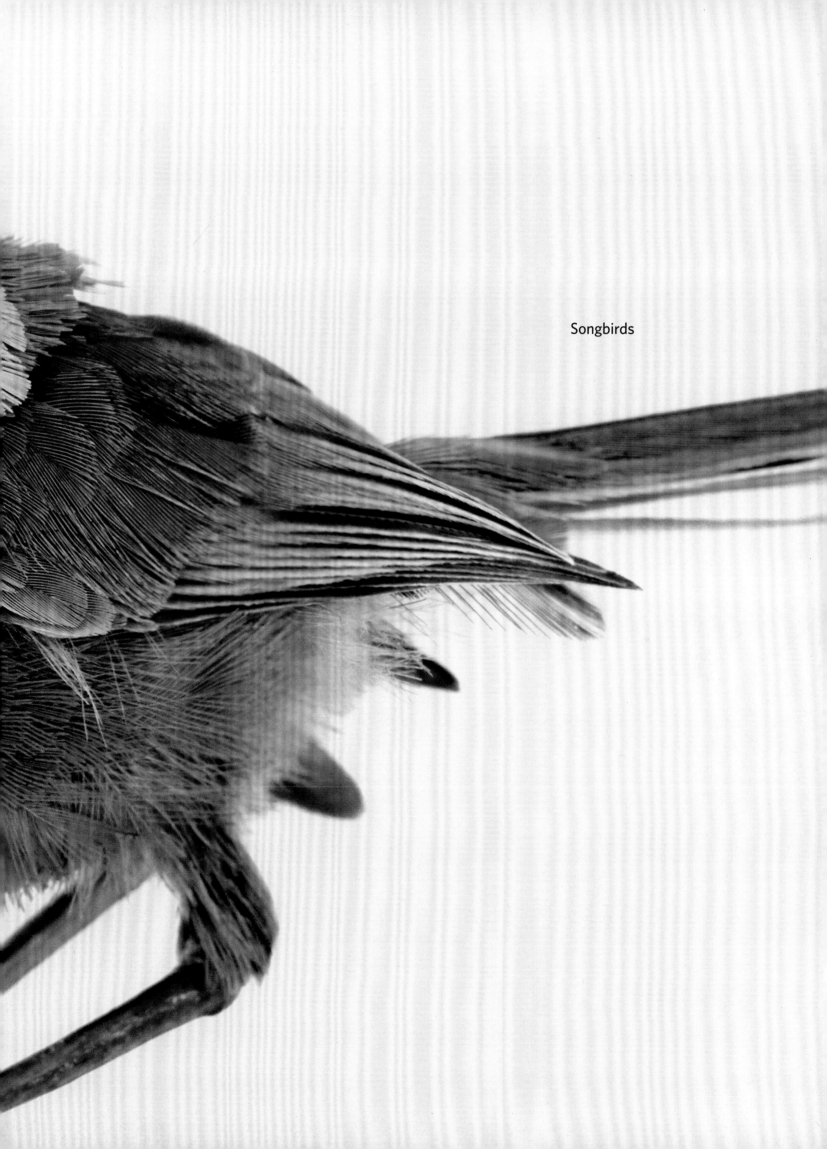

Songbirds

Ellery
Red-browed finch
Neochmia temporalis

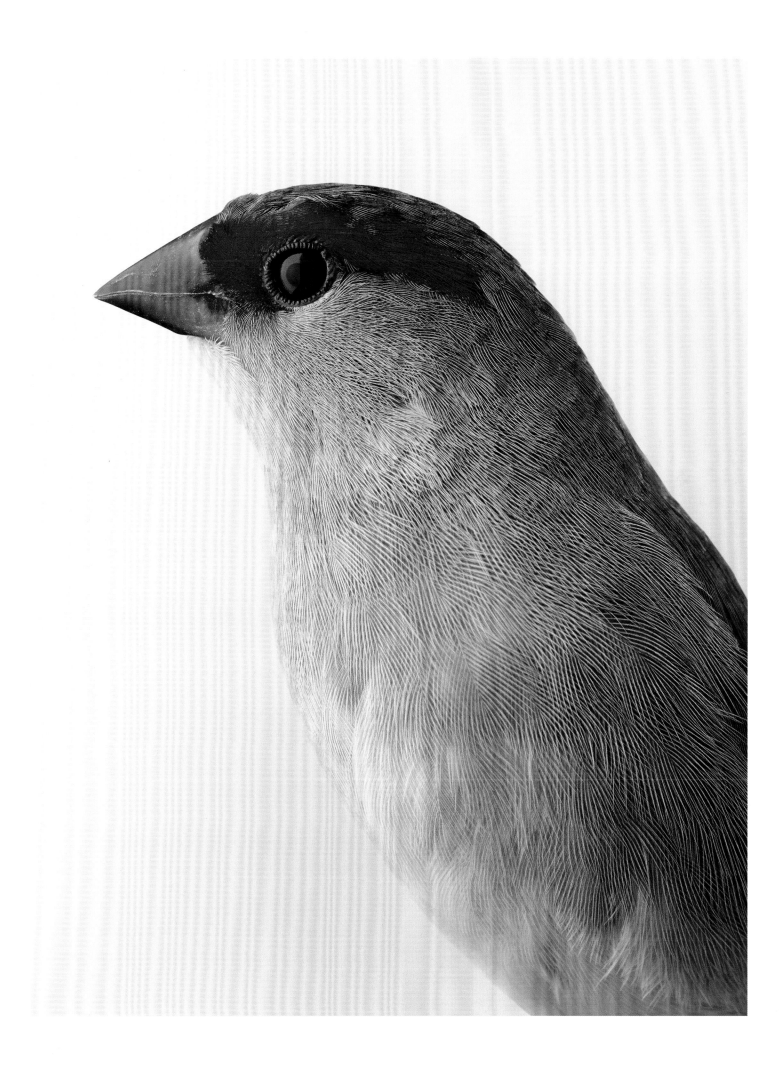

Desmond
Diamond firetail finch
Stagonopleura guttata

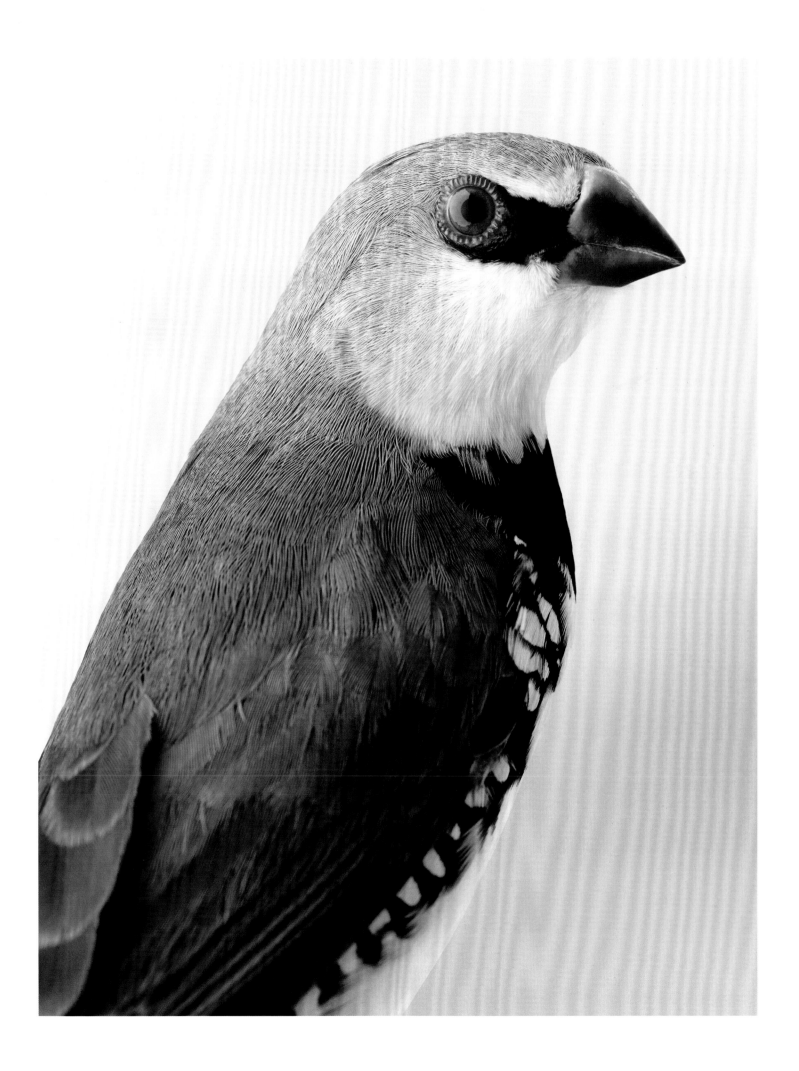

Charlie
Black-headed gouldian finch
Erythrura gouldiae

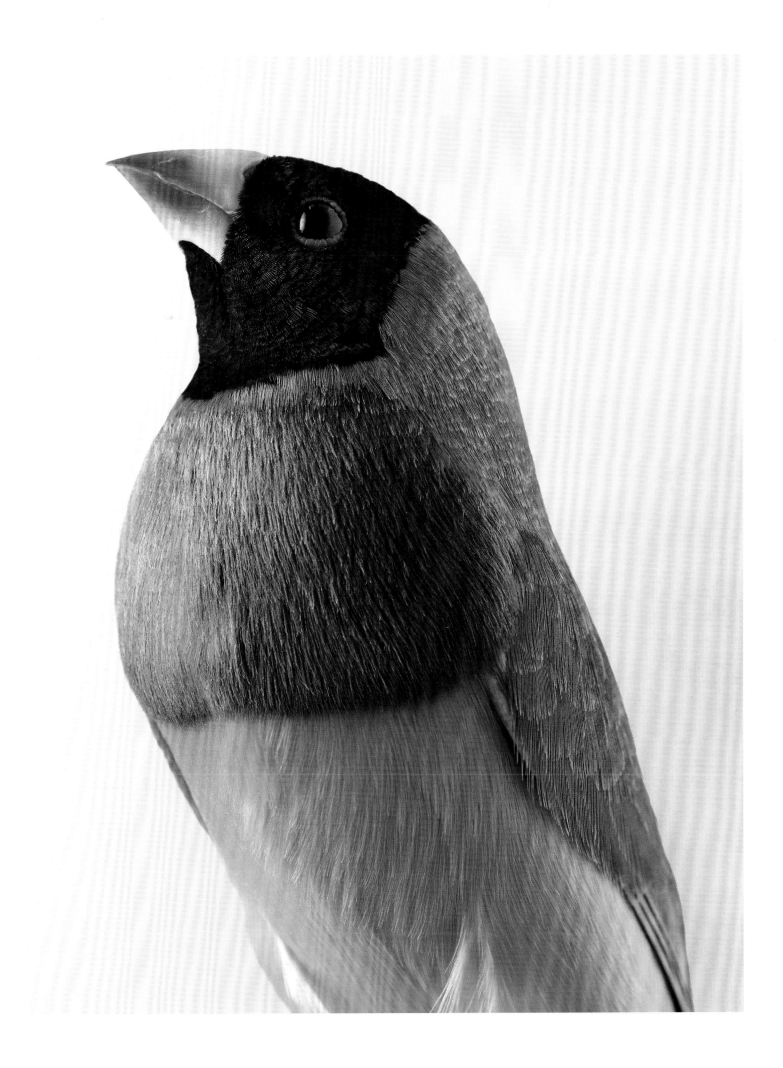

Christo
Orange-headed gouldian finch
Erythrura gouldiae

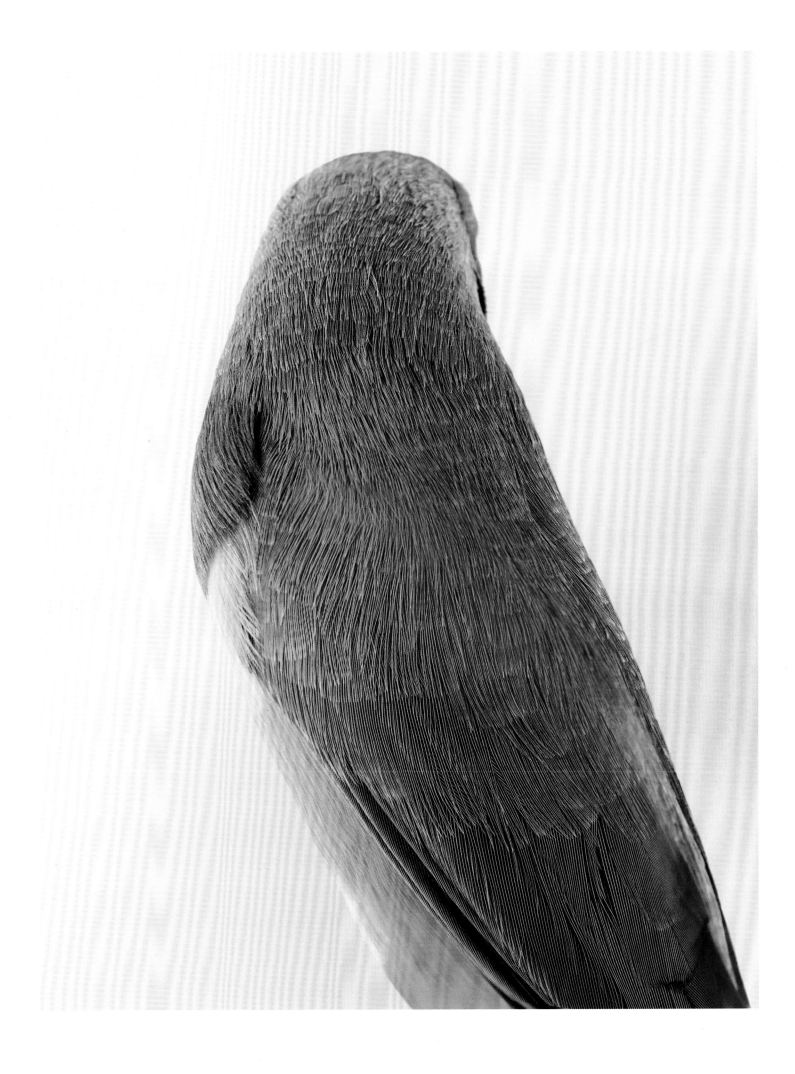

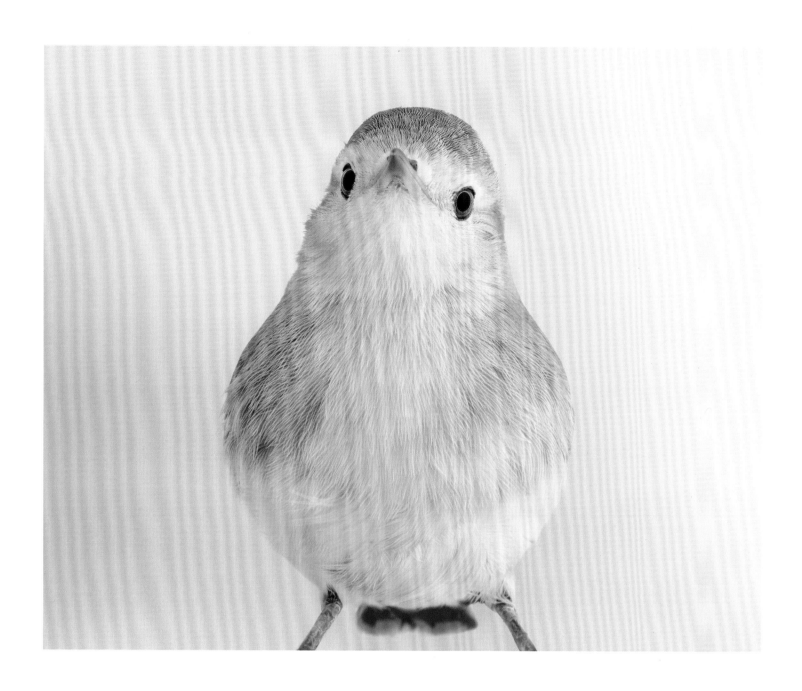

Amanda
Orange chat
Epthianura aurifrons

Ben
Orange chat
Epthianura aurifrons

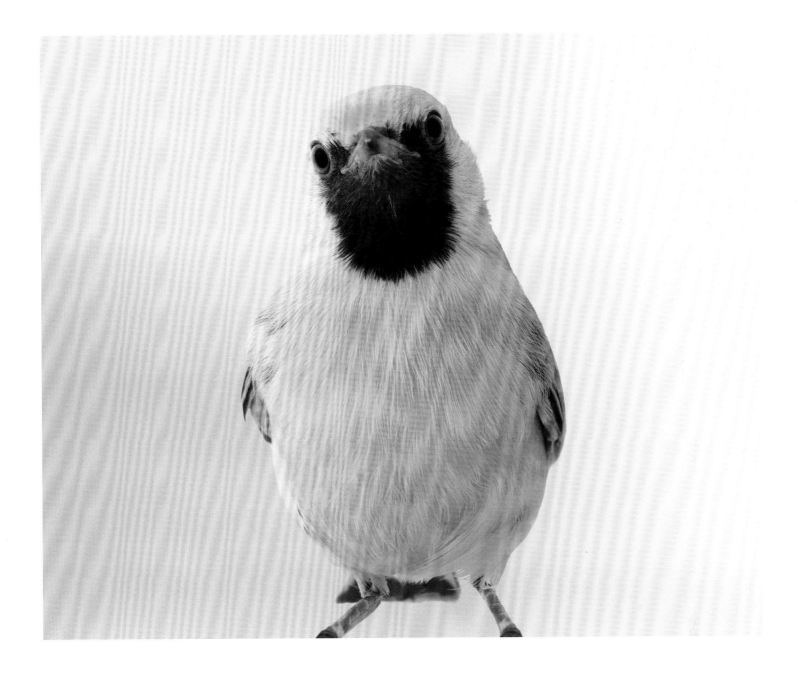

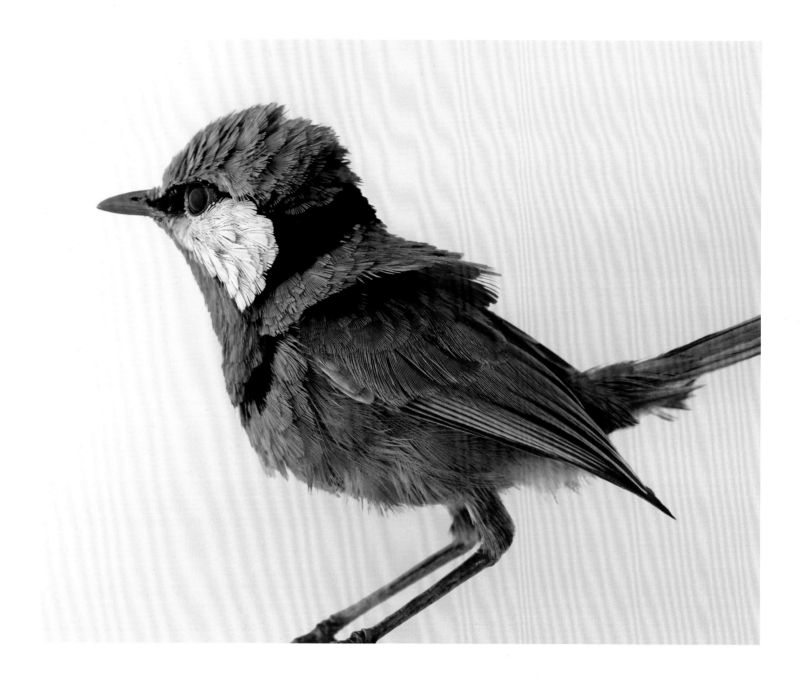

Pepe No. 1
Splendid fairywren
Malurus splendens

Pepe No. 2
Splendid fairywren
Malurus splendens

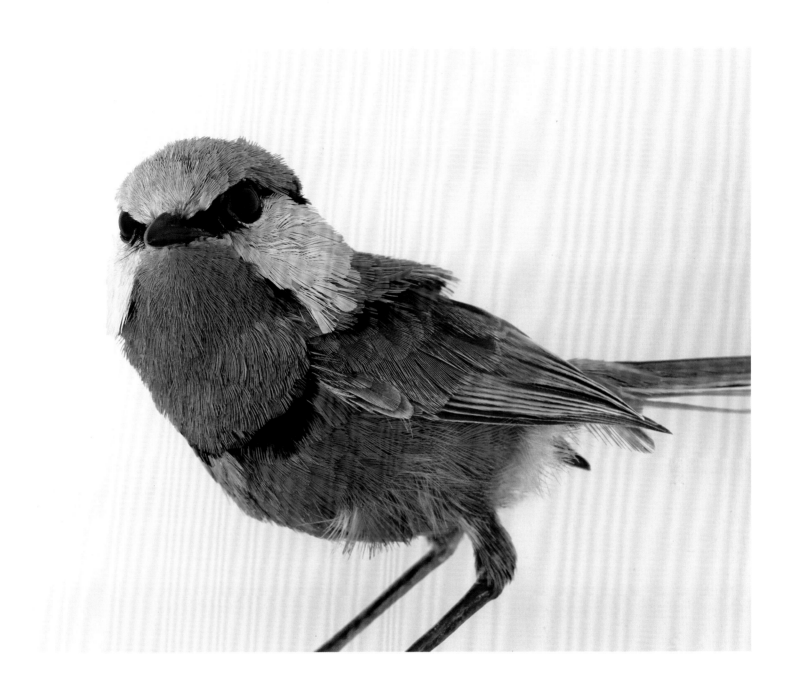

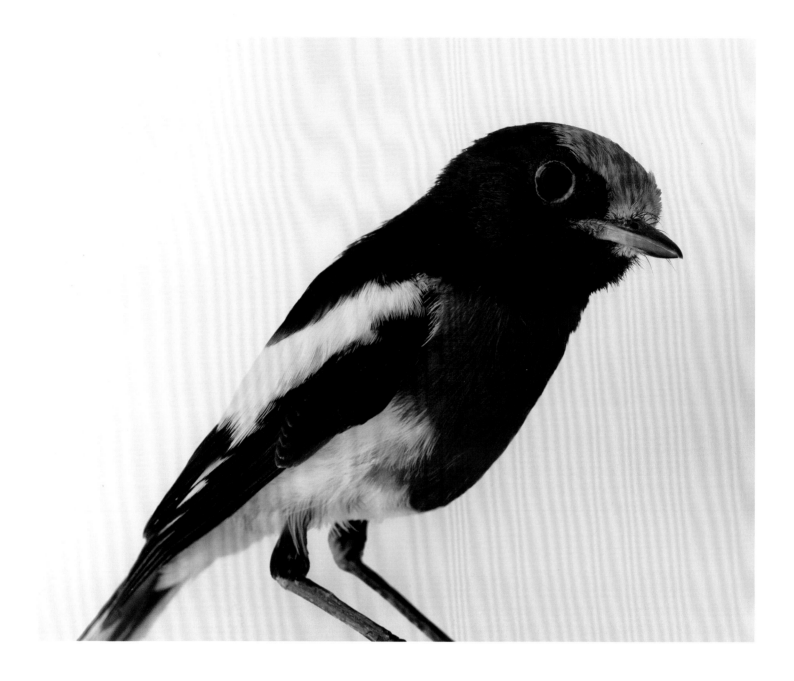

Redmond
Red-capped robin
Petroica goodenovii

Tilly
Silvereye
Zosterops lateralis

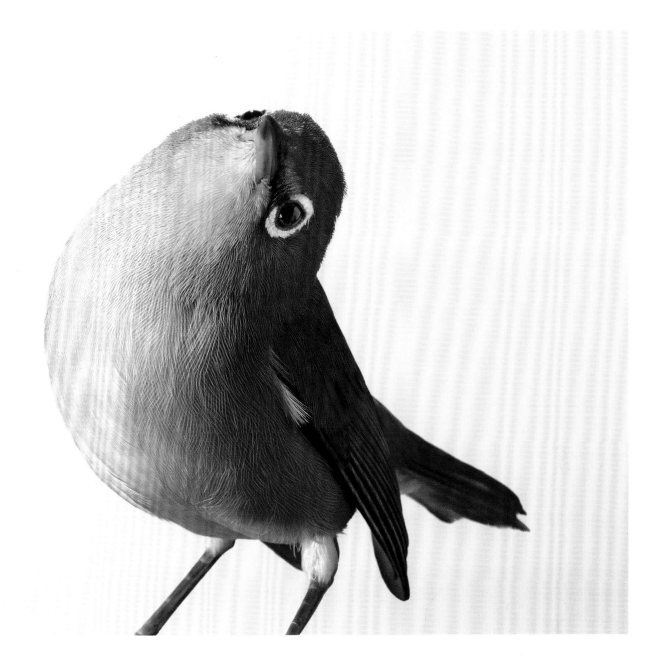

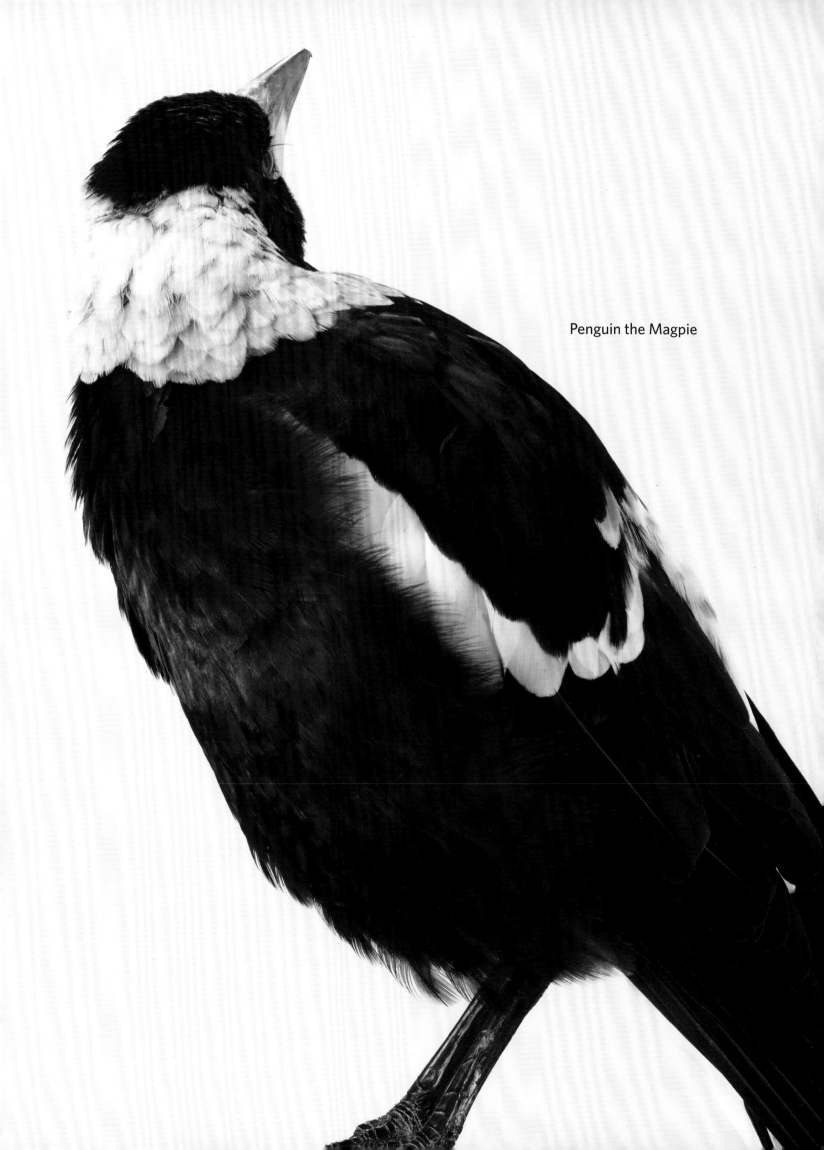

Penguin the Magpie

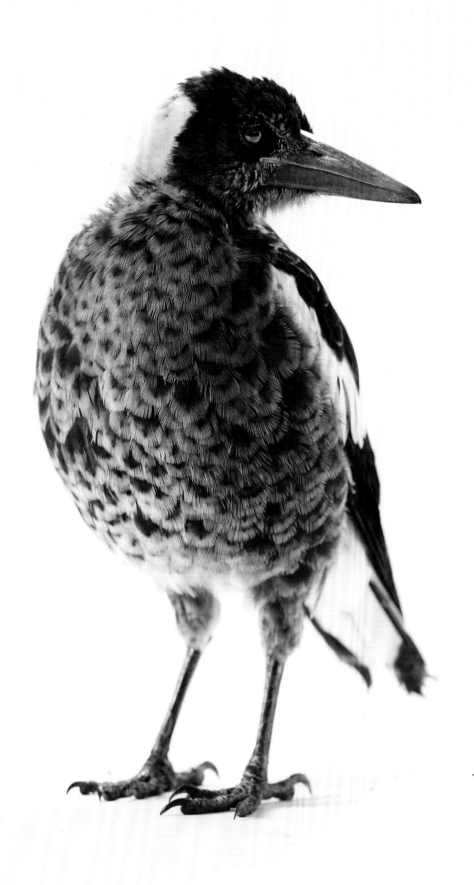

Penguin the Magpie

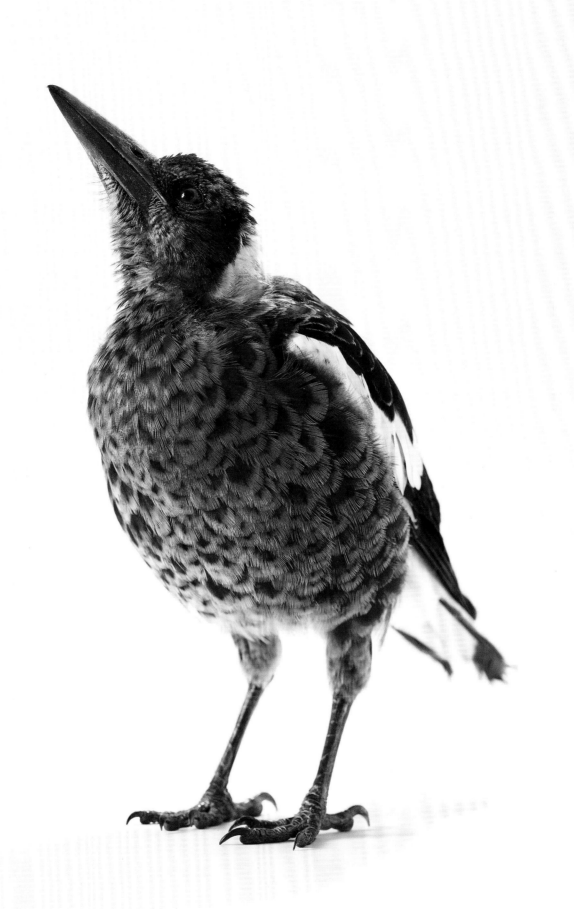

66
Penguin No. 1
Australian magpie
Cracticus tibicen

67
Penguin No. 2
Australian magpie
Cracticus tibicen

Penguin No. 3
Australian magpie
Cracticus tibicen

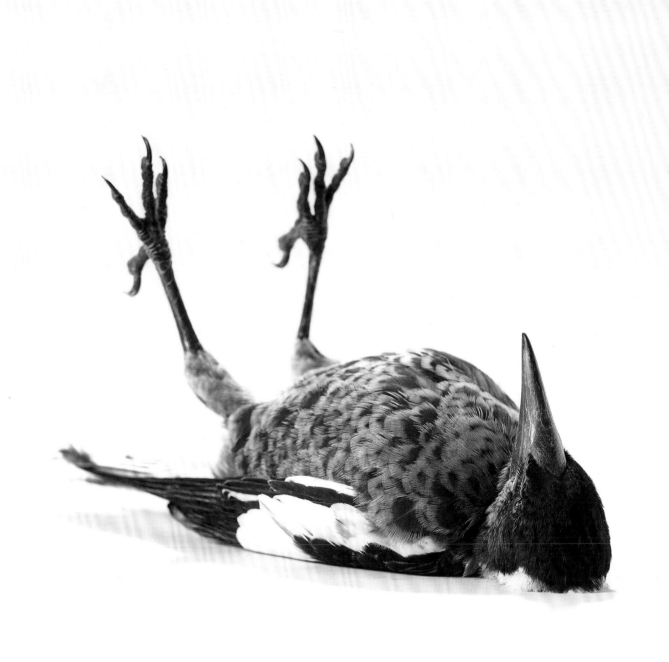

Penguin No. 4
Australian magpie
Cracticus tibicen

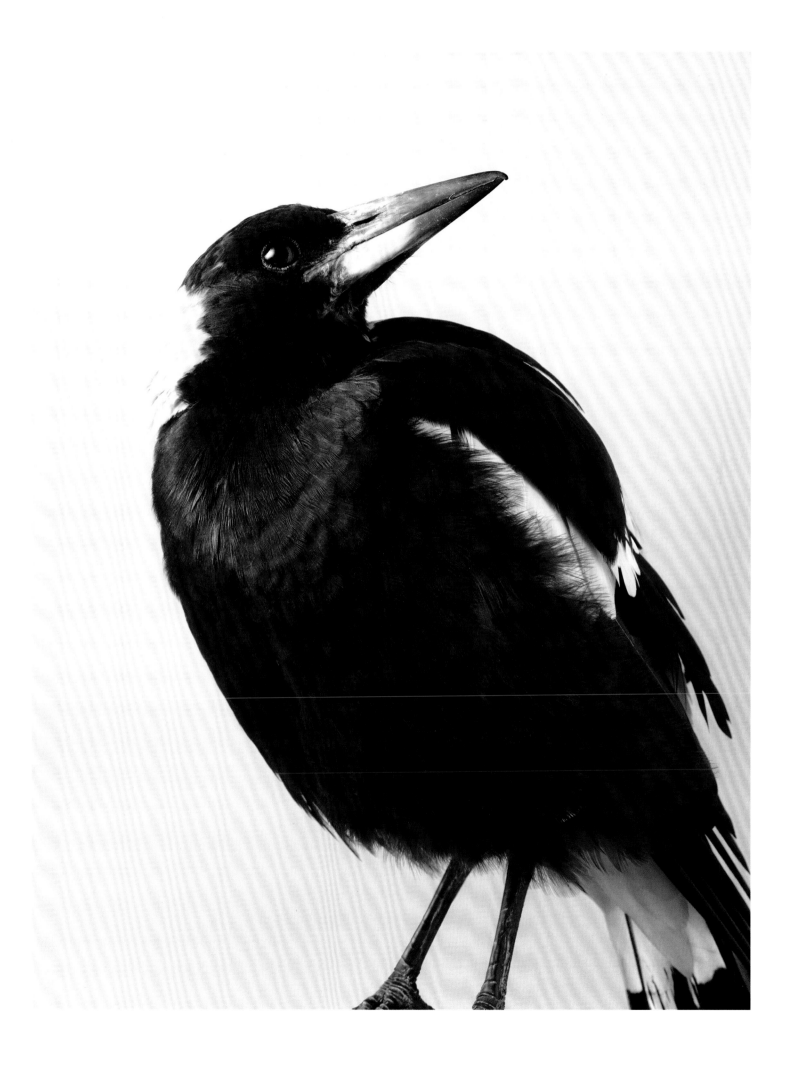

Penguin No. 5

Australian magpie

Cracticus tibicen

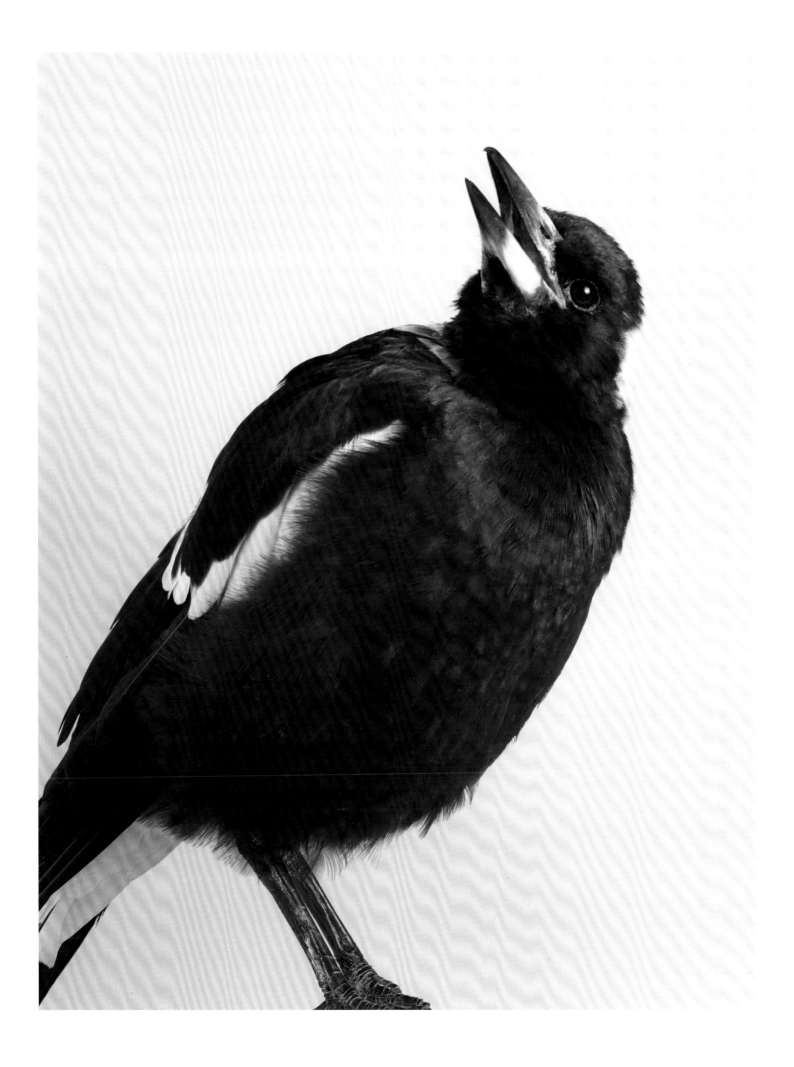

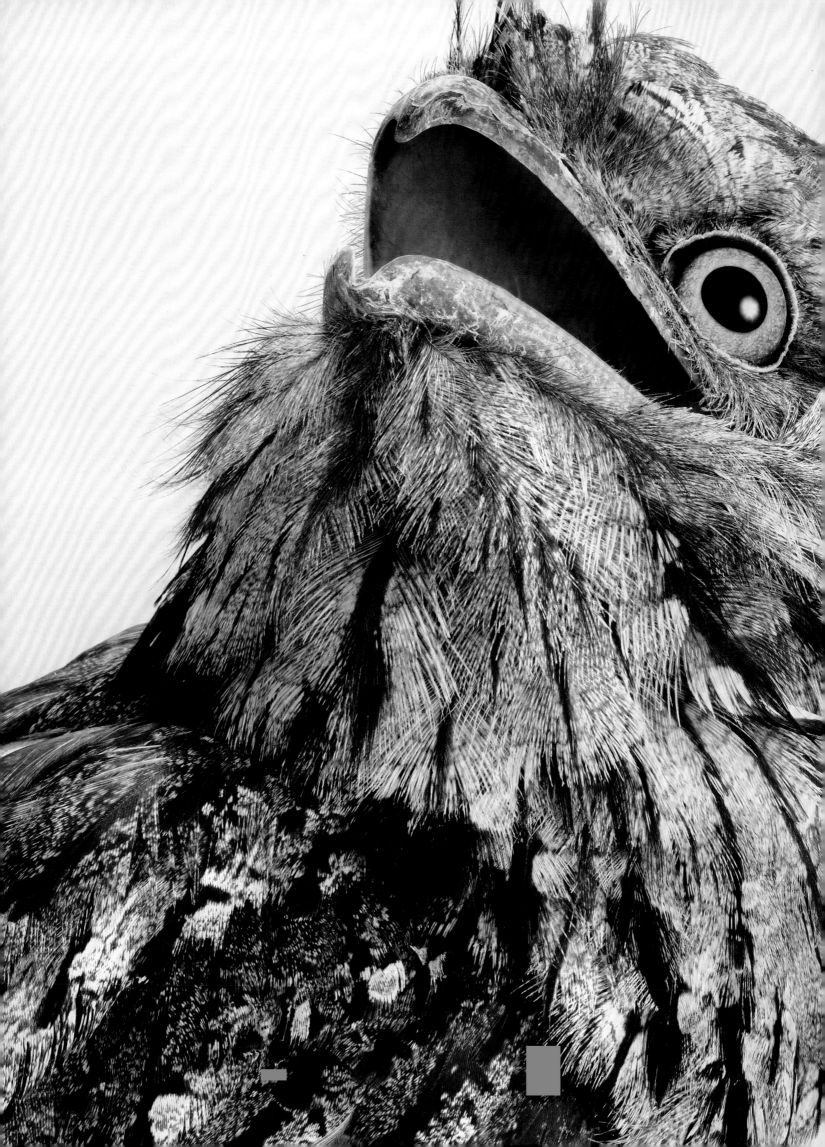

Ode to a Tawny

Lady
Tawny frogmouth
Podargus strigoides

Ode to a Tawny

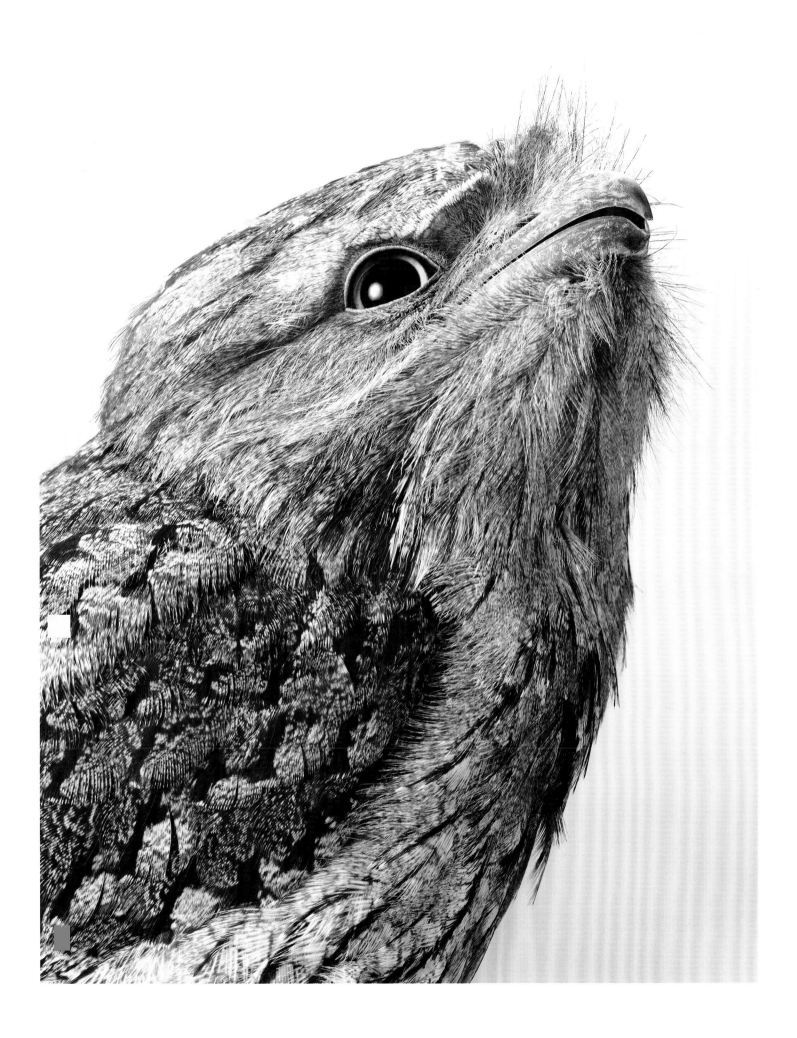

Roscoe
Tawny frogmouth
Podargus strigoides

Ode to a Tawny

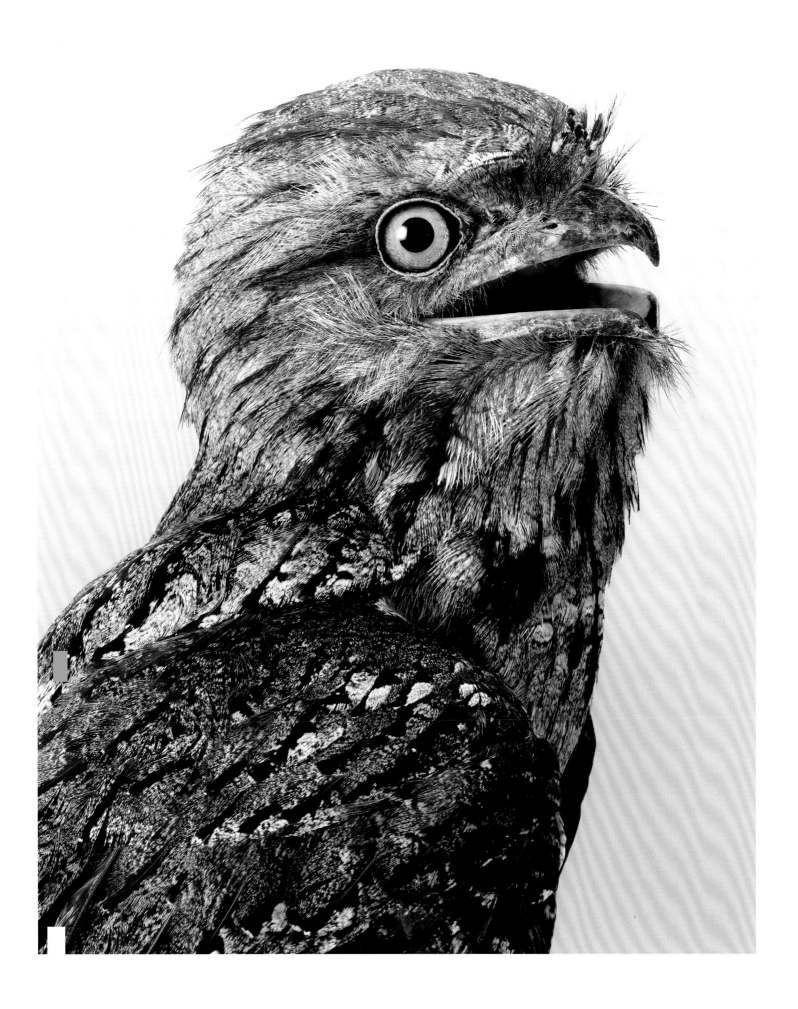

Beaker
Tawny frogmouth
Podargus strigoides

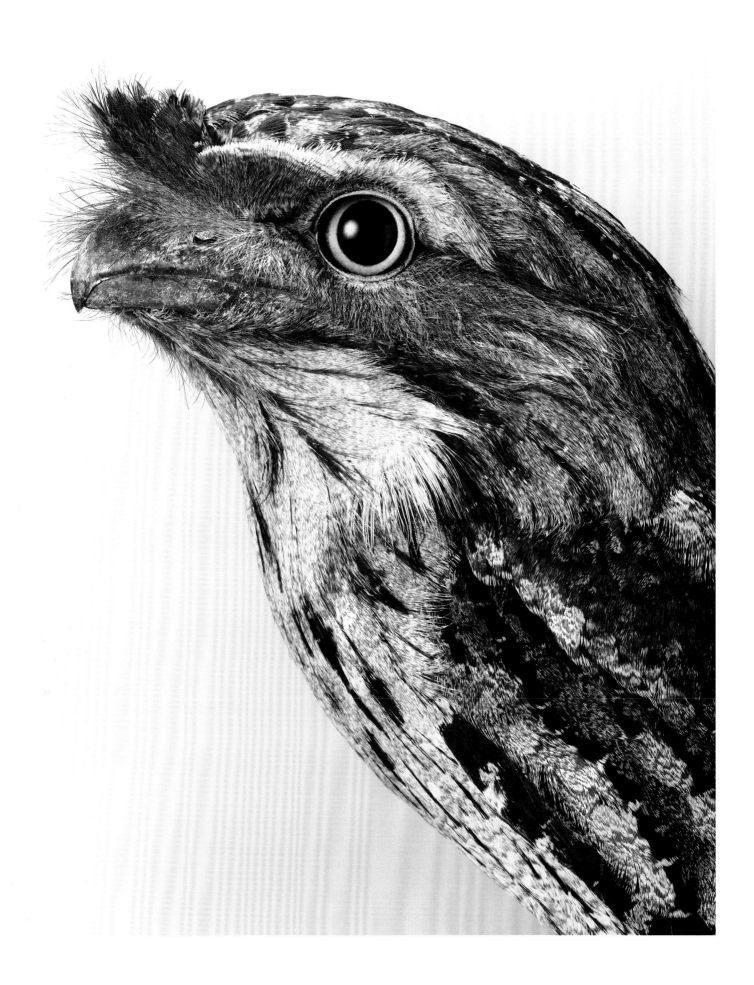

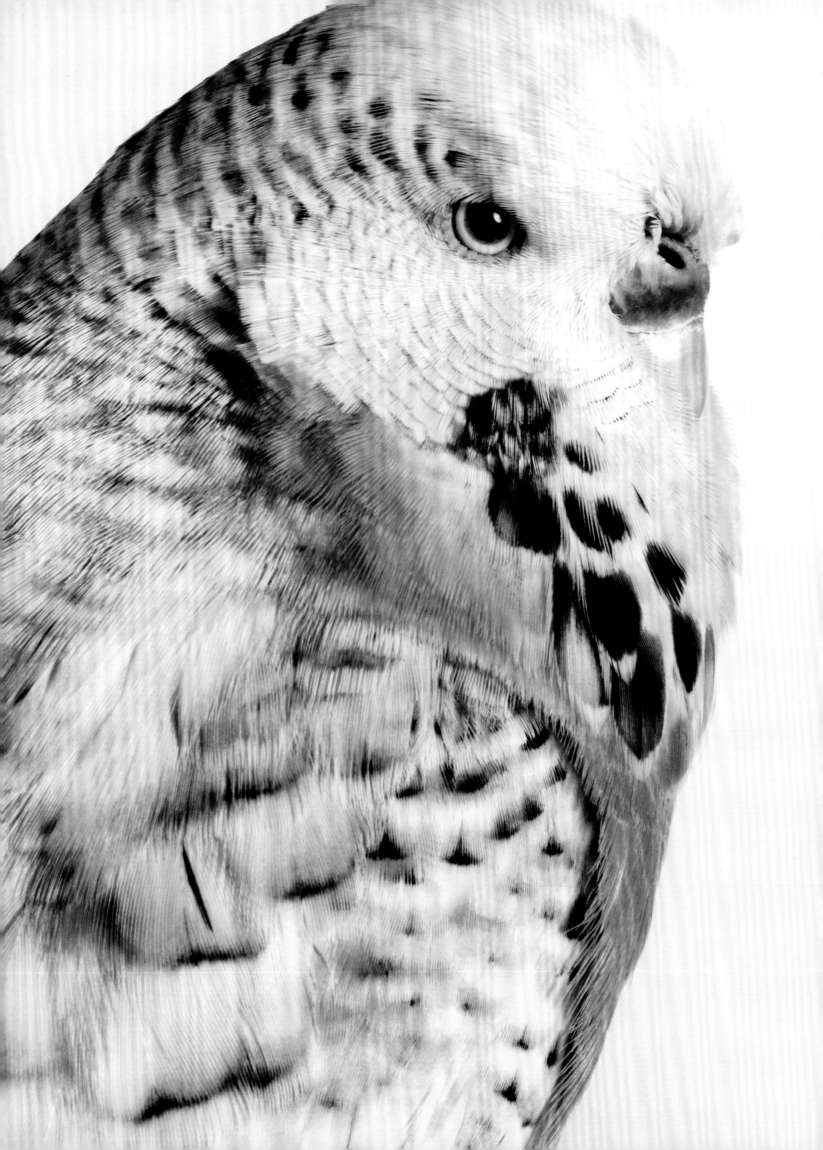

Portrait of a Budgerigar

Jimmy
Budgerigar
Melopsittacus undulatus

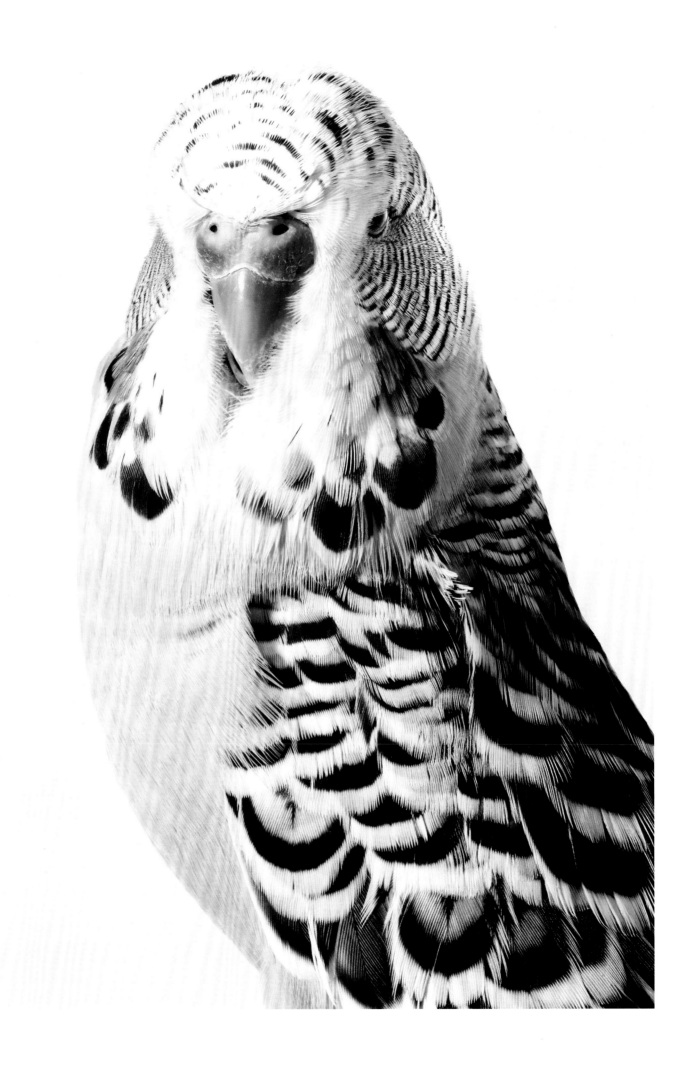

Vincent
Budgerigar
Melopsittacus undulatus

Vincent
Budgerigar
Melopsittacus undulatus

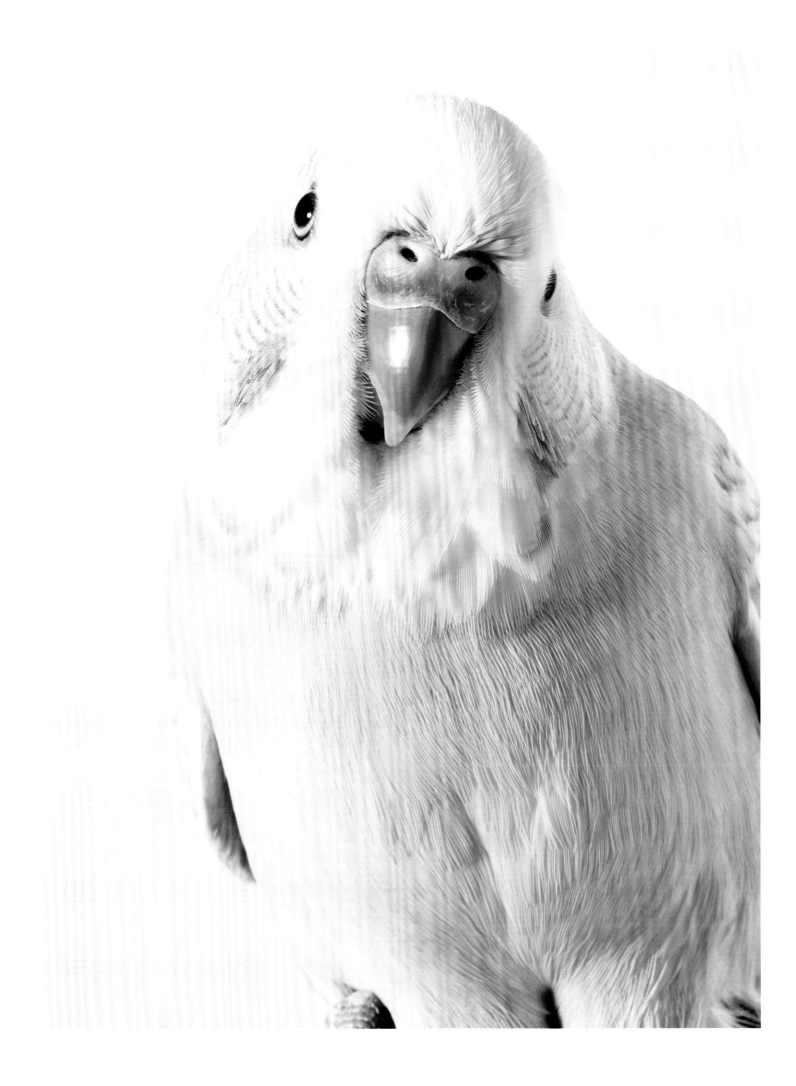

Spencer
Budgerigar
Melopsittacus undulatus

Spencer
Budgerigar
Melopsittacus undulatus

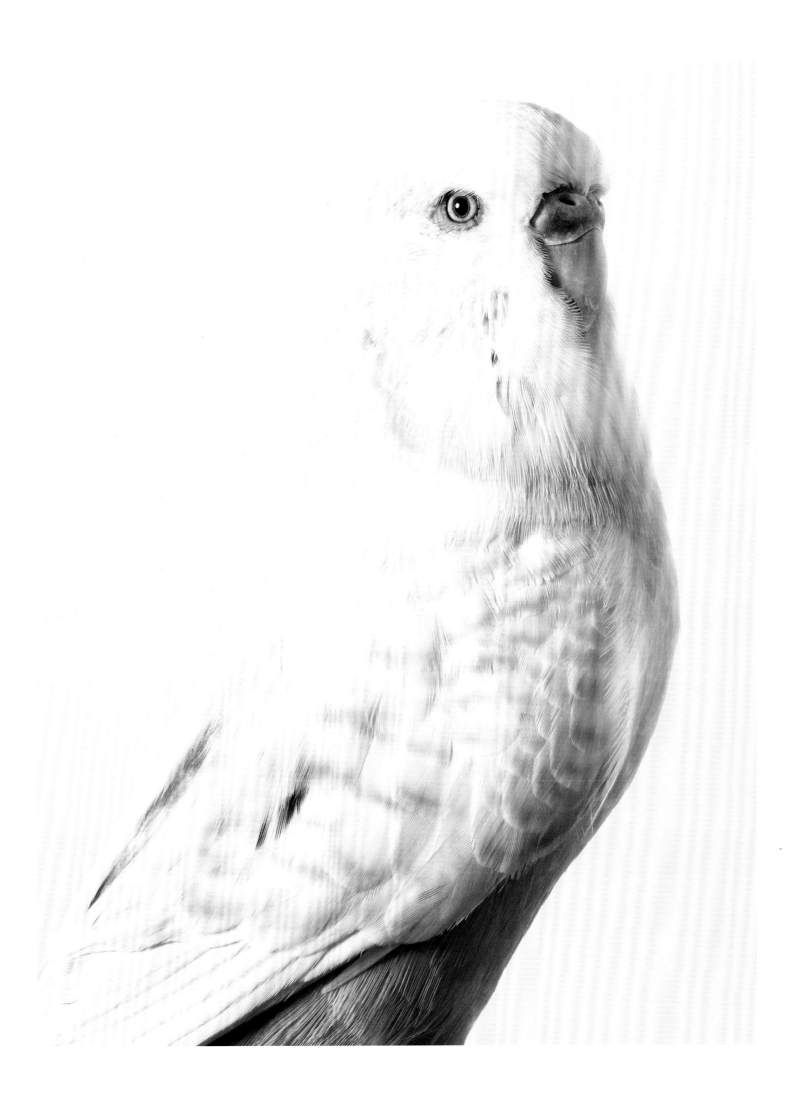

Mrs. Plume
Budgerigar
Melopsittacus undulatus

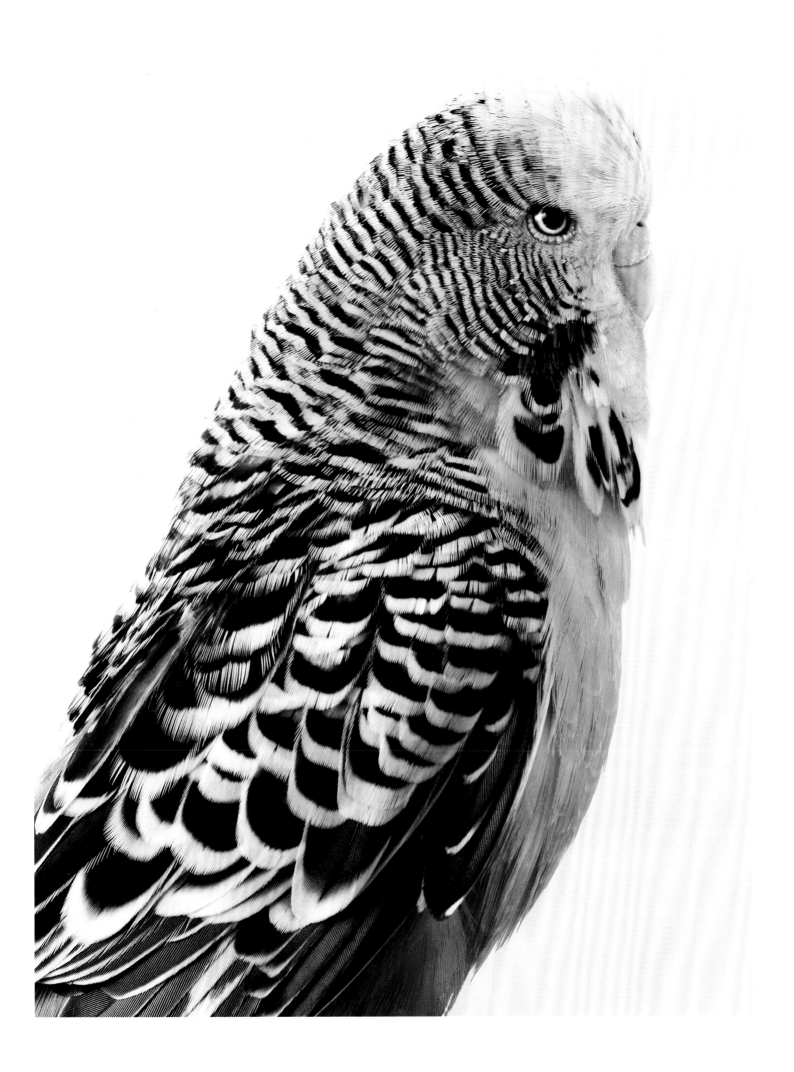

Terry
Budgerigar
Melopsittacus undulatus

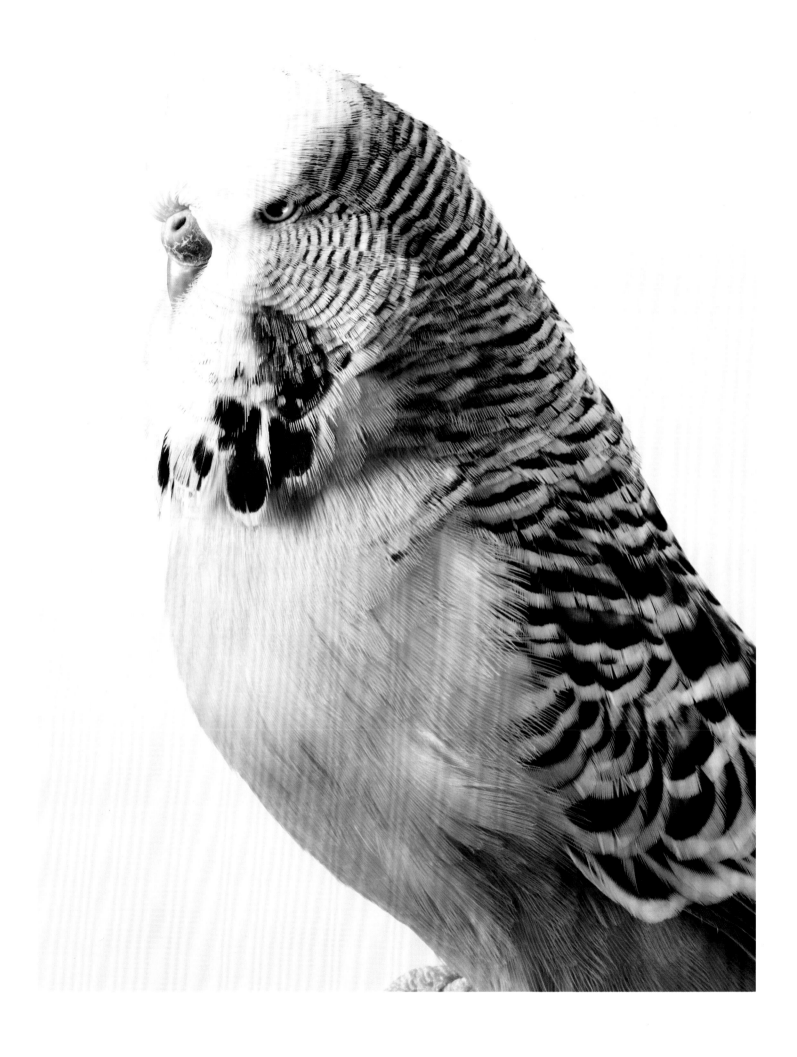

Little Holly Squawkamole
Budgerigar
Melopsittacus undulatus

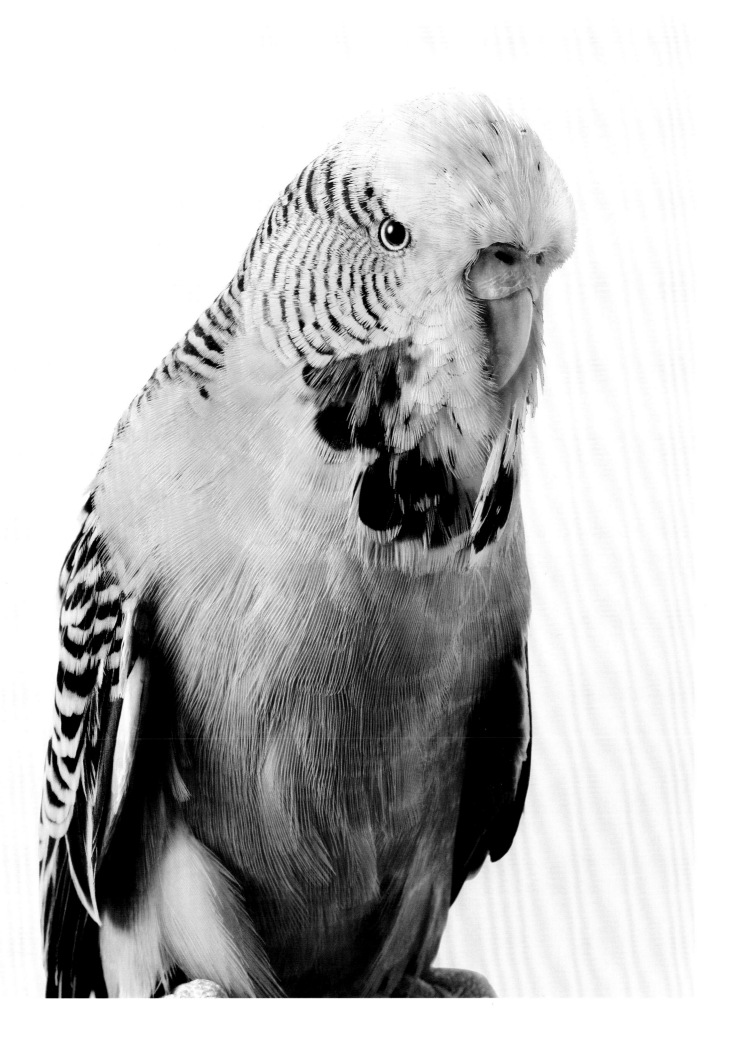

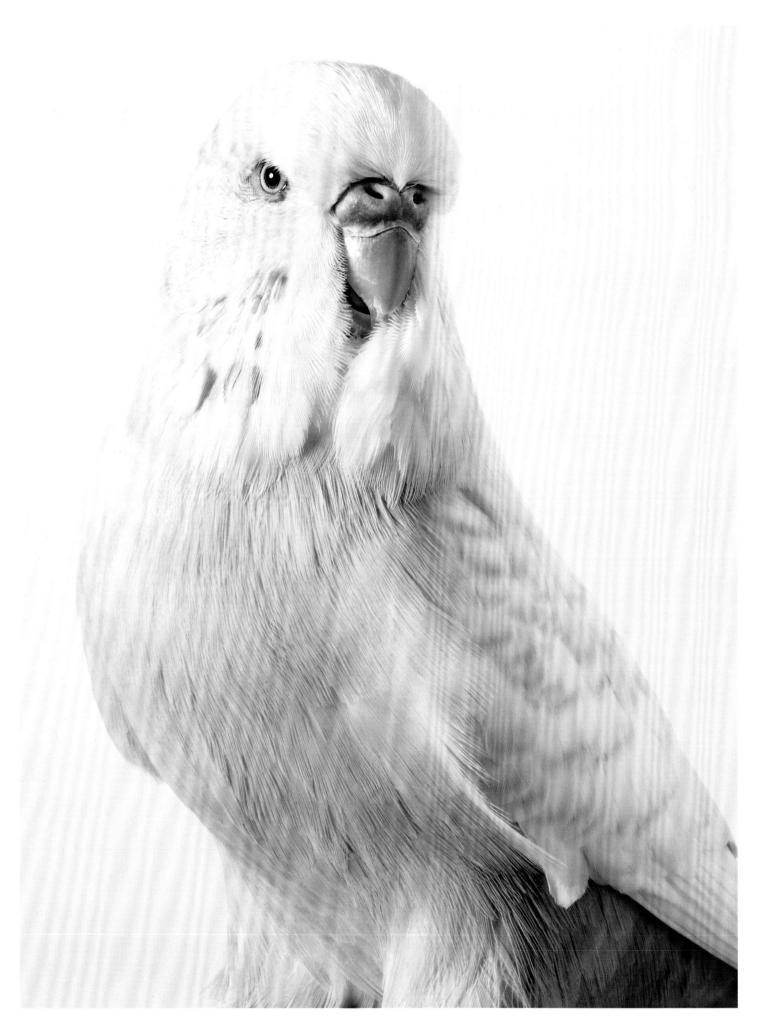

Portrait of a Budgerigar

96
Cliff
Budgerigar
Melopsittacus undulatus

97
Flight Sergeant Chalky No. 1
Budgerigar
Melopsittacus undulatus

Flight Sergeant Chalky No. 2
Budgerigar
Melopsittacus undulates

Suzie
Budgerigar
Melopsittacus undulatus

Portrait of a Budgerigar

Salvador
Budgerigar
Melopsittacus undulatus

Barnaby Rudge
Budgerigar
Melopsittacus undulatus

Portrait of a Budgerigar

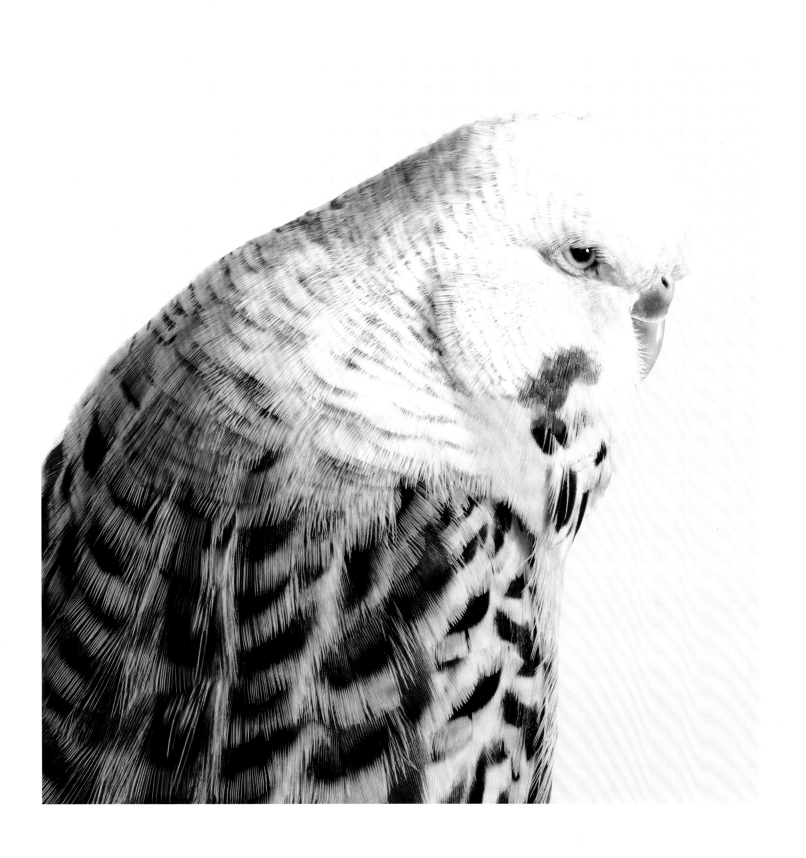

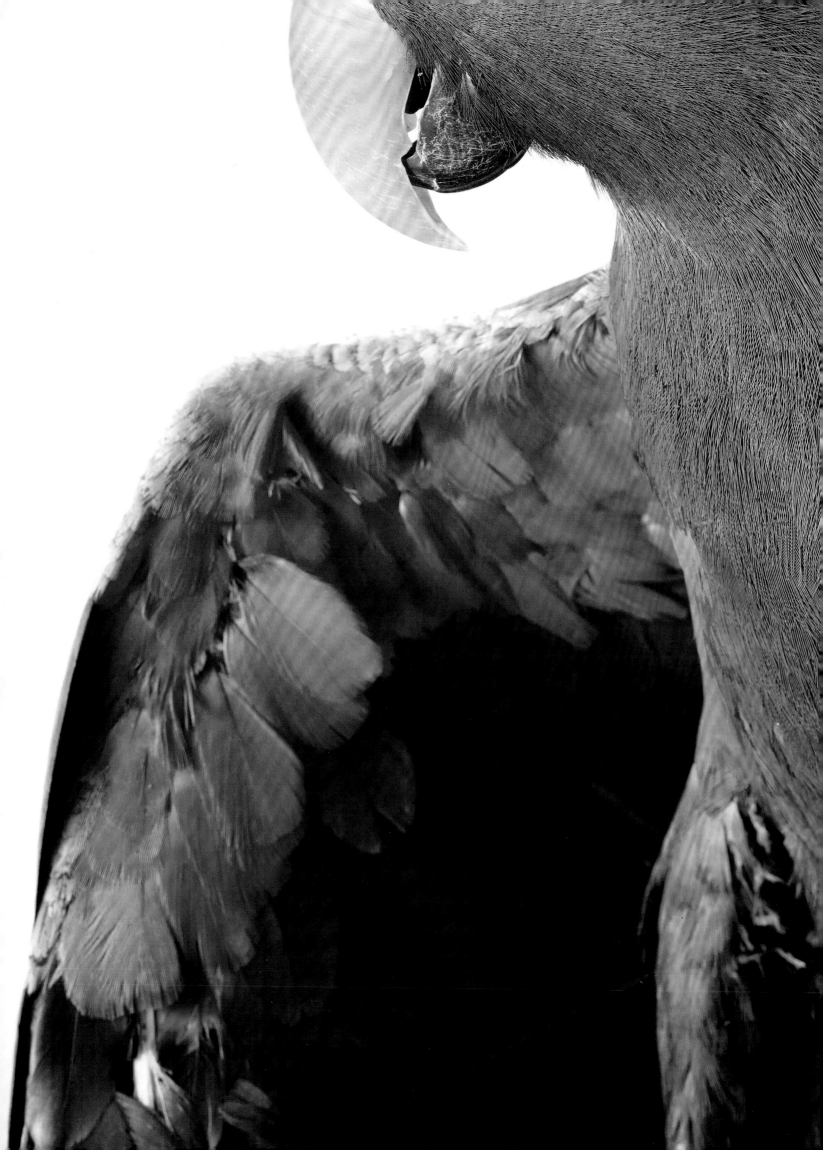

The People in Parrots

Blue
Orange-bellied parrot
Neophema chrysogaster

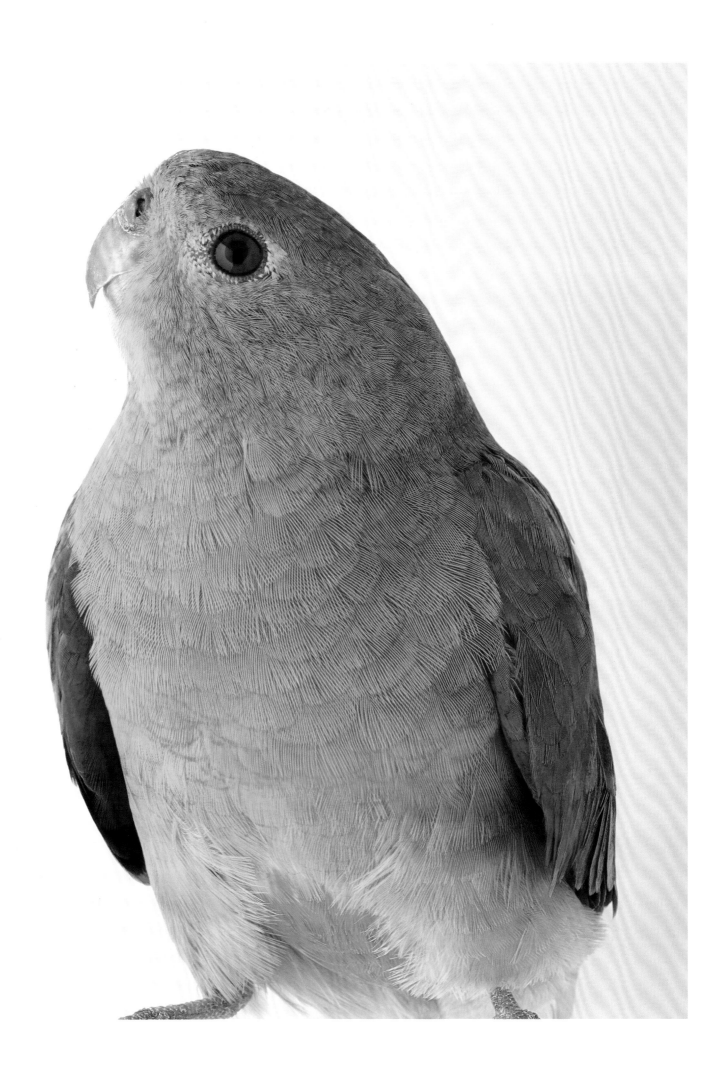

Paolo
Varied lorikeet
Psitteuteles versicolor

The People in Parrots

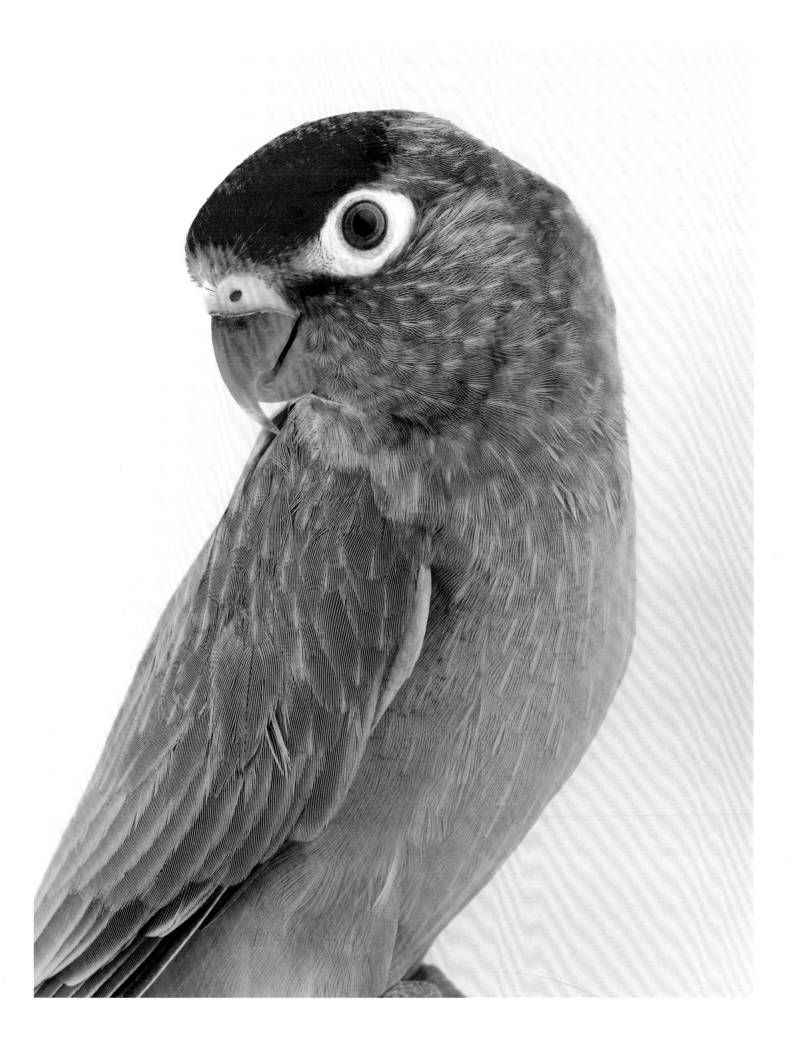

Lucy
Scaly-breasted lorikeet
Trichoglossus chlorolepidotus

The People in Parrots

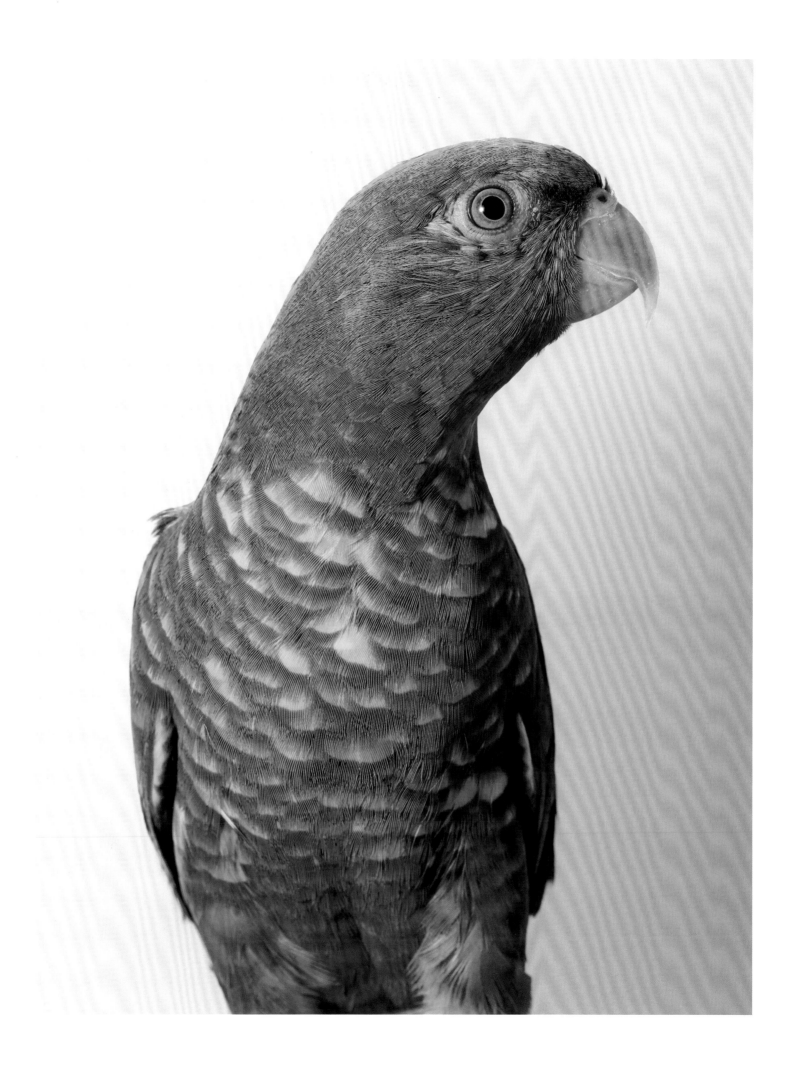

Finn
Mulga parrot
Psephotus varius

The People in Parrots

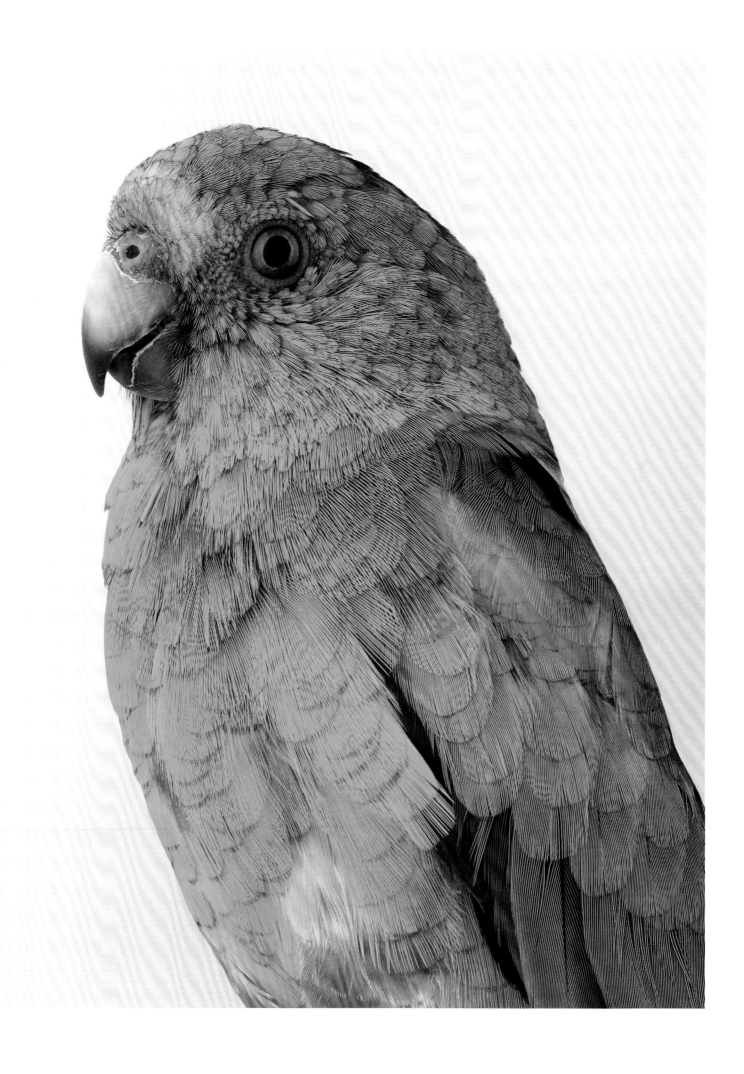

Ralph
Red-collared lorikeet
Trichoglossus rubritorquis

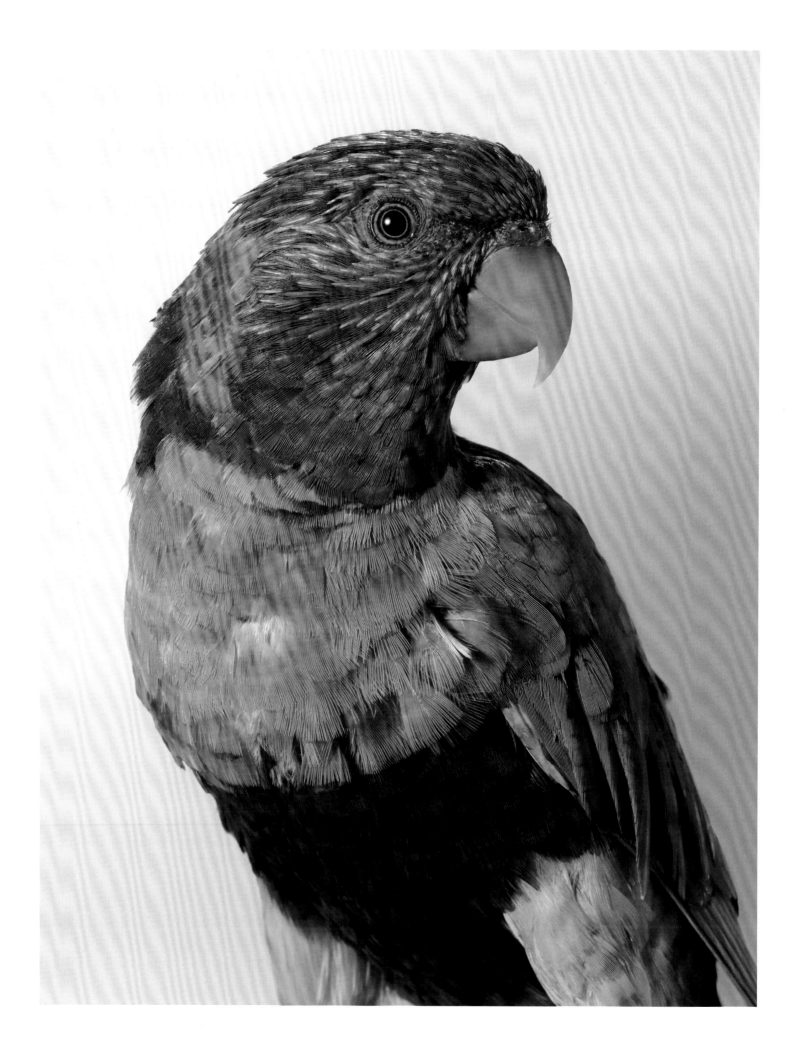

Oscar
Eclectus parrot
Eclectus roratus

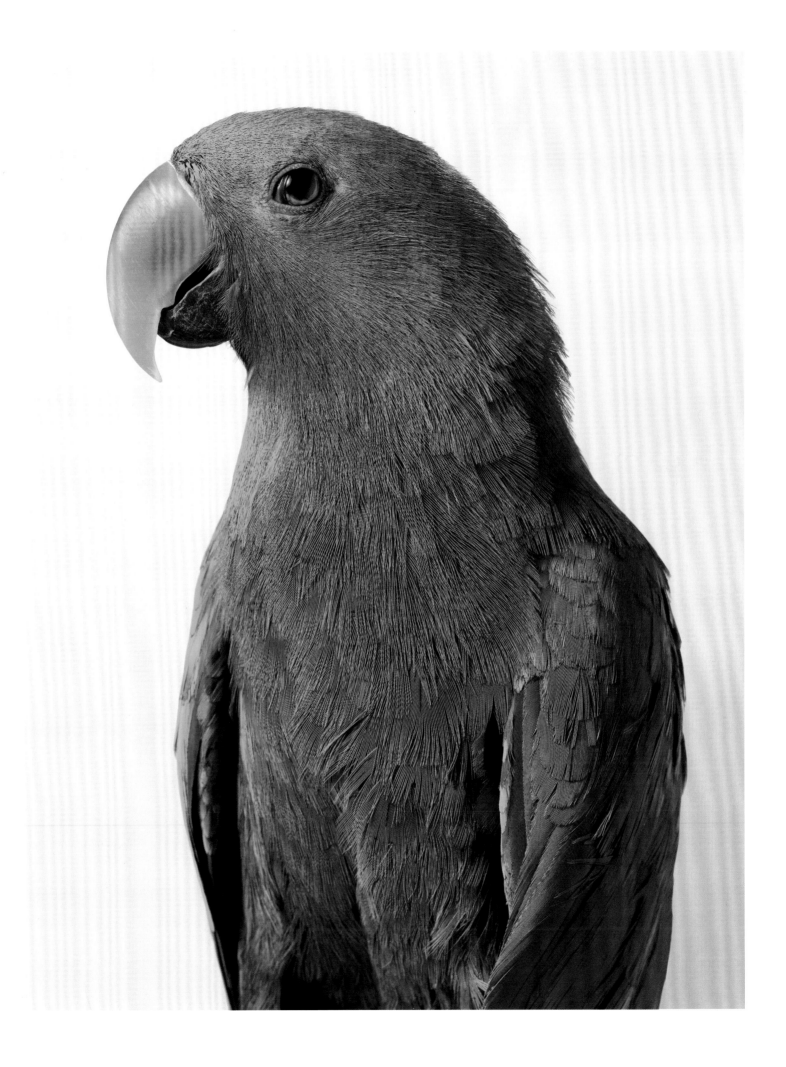

Twisty
Rainbow lorikeet
Trichoglossus moluccanus

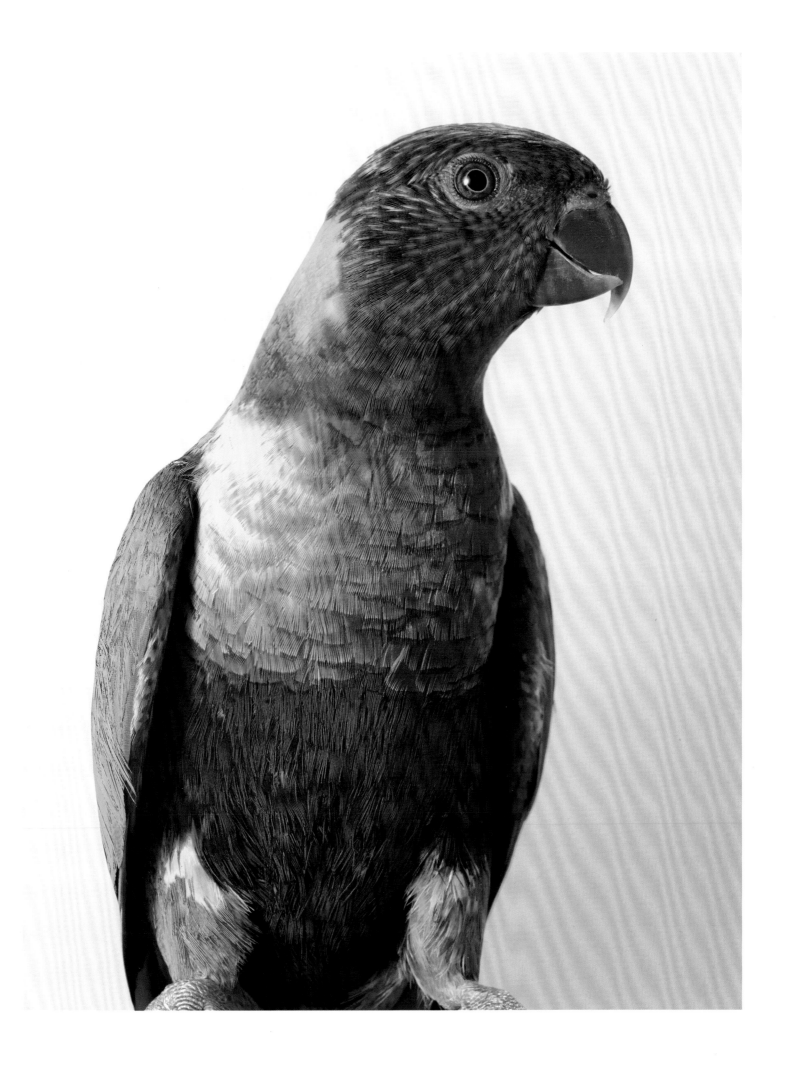

Prey

Tani
Australian masked owl
Tyto novaehollandiae

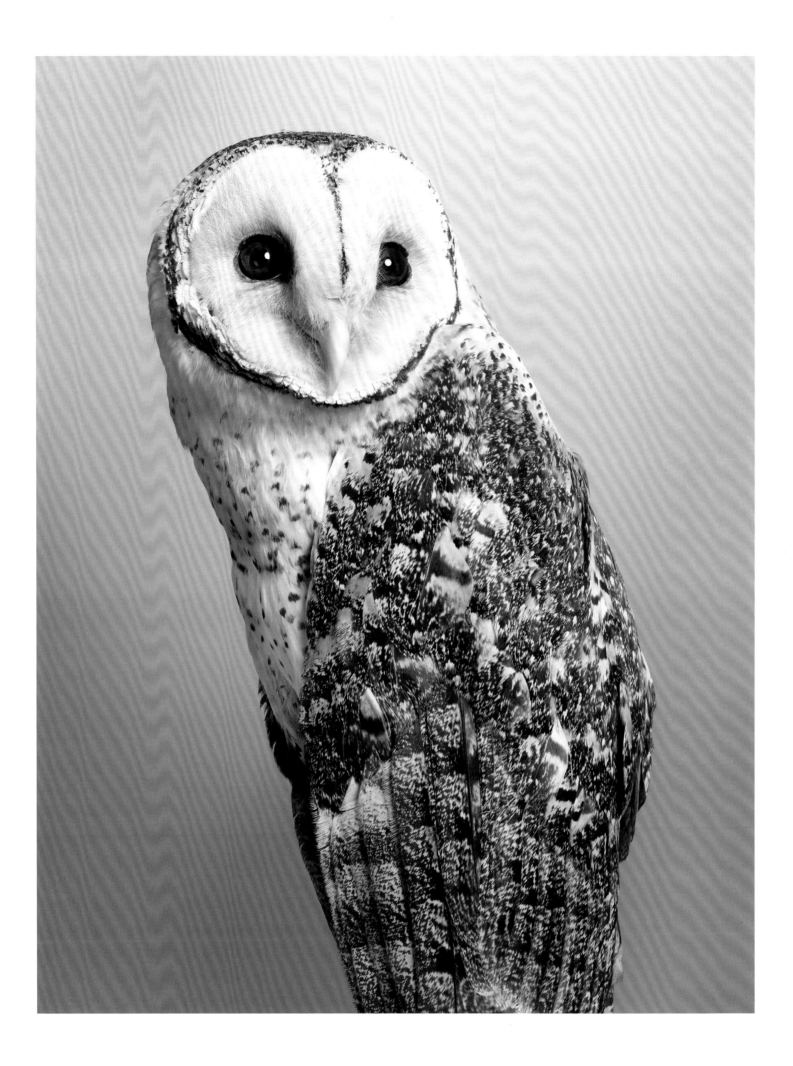

Ash
Gray falcon
Falco hypoleucos

Ash
Gray falcon
Falco hypoleucos

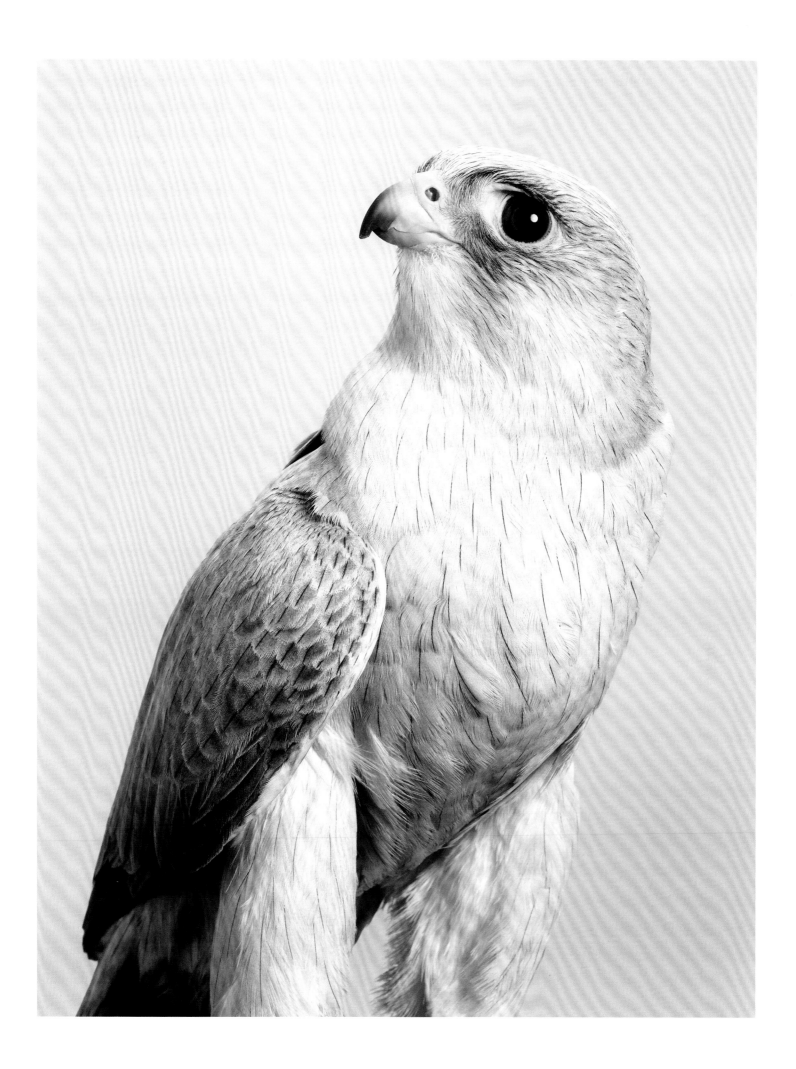

Duke
Eastern grass owl
Tyto longimembris

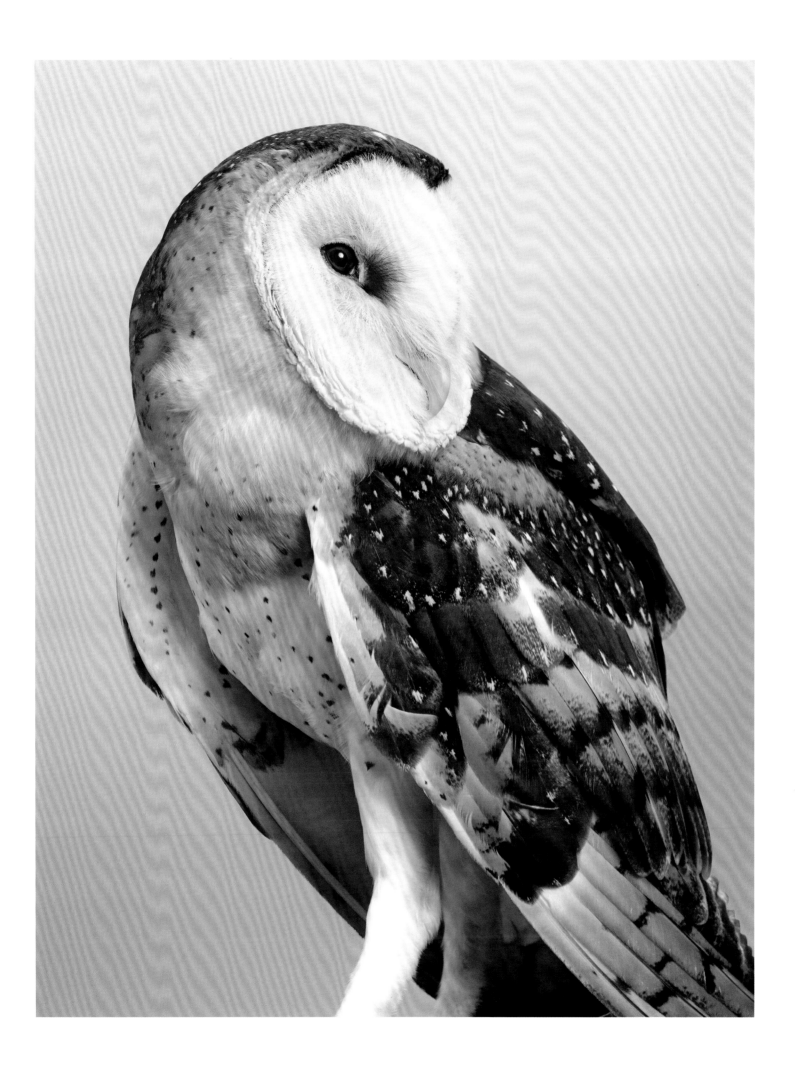

Sooty
Lesser sooty owl
Tyto multipunctata

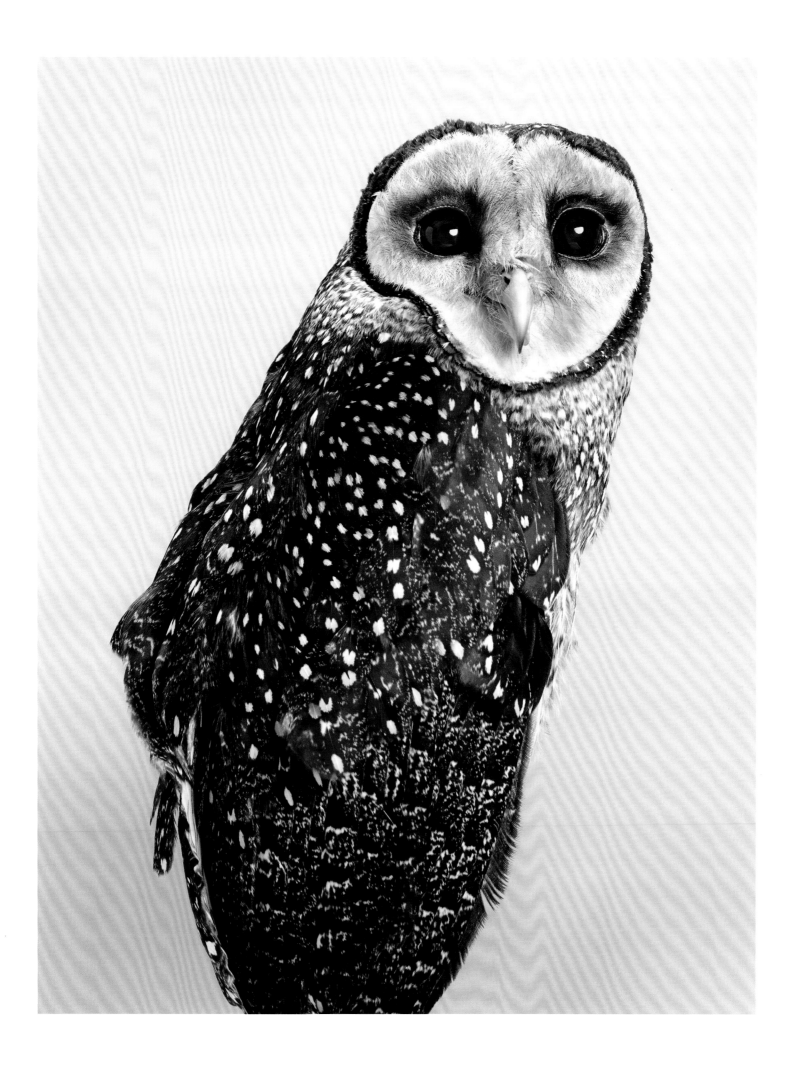

Darcy
Brown falcon
Falco berigora

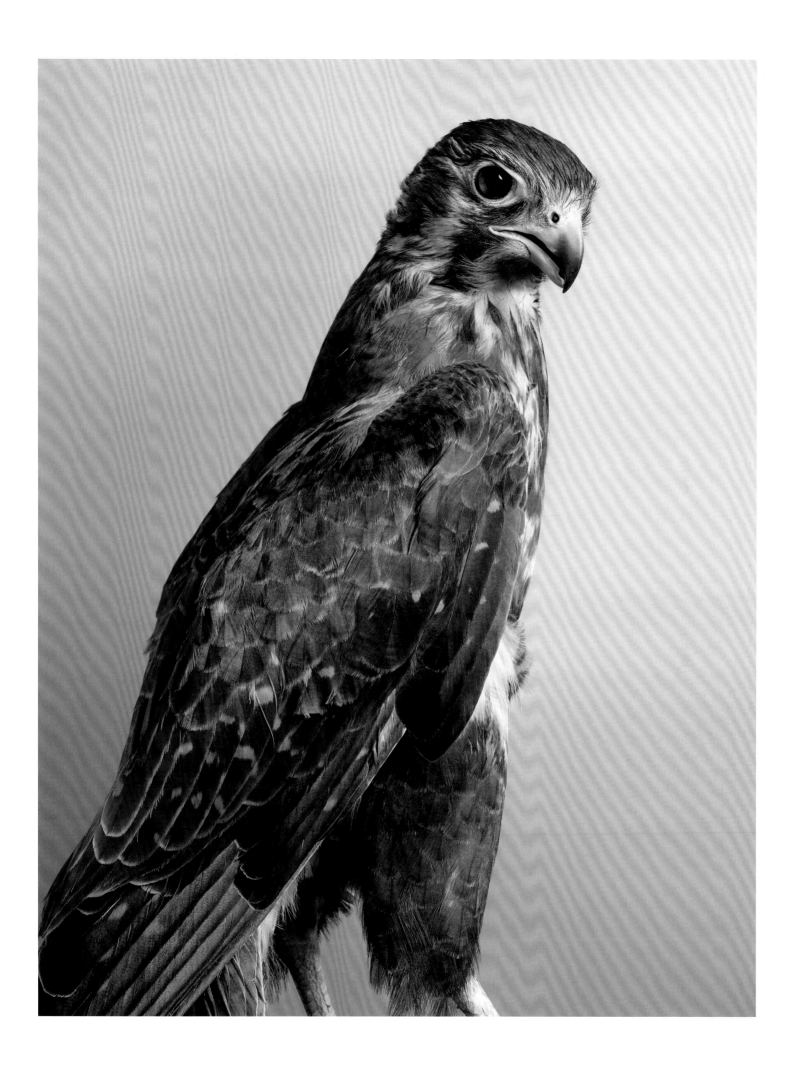

Pepper
Southern boobook
Ninox boobook

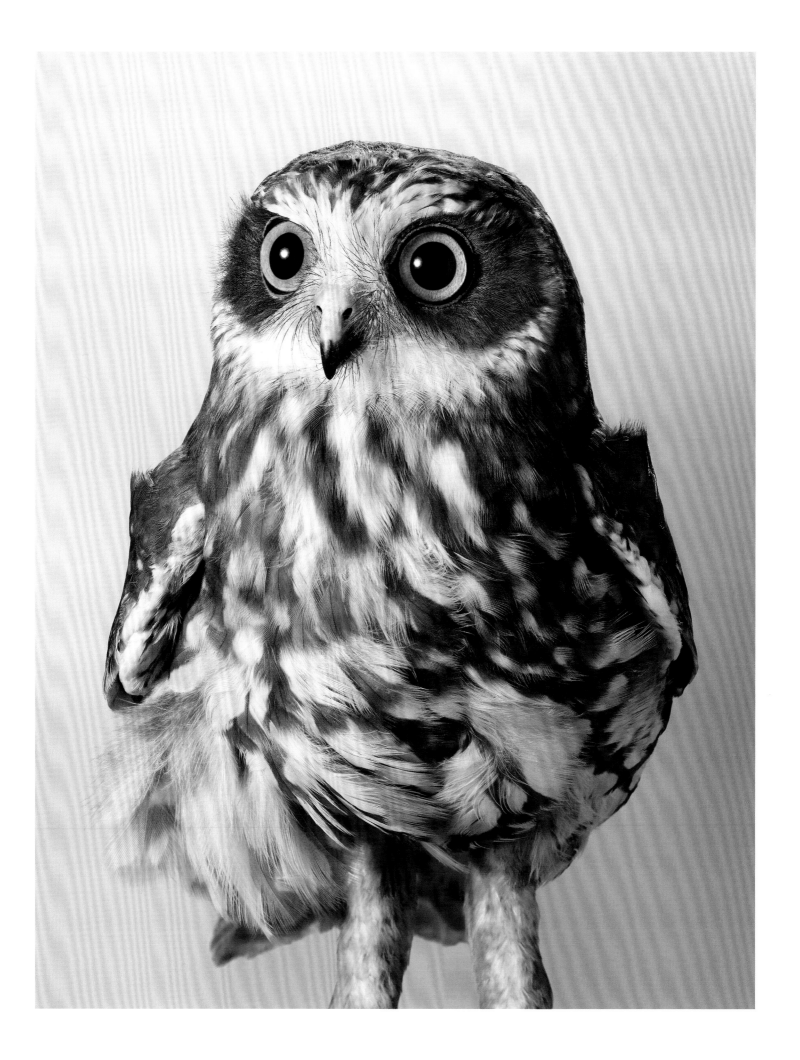

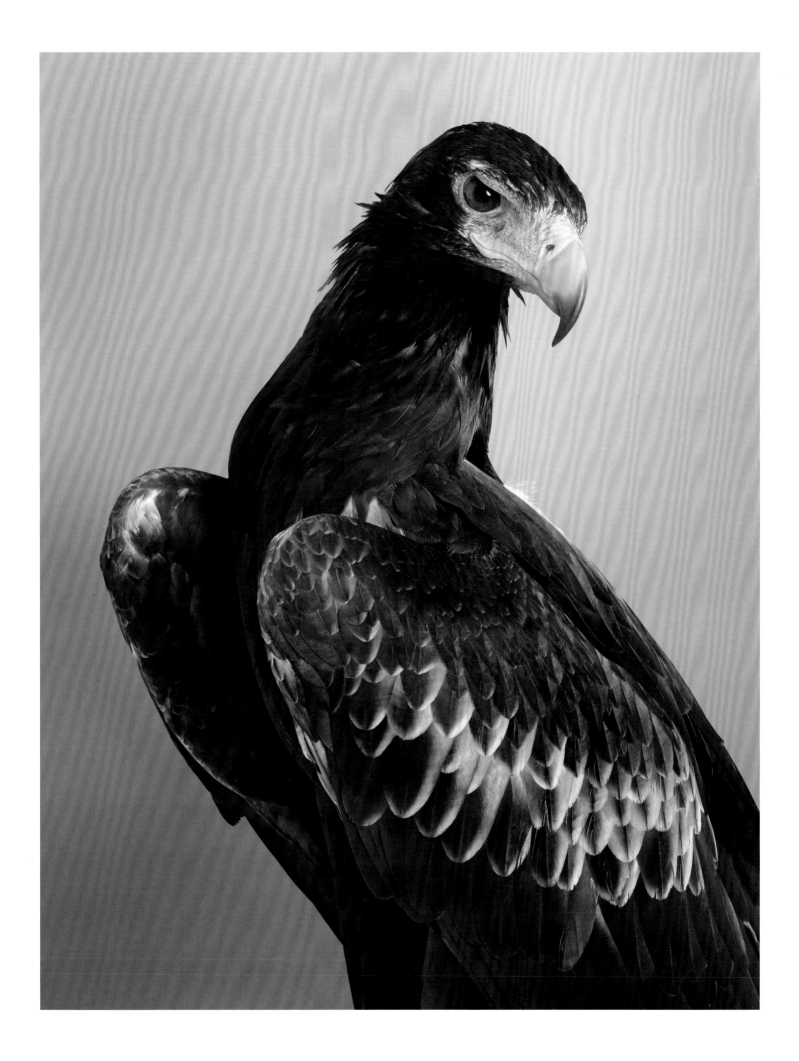

Prey

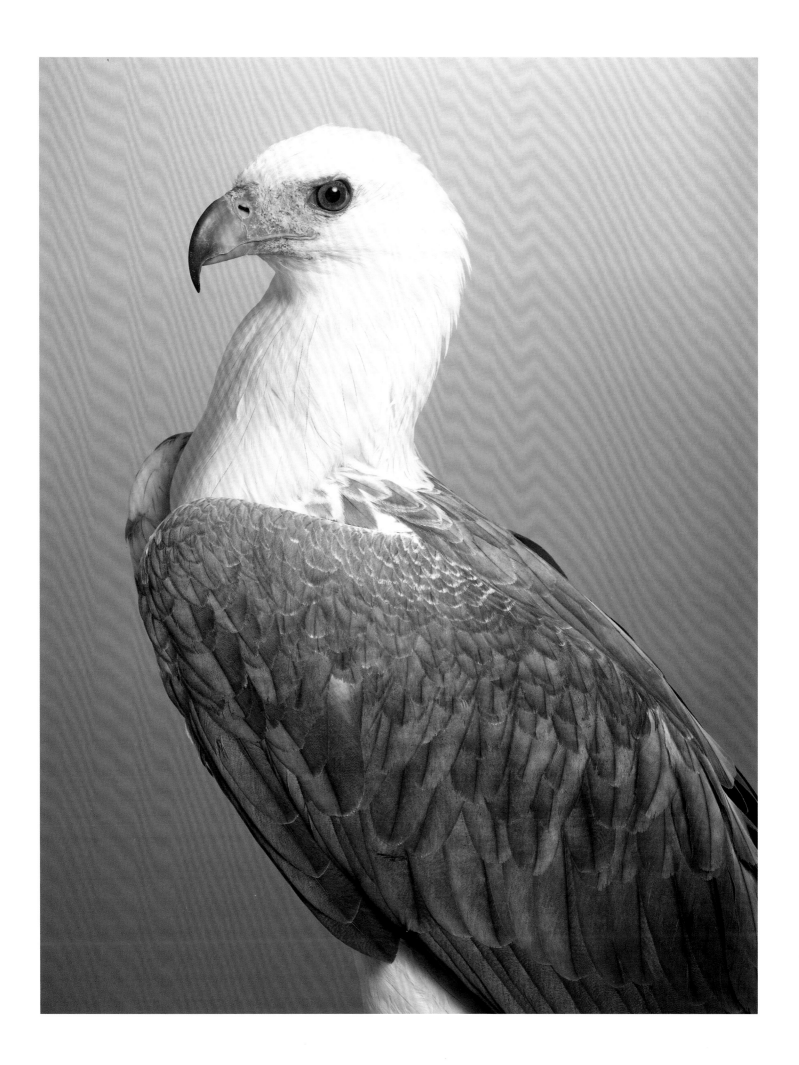

136
Soren
Wedge-tailed eagle
Aquila audax

137
Dexter
White-bellied sea eagle
Haliaeetus leucogaster

Cleo
Peregrine falcon
Falco peregrinus

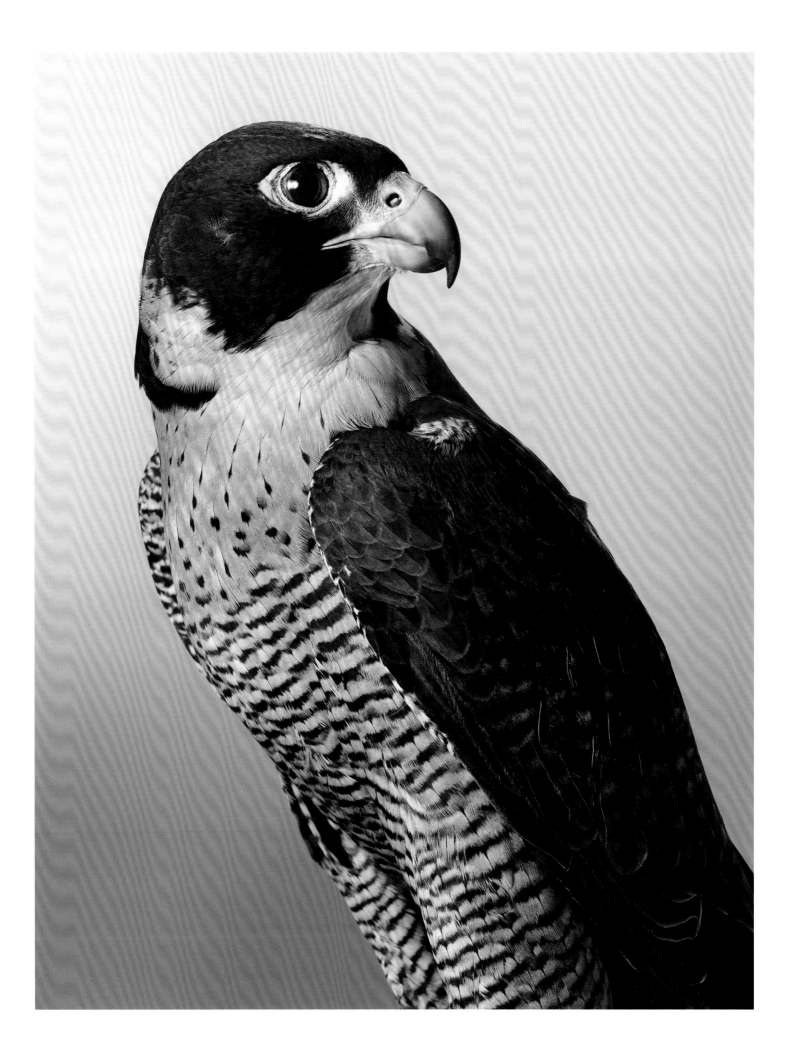

Jeda
Greater sooty owl
Tyto tenebricosa

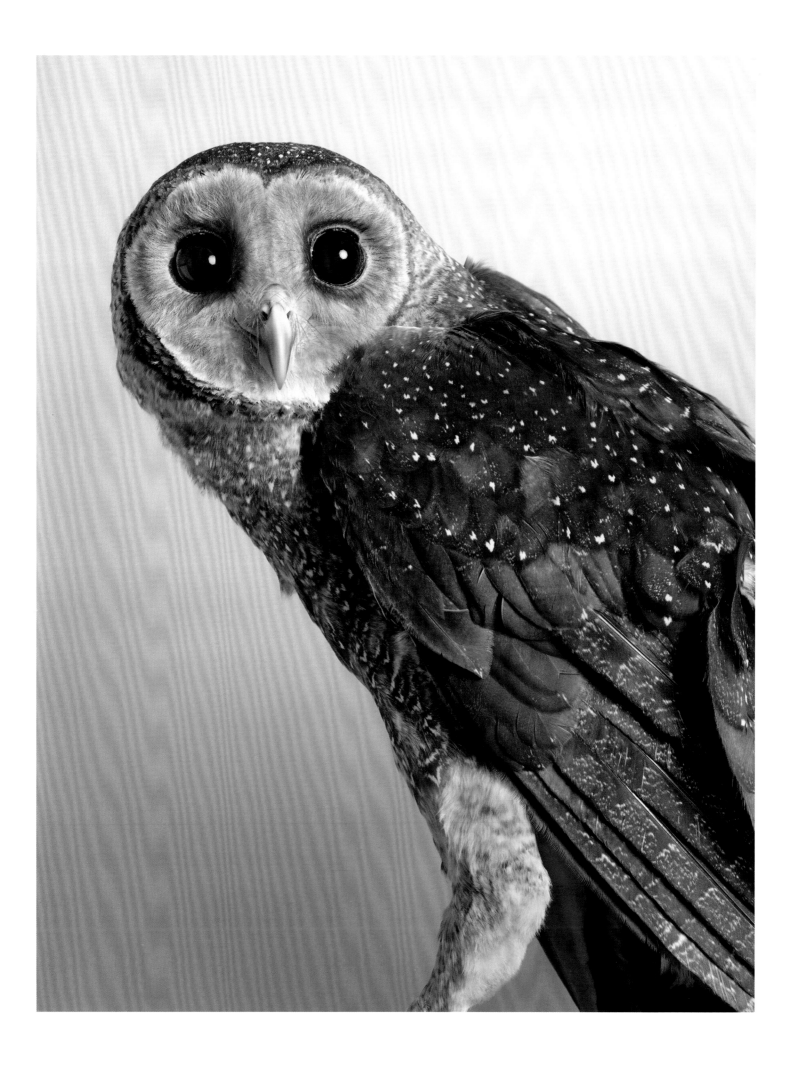

Fenrick
Black kite
Milvus migrans

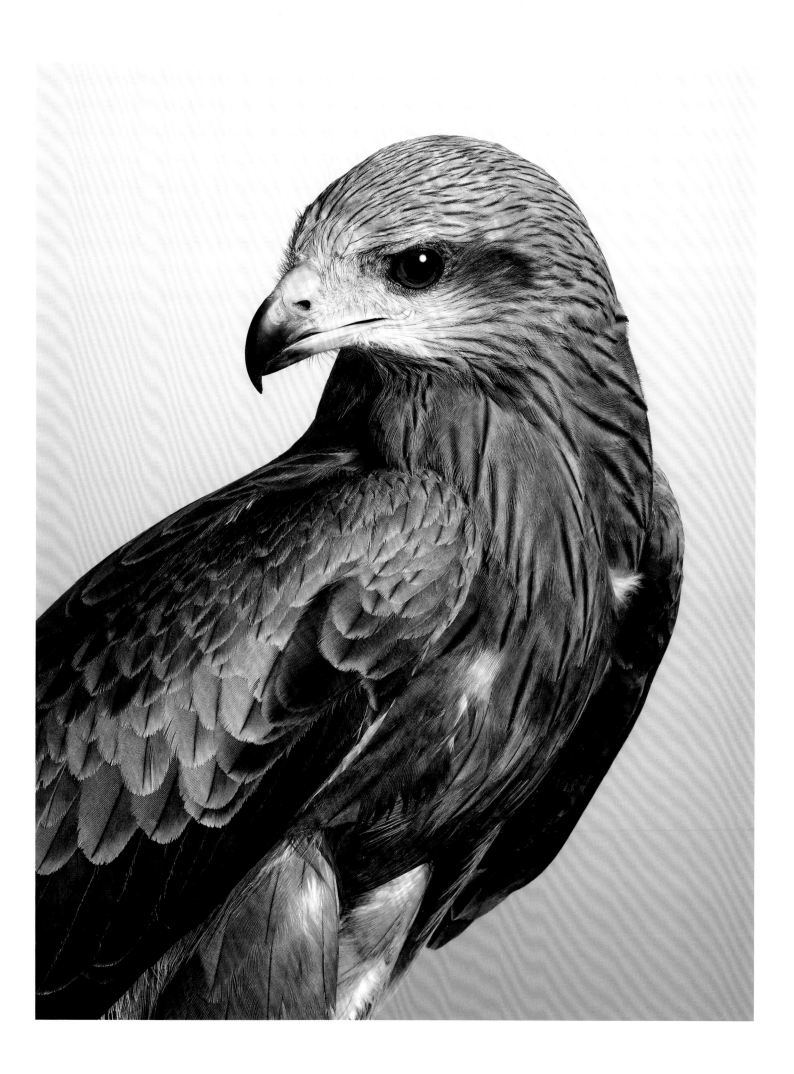

Mulga
Black-breasted buzzard
Hamirostra melanosternon

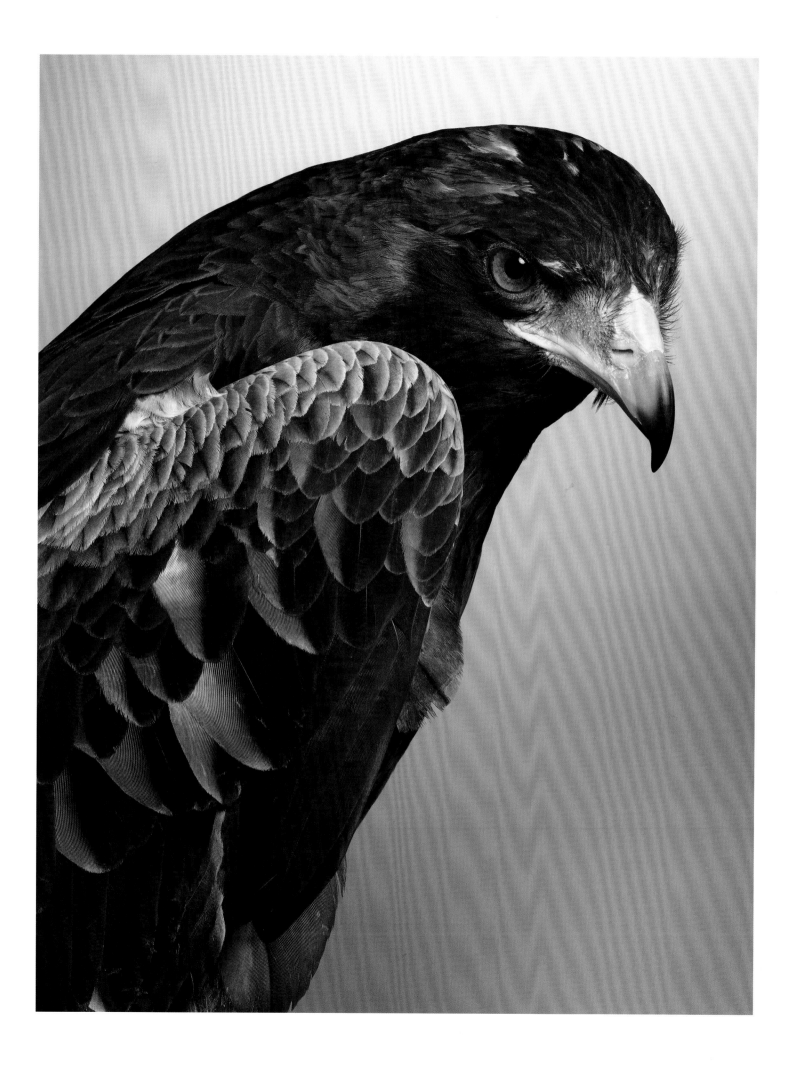

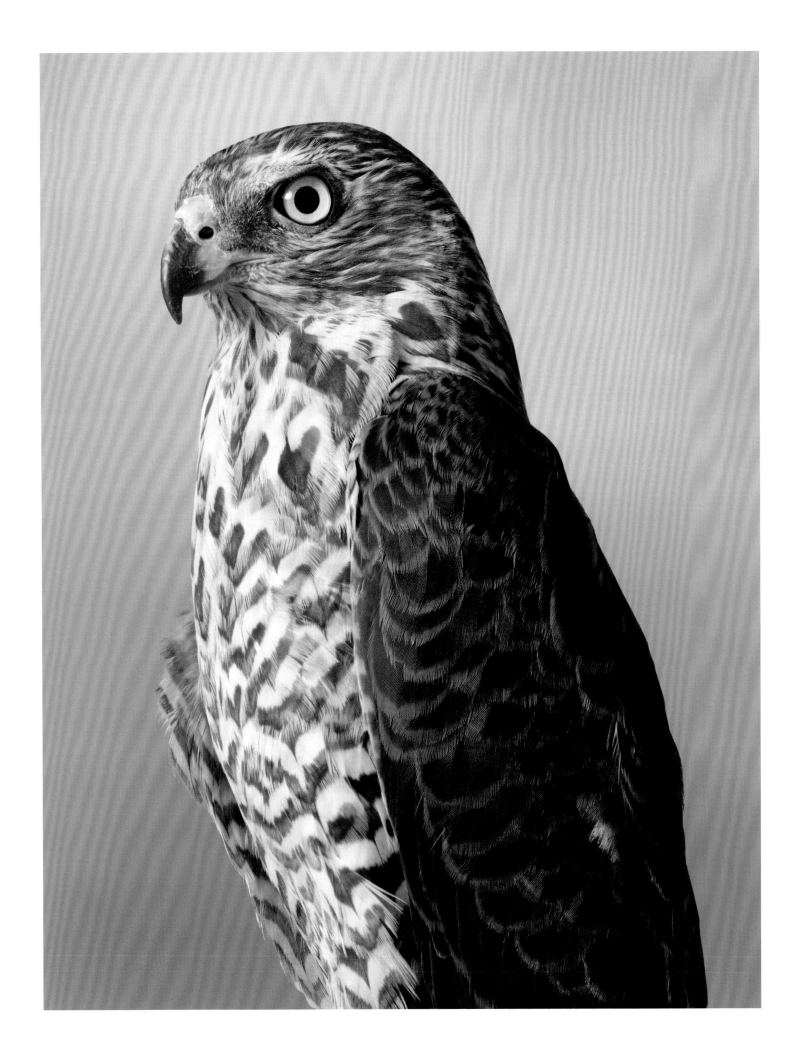

Prey

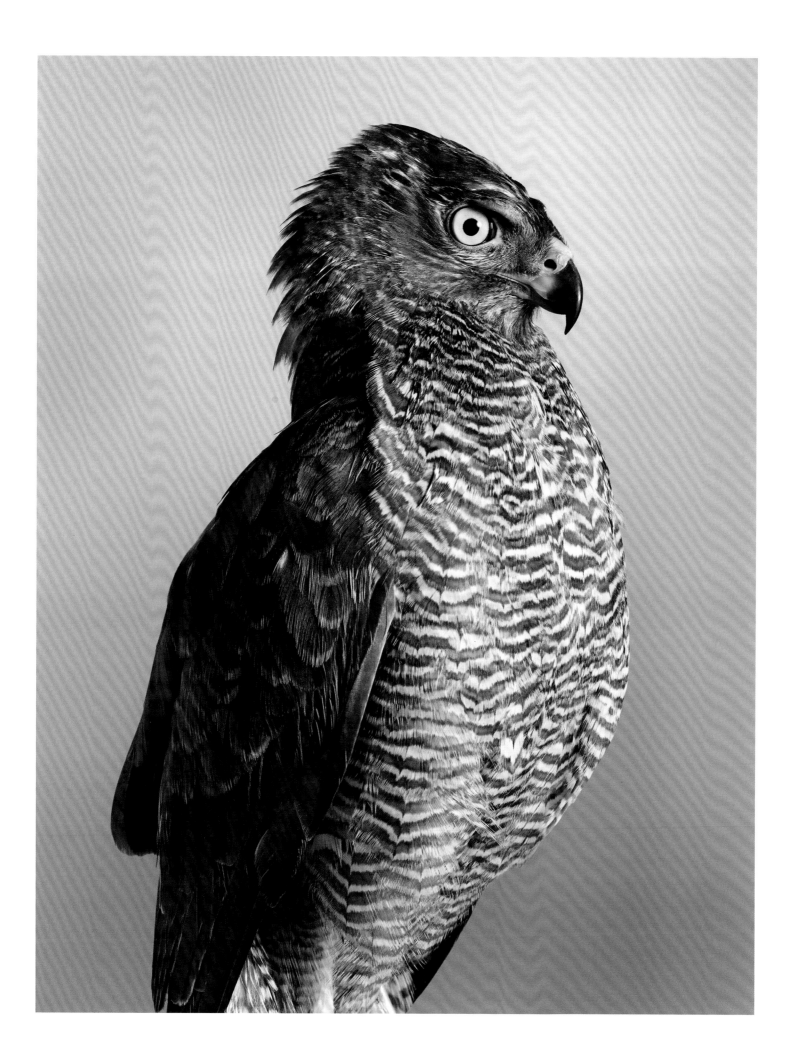

146
Trinity (young)
Brown goshawk
Accipiter fasciatus

147
Trinity (mature)
Brown goshawk
Accipiter fasciatus

Yule
Barking owl
Ninox connivens

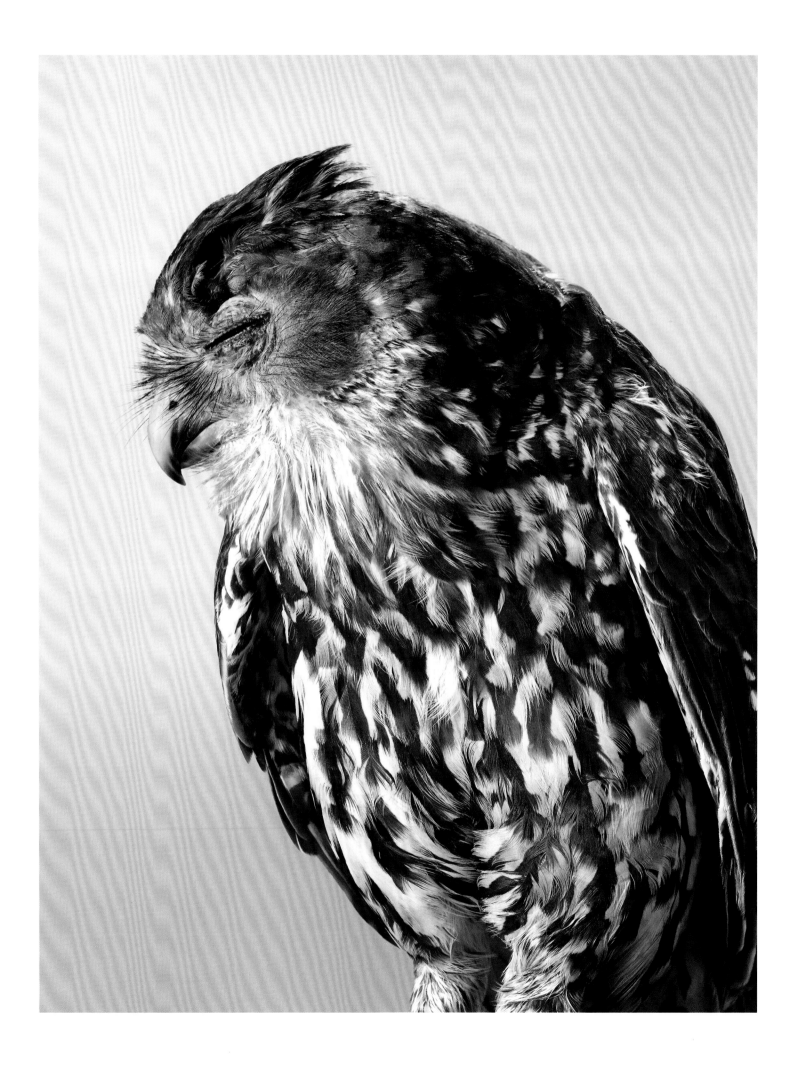

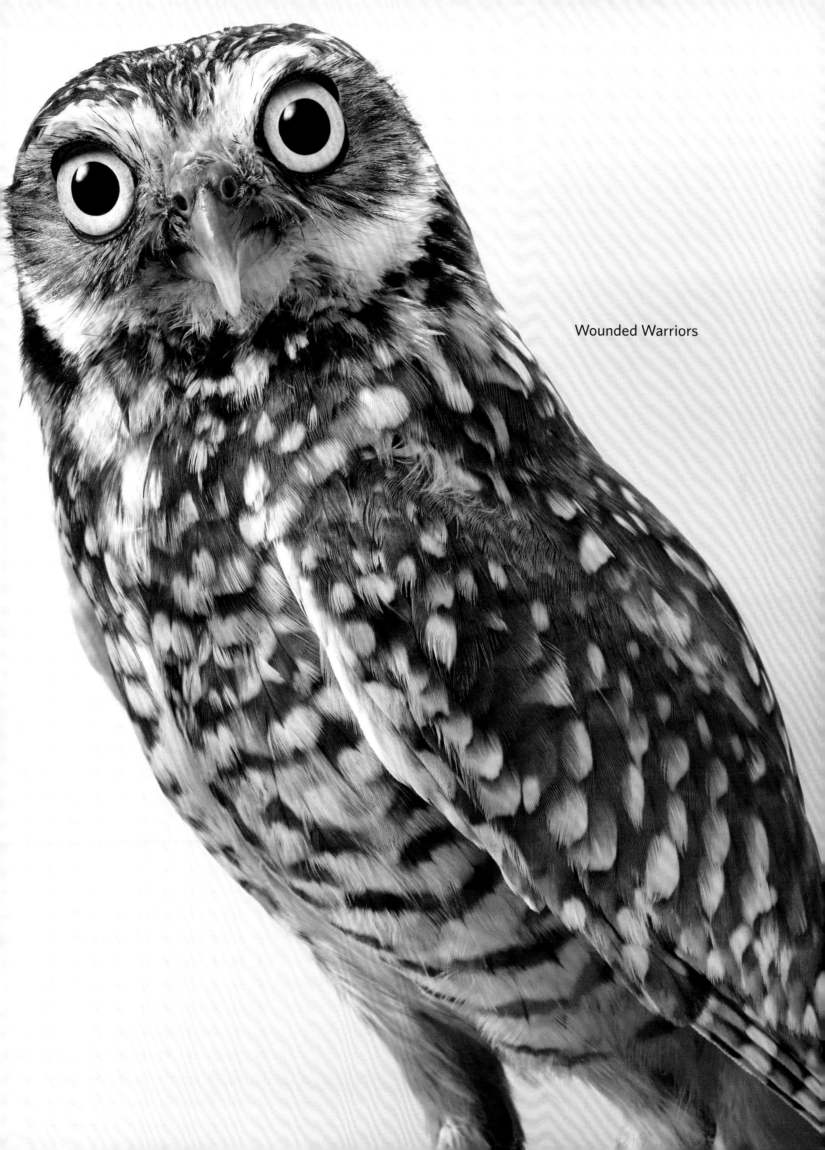

Wounded Warriors

Forrest
Great horned owl
Bubo virginianus

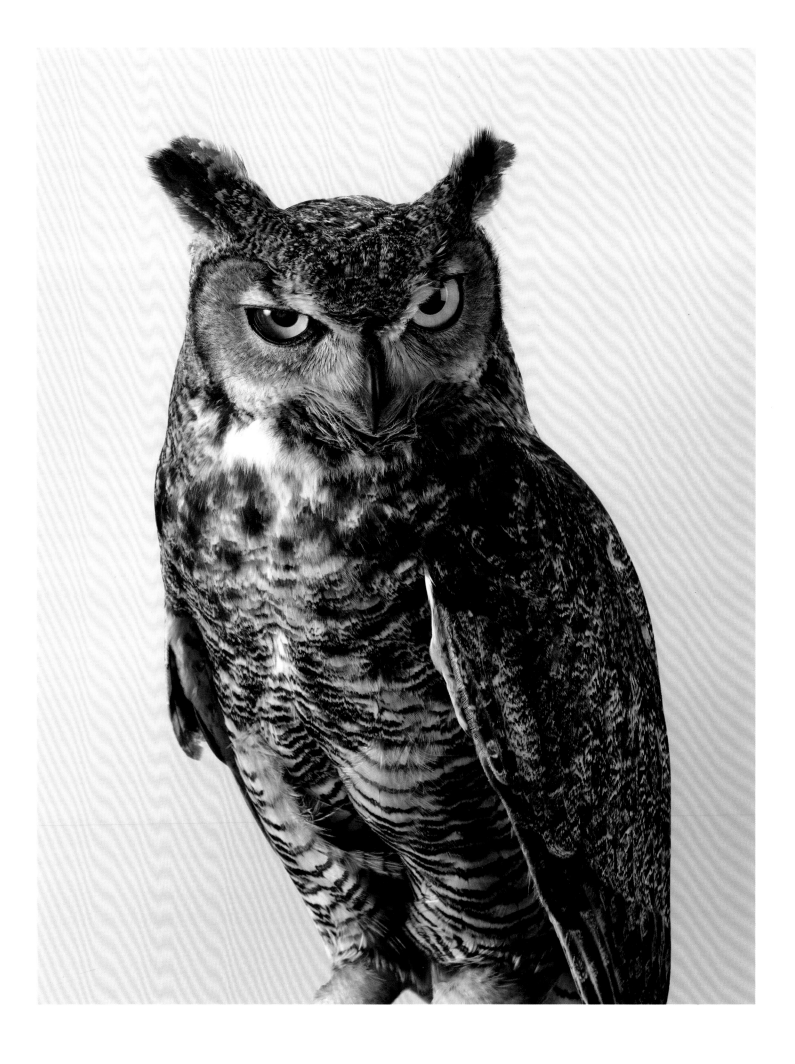

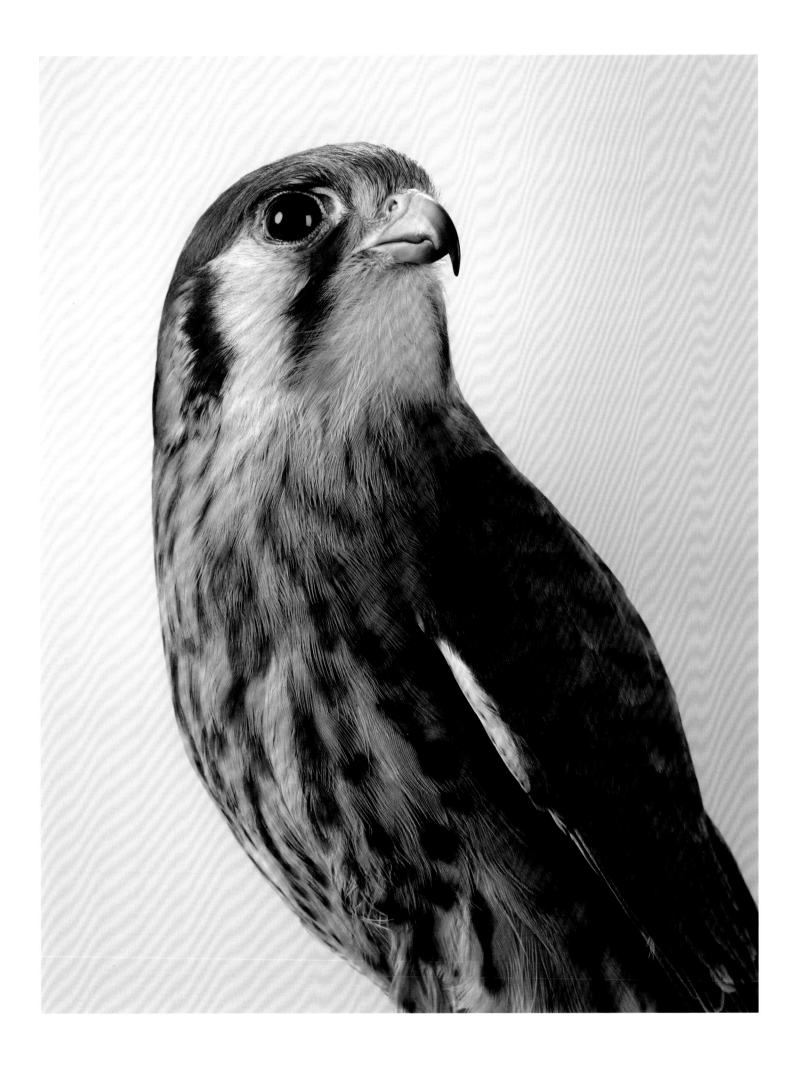

Wounded Warriors

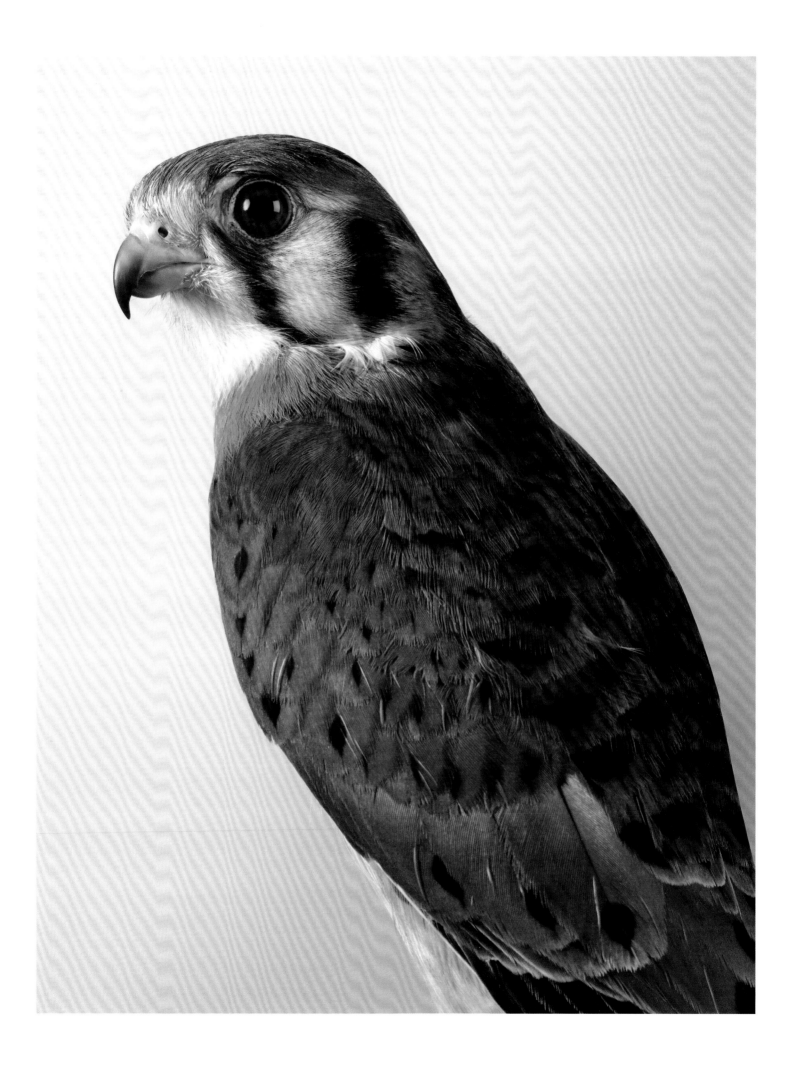

154
Kira
American kestrel
Falco sparverius

155
Bob
American kestrel
Falco sparverius

Drifter No. 1
Broad-winged hawk
Buteo platypterus

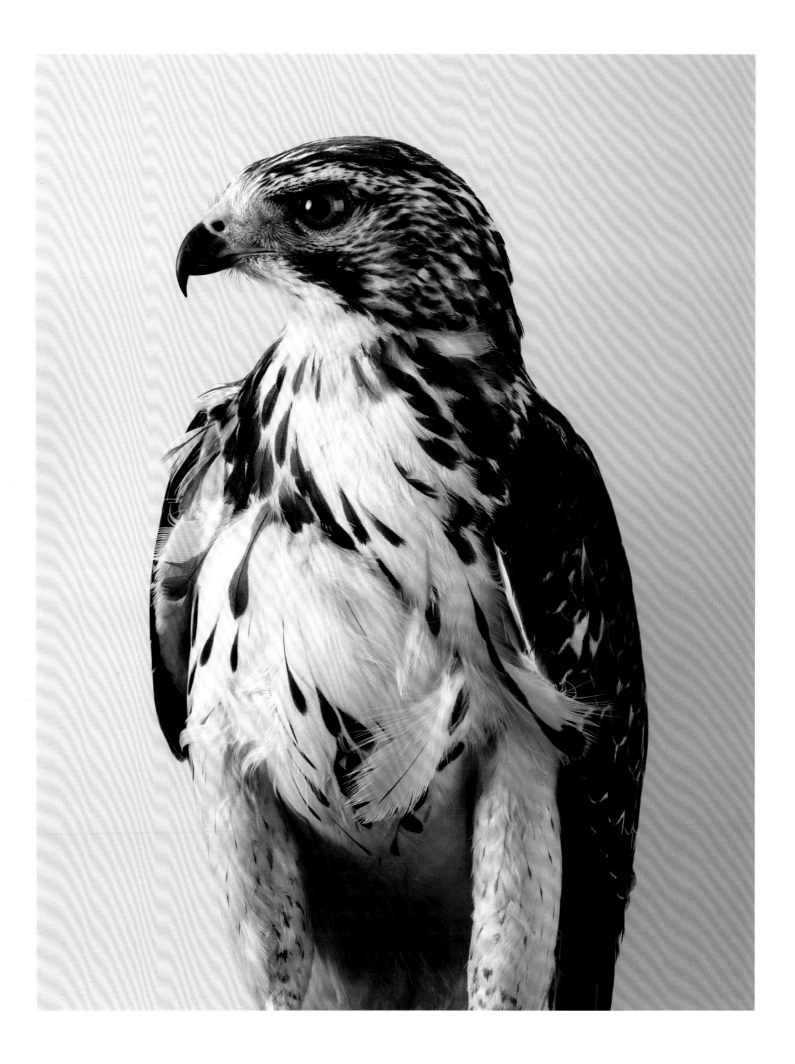

Drifter No. 2
Broad-winged hawk
Buteo platypterus

Wounded Warriors

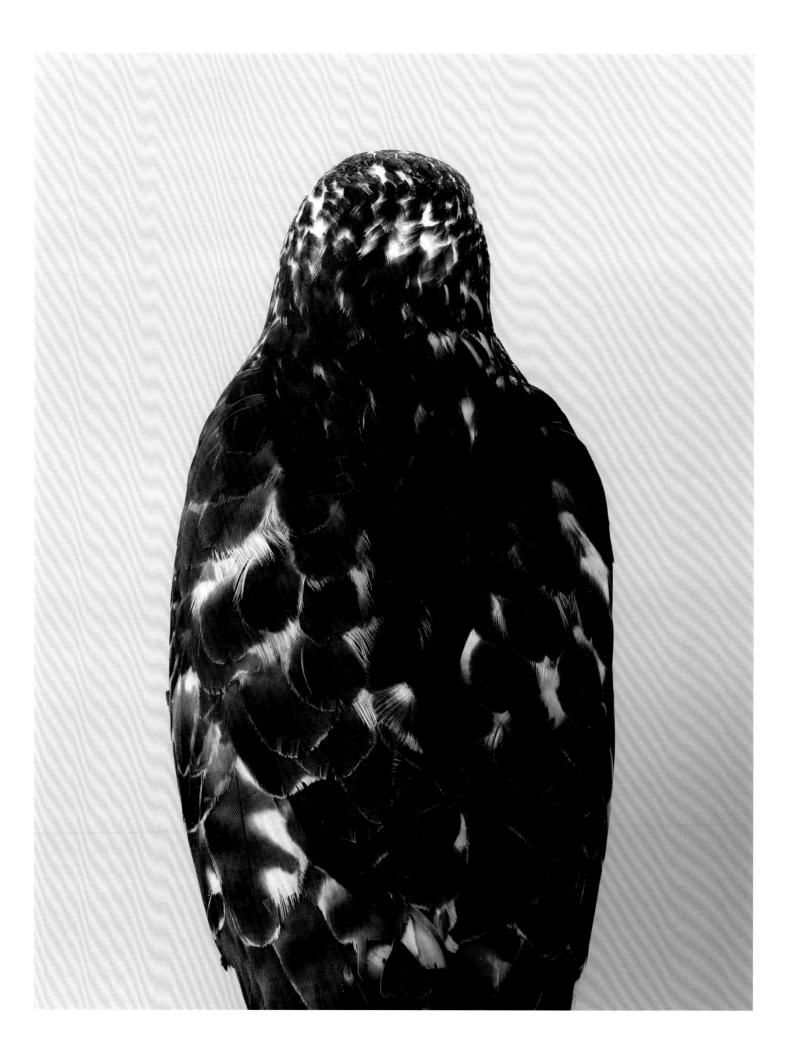

Shytan
Golden eagle
Aquila chrysaetos

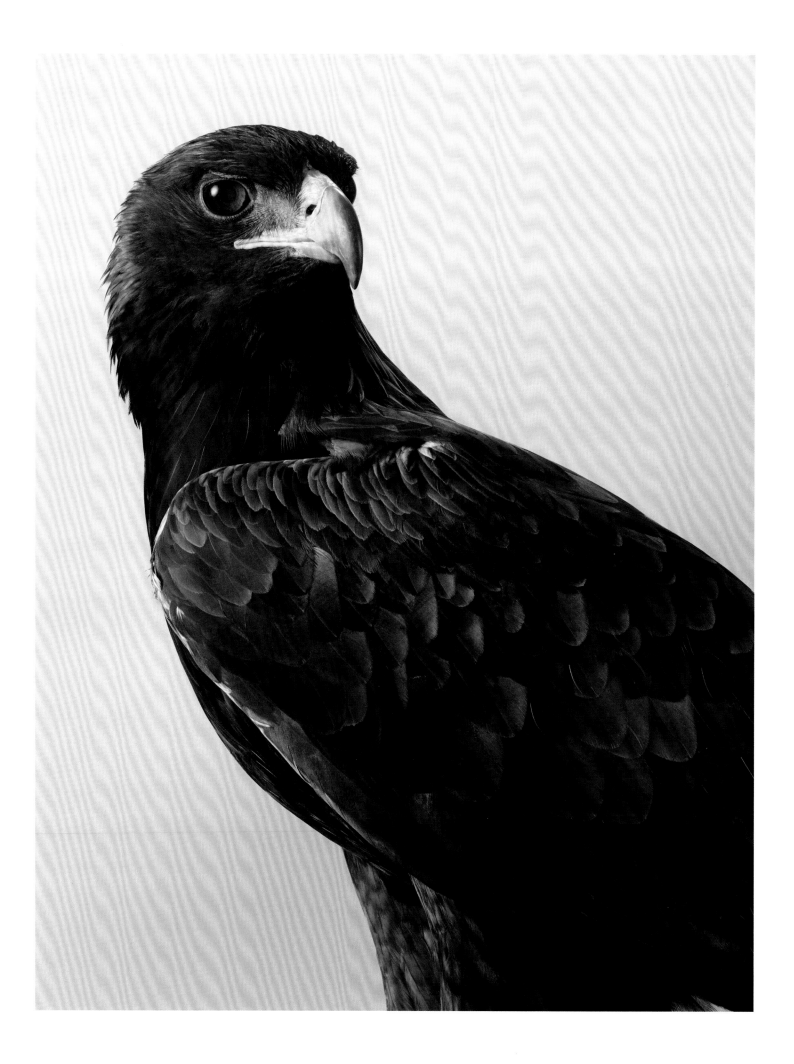

Ava
Western barn owl chick
Tyto alba

Wounded Warriors

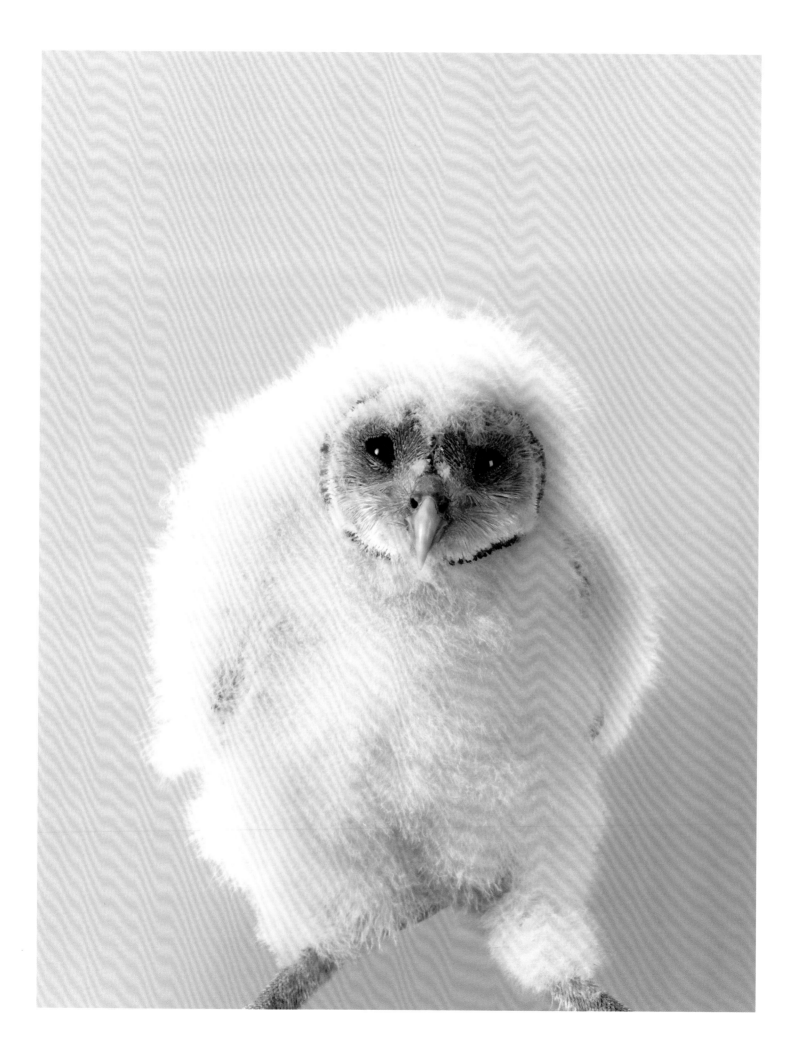

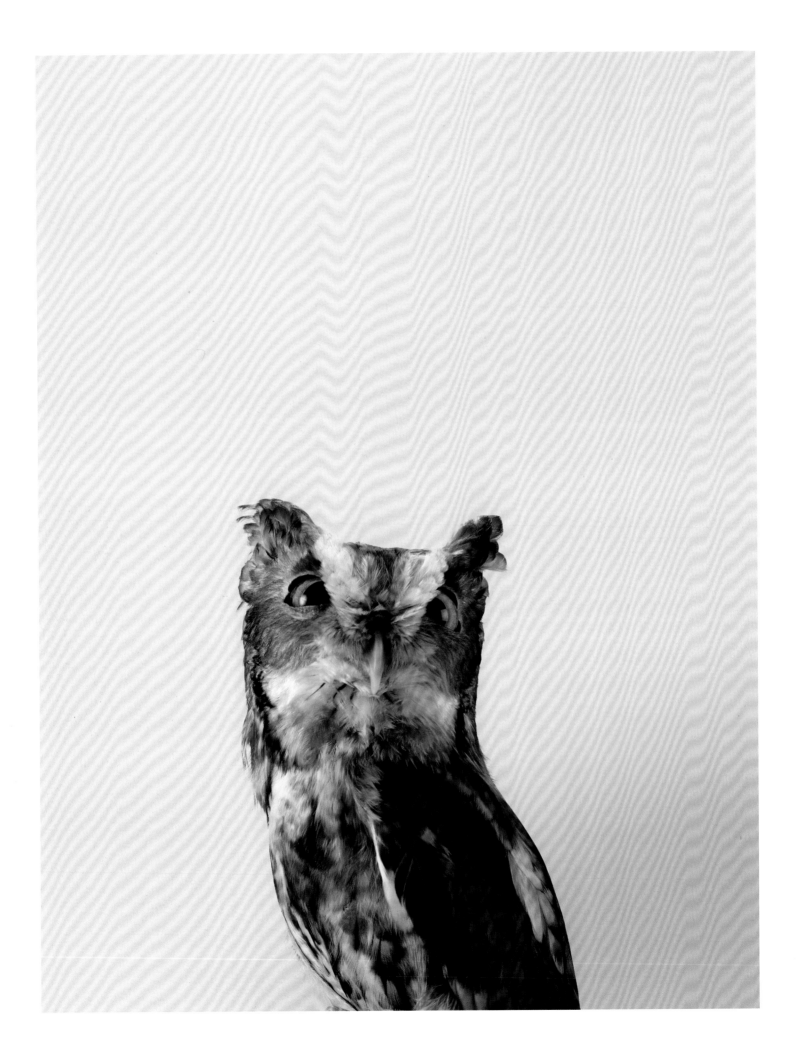

Wounded Warriors

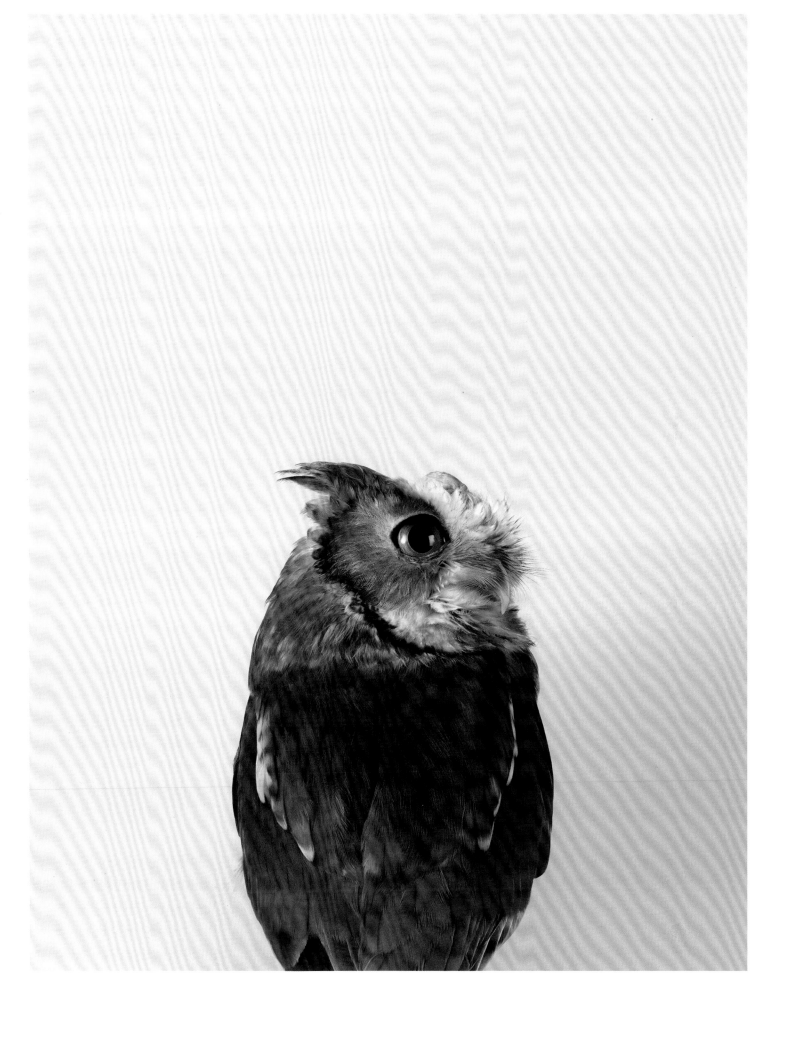

164
Riley No. 1
Eastern screech owl
Megascops asio

165
Riley No. 2
Eastern screech owl
Megascops asio

Handsome
Turkey vulture
Cathartes aura

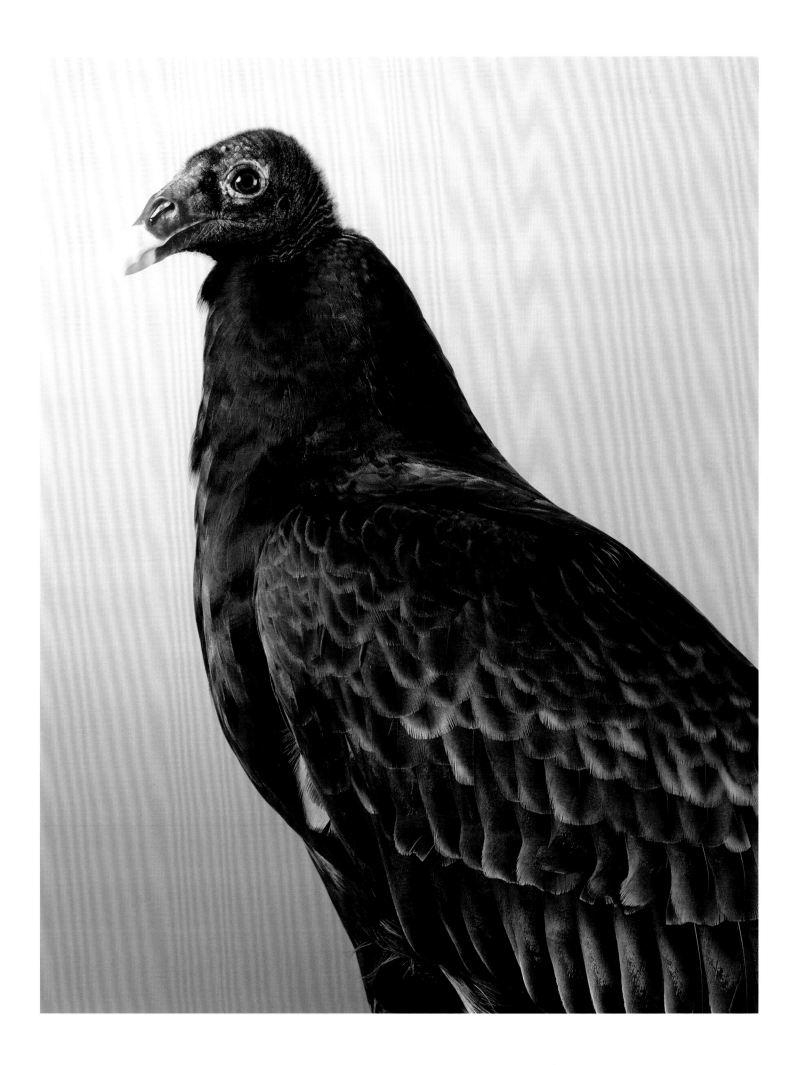

Wonder
Turkey vulture
Cathartes aura

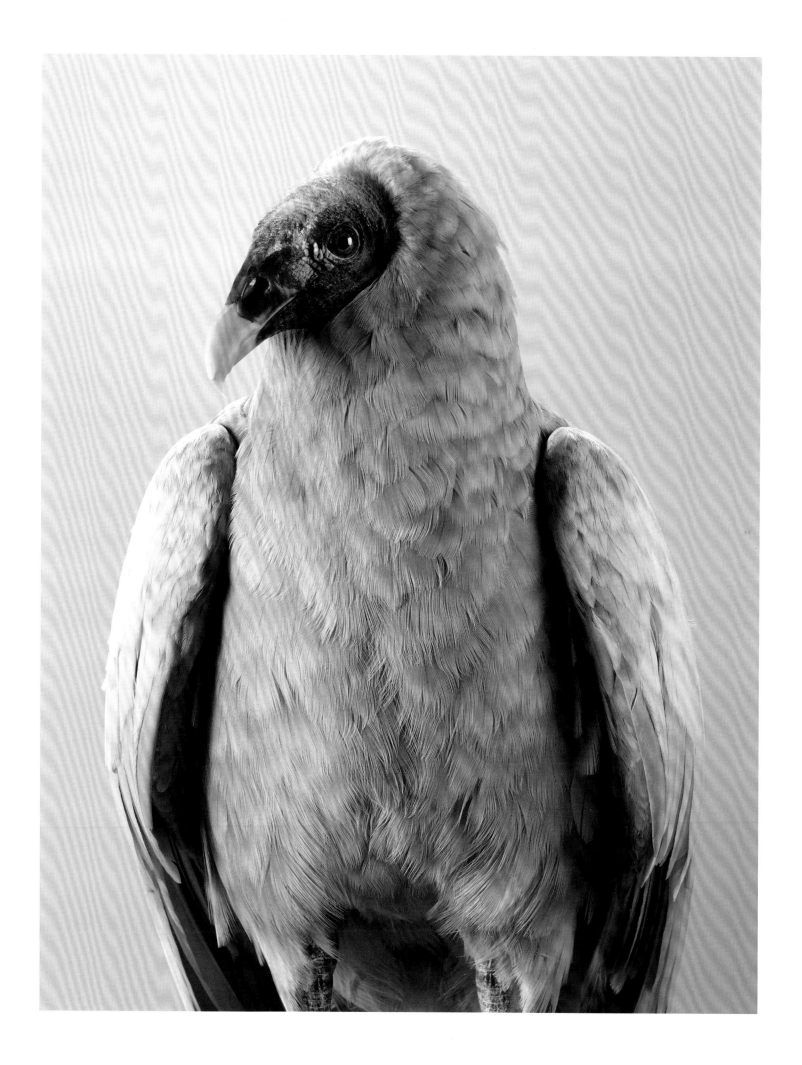

Pixie
Northern pygmy owl
Glaucidium gnoma

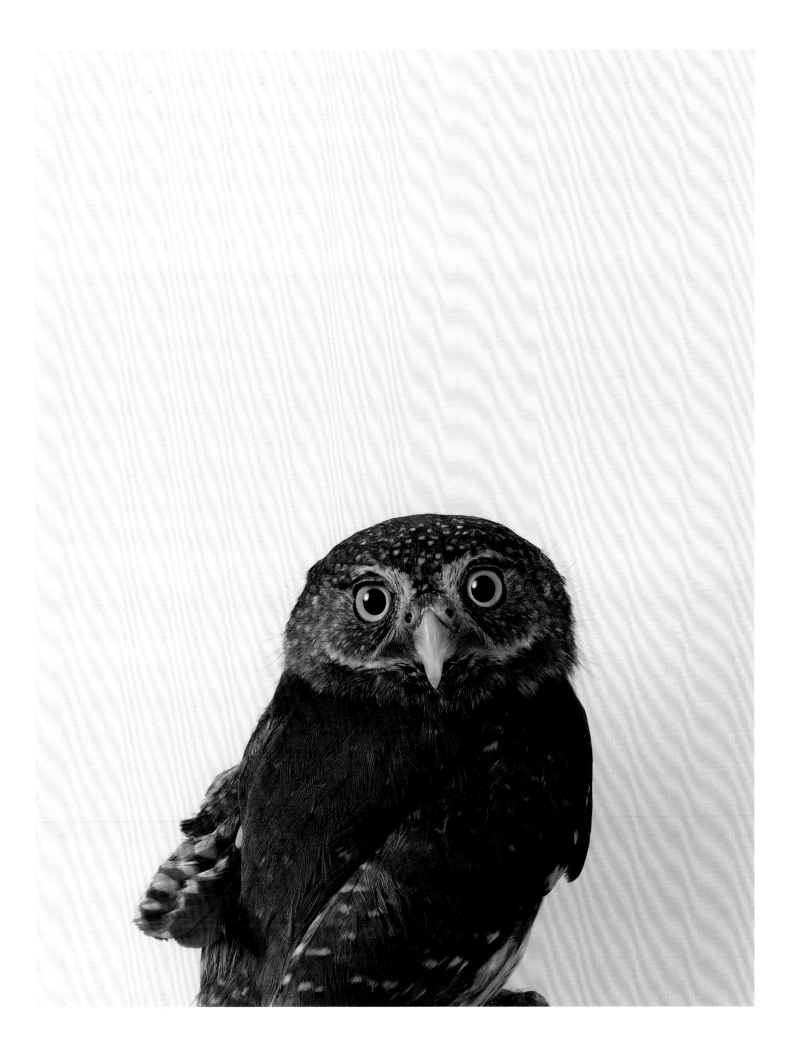

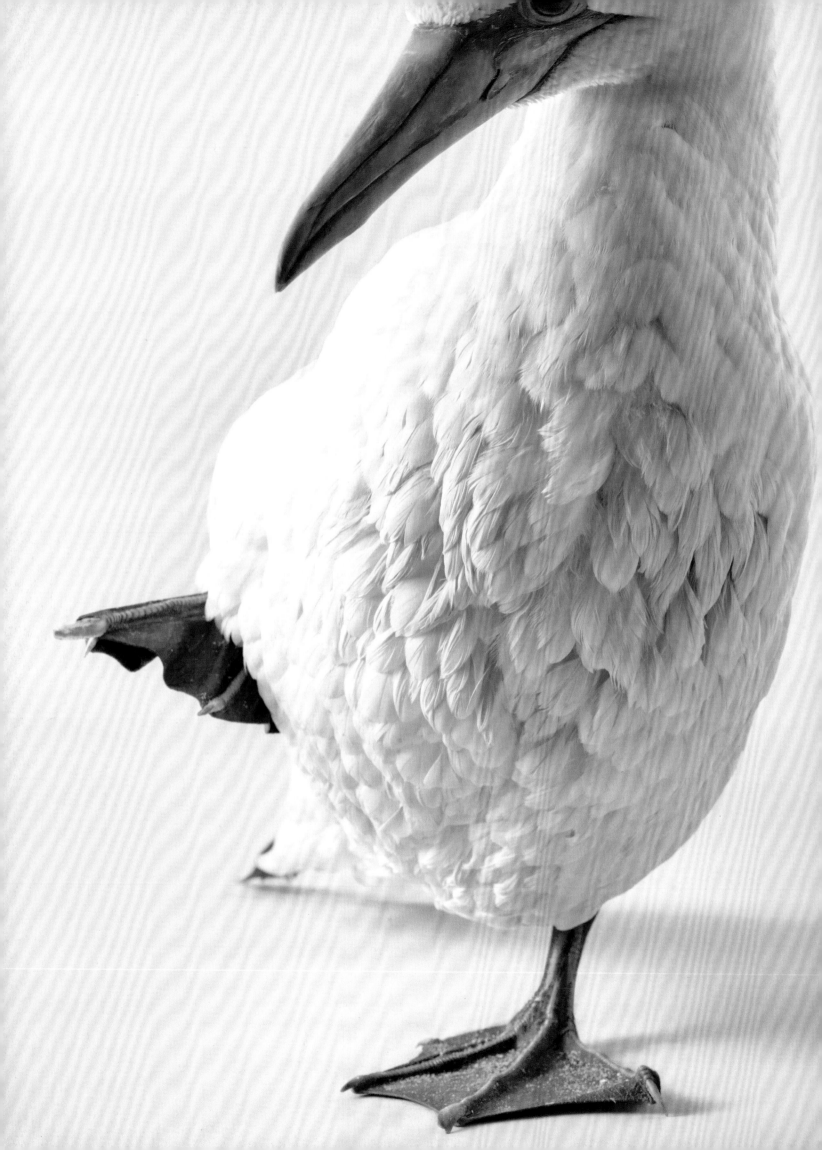

Lost

Chicken
Australasian gannet
Morus serrator

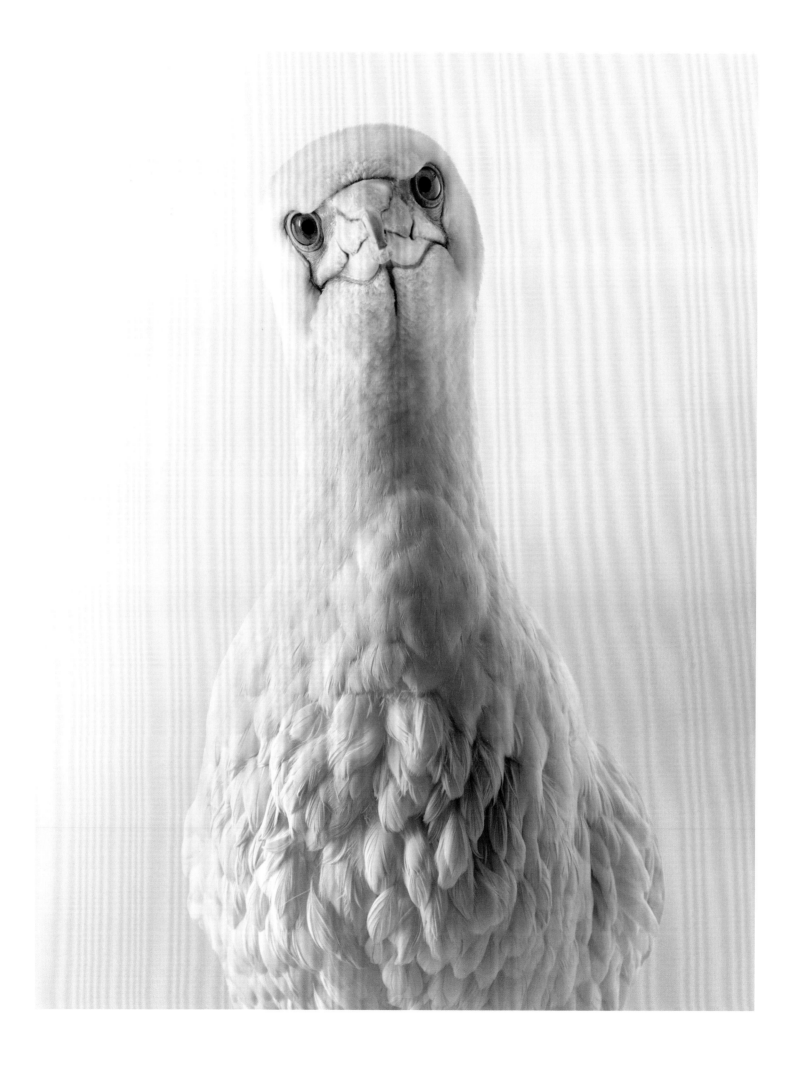

List of Works

21
Seisa
Palm cockatoo
Probosciger aterrimus

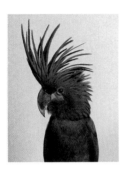

22
Mrs. Skyring
Gang-gang cockatoo
Callocephalon fimbriatum

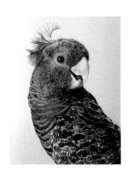

23
Commander Skyring
Gang-gang cockatoo
Callocephalon fimbriatum

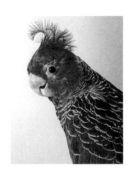

I have never met a more curious bird than Seisa (pronounced "Say-Sha"), the palm cockatoo. She was fascinated by all my equipment, and as I was setting up she did everything she could to keep her eye on me. Once we started shooting she was gentle and shy, but what struck me most was her intense eye contact. She looked deeply into my eyes and listened very carefully to everything I said. She looked so otherworldly that I imagined I was photographing an alien species. She began to trust me more and more, and by the end of the shoot she had come up to me to nuzzle into my neck.

Palm cockatoos are found mainly in north Queensland and New Guinea. Seisa lives at Adelaide Zoo and has been lovingly raised there since she was an egg. It is incredibly hard to breed and raise a palm cockatoo, so this is a credit to the zoo.

If a male palm cockatoo wants to breed, he has to learn to play the drums. He must find a drumstick by breaking off a twig, then strip off the bark and drum with one foot by his nest hollow, high in a tree trunk. The sound travels more than 100 yards (100 meters) and captivates the female palm cockatoos. Once he finds a partner, however, his drumming days are over and the drumstick is splintered for use in the nest. Sound familiar?

Palm cockatoos feed on particularly hard-shelled nuts and seeds, which they break into with their uniquely shaped beak. They have distinctive red patches on their cheeks, which change color when they are alarmed or excited. They lay only one egg during nesting and suffer from a low breeding success rate, but this is offset by their exceptionally long life span of forty to sixty years.

Commander and Mrs. Skyring are residents at Featherdale Wildlife Park, Sydney. Before I photographed them, I was able to observe them together, and they acted like any other married couple, sharing cuddles, grooming, and having the occasional squawky disagreement . . .

Mrs. Skyring started destroying the wooden perch as soon as she sat for her portrait, and then was more interested in eating a peanut than paying me any attention. But suddenly, when she was ready, she turned on the charm. I got so many great photographs, it was very hard to settle on a final portrait.

Commander Skyring was very different in personality. He remained composed throughout the entire shoot, and kept quite still, watching me closely. I felt like he knew I outranked him and he was waiting for my orders.

During the breeding season, gang-gang cockatoos can be found in pairs or small family groups at high altitudes, inhabiting trees in tall mountain forests. In winter and fall, the cockatoos are often found in flocks of up to sixty birds that migrate to lower, drier areas and are especially common in towns and cities in southeast Australia. The cockatoos form close, lifelong partnerships, and both parents share the responsibility of raising their young. On some occasions "crèches" are formed where the young of several pairs roost together while the parents forage for food.

25
Slim
Sulphur-crested cockatoo
Cacatua galerita

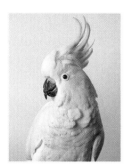

27
Nora
Red-tailed black cockatoo
Calyptorhynchus banksii

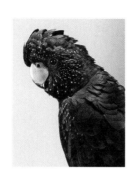

29
Neville
Major Mitchell's cockatoo
Lophochroa leadbeateri

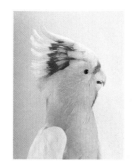

Slim was immediately comfortable with the camera, and I would go so far as to say he loved the portrait session as much as I did. Confident and curious in my company, he was a pleasure to shoot. I love how his sulphur-crested relatives have moved into our cities, and I am not the only one who loves their company.

The Cockatoo Wingtag Project, which is run by the University of Sydney, the Royal Botanic Gardens and Domain Trust, and the Australian Museum, involves wing-tagging sulphur-crested cockatoos within the Sydney region to monitor their movements. People are asked to report sightings via a dedicated Facebook page, and the affection shown to these birds through photos and comments from the public makes me smile. The study has revealed that, like its human counterparts, the same cocky may breakfast by the harborside beaches of Mosman, lunch in the affluent Potts Point, then spend a long afternoon talking to his mates on a balcony in Kirribilli, just up the road from the prime minister's Sydney residence.

These family-oriented birds incubate and raise their young together, and even once their young are able to care for themselves, they remain with their parents and family groups indefinitely. Unfortunately, not everyone loves that cockies have moved to the city. Cockatoos are often seen as destructive because they have a habit of damaging buildings. They need to chew to keep their bills trimmed, and would normally chew on trees, but with fewer trees around, windowsills often provide a tasty alternative. This is why wildlife experts say you should not encourage them to stay around by regularly feeding them. For a very special occasion, feed them natural foods such as banksia cones and native seeds, grasses, and flowers. Remember, if they start tucking into a building, it's not their fault—they just have to chew.

Something I love about working on these projects is the amazing people I get to meet. One is Josh Cook, a carer for Sydney Wildlife and an extraordinary human being. Josh has cared for many red-tailed black cockatoos and other birds in need. When I visited his house, the first thing I noticed was the sound of so many birds singing—every room is filled with patients receiving care.

When I met Nora it struck me that she looked like a knight in a suit of armor. Her feathers were so defined that they looked like hard metal pieces rather than soft, light feathers. She was incredibly human in all her expressions, and when I came home from the shoot I found myself coming back to this portrait of her time and time again.

Who was Major Mitchell? He was a Scottish-born Australian explorer and surveyor whose full title was Lieutenant Colonel Sir Thomas Livingstone Mitchell. He was a brilliant man, and a proud one; he is known as the last person in Australia to challenge someone to a duel, after he and his surveyor general's department were criticized for excessive spending. Fortunately, both shots missed their mark.

Neville was such a character, and very funny and loud. To me, this image resembles a mug shot—perhaps Neville has been arrested for getting up to some kind of cockatoo mischief!

Major Mitchell's cockatoos are found mainly inland in the arid woodlands of Australia. They nest on rotted wood in the hollows of old trees, and both the male and female sit on their eggs—usually a clutch of up to four. Once the chicks hatch, the parents continue to share the responsibility of raising and feeding their young until they are about four months old. The birds form small flocks in which they forage for seeds, bulbs, and insect larvae together.

31
Pete
Red-tailed black cockatoo
Calyptorhynchus banksii

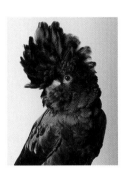

Pete is one of the few cockies that did not need to be photographed in my portable bird studio. Instead, he freely walked up and down a log that was brought in for the portrait session. I had to move fast to keep up with him, and he had so many great moves and expressions, it was hard to keep him in focus. As the shoot went on, he got more and more excited, pulling out his best moves. He was one bird that was born for the stage—think Elvis's *'68 Comeback Special*. There was a lot of impressive, loud screeching, dancing and flapping and general excitement about getting to perform, and a crest so big that sometimes you couldn't see his beak.

You can tell the difference between mature male and female red-tailed black cockatoos because the males are jet black, with scarlet bands on their tail feathers, whereas the females are a duller black and have yellow barred feathers on their breast, yellow spots on their head and wings, and a paler bill. Until the males reach puberty, at around four years old, they look similar to the females.

33
Little Stevie
Little corella
Cacatua sanguinea

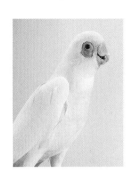

Little corellas are playful and cheeky, with powerful screeches and screams. And Little Stevie is a handsome devil. He has beautiful white feathers with tiny splashes of color. During the shoot, he stood tall and was a very composed bird. I started seeing him as a feathered dandy, with elegant, beautiful little legs in a pair of white stovepipe trousers and a matching white fitted suit jacket and shirt.

Little corellas become very noisy when they play. They have been seen enjoying sliding down the roofs of silos and spinning around on the blades of windmills. These gregarious birds form large flocks and feed raucously together on the ground. They have conversations with each other and show off by hanging upside down, using their feet, beaks, or both. Although he dresses well, Little Stevie loves nothing more than hanging upside down from branches and screaming, sending his audience into a frenzy.

35
Queenie
Galah cockatoo
Eolophus roseicapilla

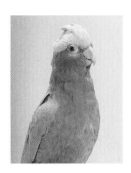

Galahs are one of the most common cockatoos in Australia, as they have been able to benefit from European settlement, in some cases stealing grain and water from human dwellings and farms. Even though they are now widespread, a galah's life is hard from the beginning. About 50 percent of all chicks die in their first six months.

Fortunately, Queenie is a survivor, and a real lady. She was the perfect sitter, and remained very calm and still for the duration of the shoot, only following me with her eyes.

Galahs congregate in large, rowdy flocks and roost together at night in trees. They feed on the ground on seeds, and in some areas are viewed as agricultural pests. Their supposed foolishness comes from their intense curiosity, playfulness, and hilarious call being interpreted as clownish; in Australia, someone who is acting in a silly manner is often called a galah. They are known for their acrobatic flight, but spend most of the day among the foliage of trees, sheltering from the sun.

37
Melba
Yellow-tailed black cockatoo
Calyptorhynchus funereus

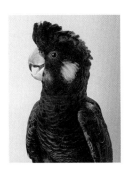

39
Bob
Long-billed corella
Cacatua tenuirostris

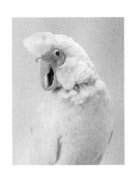

41
Kirra
Carnaby's black cockatoo
Calyptorhynchus latirostris

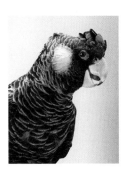

The first time I saw a yellow-tailed black cockatoo, I was driving with friends in the suburb of Clovelly, Sydney. When I spotted this majestic bird sitting on a telephone line, I nearly crashed the car. The screams of terror from my passengers were soon silenced when they witnessed what I had seen. We stood and stared in wonder. It was just so beautiful—and so big! I thought it must be an escaped aviary bird, because I had never seen a wild bird that big in the city. We headed down to the ocean nearby, and soon discovered a large flock of the cockatoos feeding in the banksia trees. As with many cockatoos, Melba's habitat is being cleared, but unlike some that thrive in the new open spaces, she likes banksia cones and seeds from other native plants to feed on. That's why she was in Clovelly, where there are trees lining the ocean.

Yellow-tailed black cockatoo adults can grow up to 25 inches (65 centimeters) in length, and if you get the privilege of seeing them fly, they will take your breath away. They flap deeply and slowly, with distinctly heavy, fluid wingbeats, and their loud, eerie, wailing calls carry for long distances. The portable bird studio that I use to photograph cockatoos was designed for large birds, but when Melba came in, her head almost touched the ceiling and her tail feathers touched the floor. She was calm and confident, a gentle giant.

Bob is a rescued long-billed corella whom I met at the home of Daphne Turner, a dedicated WIRES (NSW Wildlife Information, Rescue, and Education Service) volunteer. WIRES rescues tens of thousands of native birds, possums, snakes, and marsupials in New South Wales, Australia.

Long-billed corellas originated in western Victoria and southern New South Wales, but flocks have started to form in Sydney and other major cities after aviary birds escaped and bred. They are sociable birds, most often found in large flocks in grassy woodlands and even in urban park areas in southeast Australia. One of my favorite places to see them is in Centennial Park, Sydney, where large flocks dig for roots, seeds, and bulbs, using their long, pale beak as a hoe.

It was unclear at first if Bob would be OK with being photographed, but in the end he loved it. Some of his poses made me laugh, as he seemed to be an old pro who knew his best side for portraits.

I was very excited to meet Kirra, the Carnaby's black cockatoo. I grew up in Perth and often saw these cockatoos, which are endemic to the southwest of Western Australia. If you are going to side with the underdog, these beautiful birds are it. Their population has decreased by more than 50 percent over the last forty-five years, and they are high on the endangered species list.

The problem is that the birds are fussy and that humans keep knocking their tree houses down. They only nest in mature eucalypti, such as salmon gum and wandoo (white gum), which need around a hundred years to form hollows suitable for nesting. Land clearing for farming, and removal of nest hollows when trees are harvested for firewood—or sometimes just to make properties look "tidy"—wipe out or fragment the birds' homes.

A documentary about the Carnaby's black cockatoo, called *On a Wing and a Prayer*, describes the birds like this: "Playful, mischievous, and highly intelligent, Carnaby's black cockatoos are adored by thousands, hunted by many, and saved by few. Hope for their future is in the hands of the local community." The more people know about these beautiful birds, the better chance they have for survival, and the cheeky Kirra is a wonderful ambassador for her species.

The sociable Carnaby's black cockatoo is found only in southwest Australia and moves seasonally from coastal areas to drier inland areas in its breeding season. Outside of breeding season, these birds can be seen flying in large feeding flocks. However, they form smaller flocks when returning to their nesting sites—usually the natal home of the female. These cockatoos form monogamous pairs, and the females have been known to continue breeding until they're about twenty years old. They lay two eggs, which the female alone incubates, in a hollow of a tree lined with bark. She relies completely on the male to provide her with food and water during this period. Most commonly, only one of the clutch survives, and after fledging, the chick exits from the hollow fully grown.

43
Matilda
Major Mitchell's cockatoo
Lophochroa leadbeateri

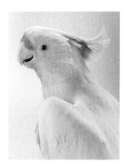

Because of their white and salmon-pink plumage and large, bright red and yellow crest, Major Mitchell's cockatoos are generally recognized as the most beautiful of all cockatoos. Like all females of the species, Matilda has a light reddish-brown iris, as opposed to male Neville's black iris (p. 179). In contrast to their beauty, to our ears their song is sad and mournful.

Matilda was such a shy bird, but so gentle and trusting, and I did my best to capture this in her portrait. It's this sweet-temperedness that I love.

45
Rosie
Red-tailed black cockatoo
Calyptorhynchus banksii

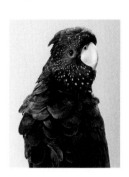

Red-tailed black cockatoos can be found across mainland Australia. The sociable bird is often seen in large flocks, and feeds in trees, using its strong beak to break open seeds. They breed sporadically throughout the year, and nest in holes or hollows of tree limbs. The female cockatoo lays only one egg, which she alone incubates while the male provides her with food. The young bird is fledged in ten to twelve weeks, but will remain in its parents' care long after it has learned to fly.

Photographing Rosie was like capturing a shy starlet on the red carpet.

47
Jarra
Cockatiel
Nymphicus hollandicus

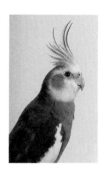

It is well known that cockatiels are native to the outback regions of inland Australia, and favor the Australian wetlands, scrublands, and bushlands. What has baffled most for years, however, is whether the cockatiel is a crested parrot or a small cockatoo. The answer from recent biological studies is that it is a cockatoo. However, it is the sole member of a subfamily called Nymphicinae. How do these naming conventions work? The position of the cockatiel in a scientific classification goes like this:

Kingdom:	Animalia (the group that comprises all animals, including humans)
Phylum:	Chordata (this means animals with a spinal cord)
Class:	Aves (includes all birds)
Order:	Psittaciformes (includes all parrot-type birds and cockatoos)
Superfamily:	Cacatuoidea (there are three superfamilies in the Psittaciformes order)
Family:	Cacatuidae (the only family in the superfamily is cockatoos)
Subfamily:	Nymphicinae (the cockatiel has its own subfamily, which is named after mythical nymphs because of its beauty)
Genus:	*Nymphicus* (the only genus of the subfamily is cockatiels)
Species:	*Hollandicus* (the only species of the *Nymphicus* genus, the cockatiel is named after New Holland, a historic name for Australia)

Clear as mud? So, in simple language, the cockatiel is part of the cockatoo family—but it is in a subfamily, genus, and species of its own.

In conclusion, Jarra is one of a kind.

List of Works

Songbirds

51
Ellery
Red-browed finch
Neochmia temporalis

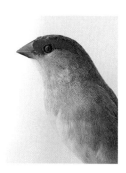

53
Desmond
Diamond firetail finch
Stagonopleura guttata

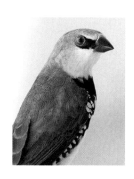

55
Charlie
Black-headed gouldian finch
Erythrura gouldiae

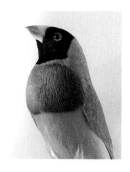

57
Christo
Orange-headed gouldian finch
Erythrura gouldiae

58
Amanda
Orange chat
Epthianura aurifrons

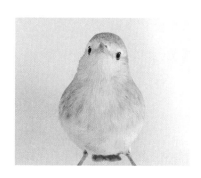

59
Ben
Orange chat
Epthianura aurifrons

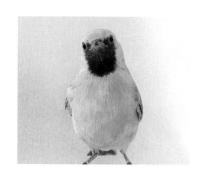

There are more than four thousand species of songbirds. They are all passerines (known as perching birds) and belong to the massive order Passeriformes. Songbirds' vocal organs are more highly developed than other bird species'. Many male songbirds use song to duel with other males to protect their territory, and to attract a mate; the more complex their repertoire is, the more successful they are said to be at finding a partner.

Finches are small songbirds with short, conical beaks designed for eating seeds. They have a bouncy flight made up of a combination of wingbeats and gliding and are very sociable with each other. I was very keen to work with finches and other small birds, as they didn't come into care often, so I contacted the Finch Society of Australia. It was here that I met dedicated club members with a wonderful sense of humor. Sydney chapter president Sam Davis introduced me to members who warmly invited me into their homes to meet their birds.

The finches were stunning. They were also impossible to photograph, as they do not like to keep still.

The orange chats, another type of songbird, were a couple, and were in constant communication with each other while they took their turns. I laughed when I looked at their poised, serious, Victorian-era poses. Sam later sent me a video of the female chat, who pretends to have a broken wing and tries to lure him (whom she considers a predator) toward her to distract him away from her chicks. It's a fascinating behavior that can be quite disturbing to watch until you fully comprehend that she is fine and is trying to trick you.

60
Pepe No. 1
Splendid fairywren
Malurus splendens

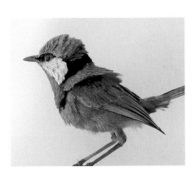

61
Pepe No. 2
Splendid fairywren
Malurus splendens

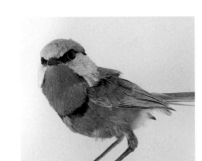

62
Redmond
Red-capped robin
Petroica goodenovii

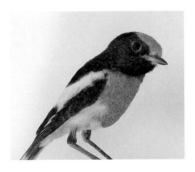

63
Tilly
Silvereye
Zosterops lateralis

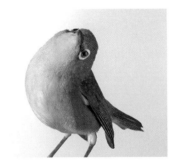

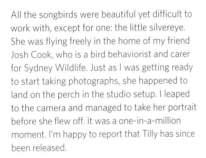

All the songbirds were beautiful yet difficult to work with, except for one: the little silvereye. She was flying freely in the home of my friend Josh Cook, who is a bird behaviorist and carer for Sydney Wildlife. Just as I was getting ready to start taking photographs, she happened to land on the perch in the studio setup. I leaped to the camera and managed to take her portrait before she flew off. It was a one-in-a-million moment. I'm happy to report that Tilly has since been released.

Penguin the Magpie

66
Penguin No. 1
Australian magpie
Cracticus tibicen

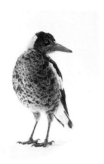

67
Penguin No. 2
Australian magpie
Cracticus tibicen

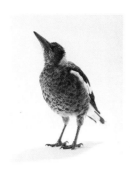

69
Penguin No. 3
Australian magpie
Cracticus tibicen

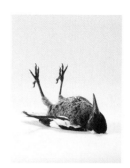

71
Penguin No. 4
Australian magpie
Cracticus tibicen

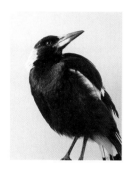

73
Penguin No. 5
Australian magpie
Cracticus tibicen

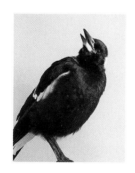

I have known Cameron and Sam Bloom for many years. Cam is a professional photographer, and I worked in a photo agency that used to represent him. They're a special family who live for adventure, and their three gorgeous boys live an outdoorsy life where surfing and skateboarding before and after school is the norm.

Penguin came into their lives as a young chick. The eldest son, Noah, found her abandoned, and the Blooms took her in. They didn't want her to forget that she is a magpie, so they raised her as a wild bird. She lives outside and spends her days foraging for worms in the garden, but chooses to visit the family regularly. Her story is a very unusual one and generally not one to be copied (if you find a wild bird it is always best to take it immediately to a wildlife carer). It's just one of those exceptions that has worked, and as a result it has given the Blooms so much happiness to come home and see her in the garden.

My portraits of Penguin were taken a year apart. The photo of her lying on her back captured something that she liked to do with the family. They would roll her onto her back and tickle her tummy. Photographing her as a young adult, it was wonderful to see how her feathers had changed. She had turned into such a beautiful young lady. Both times I photographed her, even after the shoot was over she would stay on the perch. She loved the warmth radiated by the modeling light she was under—so much so that she fell asleep at one point.

The warbling cry of the magpie is considered a quintessential Australian sound. The birds are common across Australia and are often seen in open areas, such as playing fields, where they walk along the ground together, feeding off insects and their larvae. They breed between June and December and lay clutches of two to five eggs. However, generally only one or two chicks survive, as it takes one parent per chick to feed them—Penguin is one of the lucky ones!

Ode to a Tawny

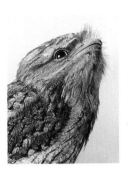

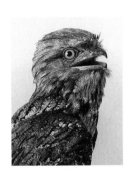

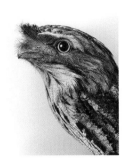

I adore tawny frogmouths. Photographing the tawnies was like being a guest on Jim Henson's *Muppet Show*. They are strange, wondrous-looking birds, and seem to belong to a time when dinosaurs roamed the earth. They can be found throughout Australia and in many different habitats, apart from arid deserts and dense forests. By nature they keep very still, so they were actually a dream to photograph. When they do decide to change positions, it is done in such a controlled way that it feels as if a puppet master is turning their head.

People often think that tawny frogmouths are owls, but they're actually a nocturnal bird that is more closely related to the nightjar family. You can tell by looking at their feet. Tawny frogmouths have dainty, little feet whereas owls have big, powerful feet used for catching prey. The tawny frogmouth prefers to catch its prey with its beak, pouncing on it from where it perches, and mainly eats insects, worms, slugs, small mammals, reptiles, and frogs.

Tawny frogmouths have evolved to be world-class magicians. When feeling threatened, they stay perfectly still, close their eyes, and take on the shape of a branch. Their feathers blend into the tree and . . . they disappear.

85
Jimmy
Budgerigar
Melopsittacus undulatus

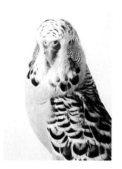

87
Vincent
Budgerigar
Melopsittacus undulatus

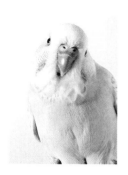

89
Spencer
Budgerigar
Melopsittacus undulatus

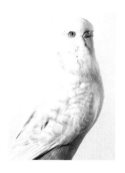

91
Mrs. Plume
Budgerigar
Melopsittacus undulatus

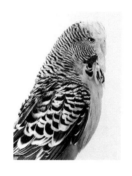

93
Terry
Budgerigar
Melopsittacus undulatus

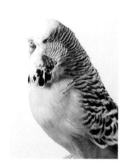

95
Little Holly Squawkamole
Budgerigar
Melopsittacus undulatus

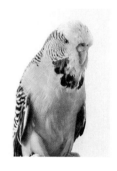

There really isn't a more Australian bird than the budgie. Just like the native budgie, the national colors of Australia are green and gold, and the budgerigar's natural habitat for the past five million years has been Australia.

The other colors that you see have developed from years of selective breeding. I was told this by Warren Wilson, a wonderful man who is president of the Budgerigar Rare and Specialist Exhibitors of Australasia. In the avicultural world, Warren's knowledge is something to behold. He knows so much about the physical variations and individual personalities of the birds he has bred in captivity that I often wonder if he might be a giant budgie himself. It's true that he walks around in short shorts, has a barrel chest, and sports a big white quiff, looking very similar to the little birds he champions. It was Warren who helped me photograph my first bird in a studio setting, and he set me on the path that I am on today.

Photographing the budgies was a heartening experience. They are beautiful little parrots and are affectionate to their flockmates and young. Because budgies are very social birds, keeping a lone bird permanently caged does raise an ethical question. Fortunately, with guidance from experts like Warren, setups can be created that give aviary birds such as these a better quality of life.

Budgies can be found in most habitats, but never far from a water source. Most of their activity, including feeding and drinking, takes place in the morning. They breed in response to significant rainfall and can have several broods in one season. The females sit on the eggs, and as is usual with many parrots, the chicks are born naked and completely reliant on their parents.

Looking through a lens, where everything appears magnified, you start to see how expressive these little birds actually are.

I would speak to them, and their reaction to my voice was one of curiosity mixed with shyness or boldness, depending on the individual. I loved that such a small bird could be so engaged. I spent two years working with these birds, and it was a project that brought me much joy.

96
Cliff
Budgerigar
Melopsittacus undulatus

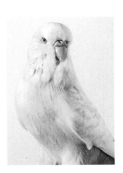

97
Flight Sergeant Chalky No. 1
Budgerigar
Melopsittacus undulatus

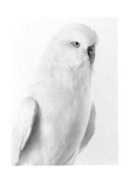

99
Flight Sergeant Chalky No. 2
Budgerigar
Melopsittacus undulatus

101
Suzie
Budgerigar
Melopsittacus undulatus

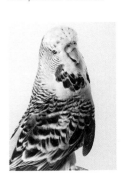

103
Salvador
Budgerigar
Melopsittacus undulatus

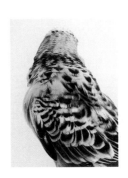

105
Barnaby Rudge
Budgerigar
Melopsittacus undulatus

109
Blue
Orange-bellied parrot
Neophema chrysogaster

I have a soft spot for parrots, and those that appear in this book endeared themselves to me in all their rainbow-colored glory. However, I can't help falling for an underdog, and a parrot with a critically endangered status is a bird who pulls heavily on my heartstrings. This is the case with the orange-bellied parrot. I had wanted to meet an orange-bellied parrot for almost ten years, after learning about its plight from Mark Holdsworth, ornithologist and champion for this species.

The current wild population of orange-bellied parrots is estimated to have less than fifty individuals. It lives and breeds in the Southwest Wilderness moorlands of Tasmania, Australia, and migrates hundreds of miles with its tiny remaining flock across Bass Strait and along the coasts of Victoria and New South Wales or South Australia to seek out its preferred winter habitat: salt marshes. On Boxing Day each year, the infamously treacherous Sydney-to-Hobart yacht race begins, and people gather in the thousands to bid farewell to the multimillion-dollar racing yachts as they leave Sydney Harbor. And every year, just a few months later, the remaining orange-bellied parrots, which are only 8 inches (20 centimeters) long and weigh only 1.5 ounces (43 grams), fly similar distances without fuss or fanfare. Between February and April they migrate from Tasmania to the Australian mainland, and then return to Tasmania to breed between October and March. The adults are first to depart, and a few weeks later their fledglings, which are only three months old, make the treacherous journey alone. It is so amazing that these young birds know what to do. It's a beautiful example of the true wonder of migration, where passageways must be built into the DNA of these most extraordinary birds.

The reason for their decline points directly to us. We have drained their wetlands for grazing, we pull out their precious salt marshes for industrial and urban development, we remove vegetation for agricultural reasons, and we've introduced foxes and feral cats into their habitat. With such a tiny population, the orange-bellied parrot is vulnerable to changes in its environment, and recently the insidious parrot beak and feather disease virus was detected in 75 percent of 2014's juveniles. While this is troubling news, Mark and other experts are hopeful that enough juveniles will survive the disease, and the Australian government is implementing urgent actions to improve biosecurity and strengthen the captive insurance population.

I have a belief that we can reverse the decline of this species. What gives me great hope is that there are thousands of people who really care about these birds. Many are volunteers for BirdLife Australia or Friends of the Orange-Bellied Parrot (Wildcare Australia), a group that undertakes population surveys, while others are assisting with habitat-management projects. The state and federal governments are committed to saving the species, and it is hoped that the carefully managed captive-breeding program, which now has approximately 340 individuals in ten private and government institutions across Australia, will eventually boost the wild population.

One of these institutions is Moonlit Sanctuary, southeast of central Melbourne, in Victoria. They trusted me to photograph my very first orange-bellied parrot. When Lisa Tuthill, a dedicated senior keeper who has been working hard on the difficult breeding program, showed me and Mark the enclosure, all I could see

were shrubs and nothing else. Then, as my eyes adjusted, I saw, nestled quietly in the leaves, three very still little orange-bellied parrots. I always knew these birds were small, but seeing them for the first time I couldn't believe just how small they were. How these tiny, gentle creatures are capable of flying such great distances astounds me.

It makes me quite emotional looking at my pictures of these birds' faces. I dearly wanted to get an orange-bellied parrot portrait for this book so that I could introduce them to you. The one featured here doesn't have a name, so I have called him Blue.

Knowing the orange-bellied parrot's plight and looking at sweet little Blue's gentle face, how could you not care passionately for this species' welfare? I hope he and all of his kind successfully breed in coming years, and we can again see flocks of these feathered gems in our skies.

111
Paolo
Varied lorikeet
Psitteuteles versicolor

113
Lucy
Scaly-breasted lorikeet
Trichoglossus chlorolepidotus

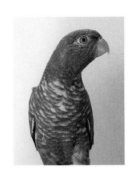

115
Finn
Mulga parrot
Psephotus varius

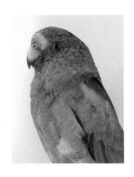

117
Ralph
Red-collared lorikeet
Trichoglossus rubritorquis

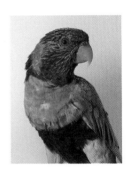

119
Oscar
Eclectus parrot
Eclectus roratus

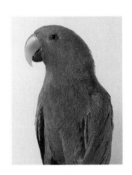

121
Twisty
Rainbow lorikeet
Trichoglossus moluccanus

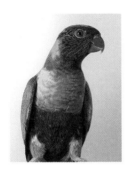

What I love about photographing parrots is noticing the differences between them. At first sight, Ralph, the red-collared lorikeet, and Twisty, the rainbow lorikeet, looked quite similar, but once I studied them closely I realized that not only were they wearing different colored trousers, but the assortment of their colored splotches was quite different as well.

Out of all the lorikeets, I would have to say that Paolo, the varied lorikeet, was prettiest. The contrasting colors of his white eye, red cap, and the fine, pale green brushstrokes on his feathers were stunning.

I also loved studying the markings on Lucy, the scaly-breasted lorikeet, particularly the little hint of red on her back. She was a dainty bird and had the typical parrot-like curiosity.

Finn's beautiful gray eyes really drew me in and the iridescent green hue of his feathers is so pretty. He was very shy, so I only took a few portraits of him, whereas Oscar, the eclectus parrot, couldn't have been more different. He flew onto my shoulder during the shoot and even tried to press a few buttons! Then he began opening his wings up for me, revealing the lovely colors underneath. It was like he was trying to sell me a watch that had fallen off the back of a truck.

Twisty, the rainbow lorikeet, was given her name because she has a twisted beak. Unbeknown to her WIRES (NSW Wildlife Information, Rescue, and Education Service) carer, Daphne Turner, she secretly found a partner, and is now the proud mother of a chick.

Prey

125
Tani
Australian masked owl
Tyto novaehollandiae

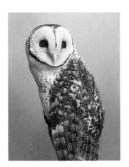

Working with wild birds is uncharted territory, as each bird has its own personality and history. You never really know if you will capture a portrait that is worthy of the subject you meet. Such was the case with Tani, who is eleven years old, 15 inches (38 centimeters) tall, and so amiable and gentle that I felt I could do a whole series just on her. I photographed her for a series of portraits on birds of prey, which I simply named *Prey*. These are carnivorous birds that are great hunters. They have very good eyesight, powerful feet, and strong curved beaks. There is something so graceful but powerful about them that made me want to learn more about this type of bird.

Tani was so sweet and her expressions so like ours, I felt like I was photographing a small human wrapped in a crocheted shawl. It was difficult to reduce my edits to one portrait, and for the first time, I included three different portraits of a bird in one exhibition.

These masked owls are found in coastal areas around Australia and southern New Guinea, and live in forests and coastal woodlands, as well as timbered waterways. The owls have various plumage colors—pale, intermediate, and dark—and they hunt prey such as possums, insects, reptiles, and small birds, which they locate by listening closely as they perch on a low branch. They have a seldom-heard harsh screeching call and are rarely seen due to their nocturnal habits.

127
Ash
Gray falcon
Falco hypoleucos

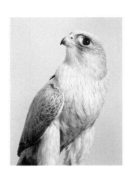

To meet Ash I had to fly all the way to Western Australia. Gray falcons are rare, and Ash is lucky to be alive. Two wildlife photographers with a passion for birds were driving along a dirt road in the remote Kimberley region and saw a flash of white to the side of the road. They stopped and stumbled upon this beautiful gray falcon staring back at them. His left wing was so disfigured that it had to be partially amputated (which can't be seen in my portrait).

Ash is now the only gray falcon in captivity in the world. He is lovingly cared for by Phil Pane from Eagles Heritage in the town of Margaret River, Western Australia.

The gray falcon is also known by the beautiful name "smoke hawk." It is not only rare, but classified as a truly nomadic species because it never nests in the same location twice, making it incredibly difficult to study. It covers large distances, and is seen, very occasionally, over arid and semi-arid Australia. The falcon is found mostly on its own but is occasionally seen in pairs or in small family groups. They hunt birds, mainly ground-feeding on birds such as parrots and pigeons, as well as large insects and mammals. They use the abandoned nests of other birds to lay a clutch of up to four eggs, which they incubate for five weeks. After the chicks are fully fledged, they remain dependent on their parents for several months.

The red goshawk is officially considered Australia's rarest bird of prey, but anecdotally, all the wildlife carers I've met think the gray falcon is just as rare, with estimations of a population of only a thousand left Australia-wide. Photographing Ash was incredibly easy, and as Phil pointed out to me, the fluffy feathers under his chin were puffed up—a sign of him being at ease. He was very chatty and spirited, but also keen to please.

129
Duke
Eastern grass owl
Tyto longimembris

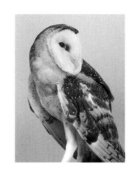

As the species name suggests, eastern grass owls are ground-dwelling owls that can be found in open grasslands, in coastal shrubland, around swamps, and on agricultural land. Duke lives at Eagles Heritage in Margaret River, Western Australia, and on meeting him it was obvious he was special.

I couldn't believe how long Duke's legs were. They were like two long Popsicle sticks holding up a beanbag—unbelievably cute. The eastern grass owl is often called the daddy longlegs owl, which says it all. Duke was a wonderfully calm bird and very easy to work with. I tried to capture his beautiful caramel, vanilla, and chocolate colors, the silver stars and chocolate sprinkles. He looked like medieval royalty wearing a magnificent spangled cloak.

As is common with most owl species, grass owls hunt at night and use their acute hearing to find their prey. Once located, the owl then goes into a vertical plunge headfirst, turning to catch its prey with its talons within the last few moments. The bird then rests on the ground to eat its catch. Grass owls nest under dense tussocks of grass in a scraped-out hollow that includes three approach tunnels.

131
Sooty
Lesser sooty owl
Tyto multipunctata

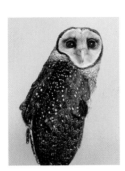

Someone must have told Sooty I was coming to take her portrait, because she had definitely enrolled in modeling school in preparation. She had obviously been doing some serious grooming, and when it came to the photo shoot, she was like an experienced professional. She would hold a pose while I took her portrait, and as soon as I did she would change her position, striking a new exquisite pose for the next shot. This went on and on, making me laugh because she was so easy to work with—I couldn't believe it.

Perhaps Sooty was a natural because she's so used to attention. She is a resident at Eagles Heritage in Margaret River, Western Australia, and an ambassador for native Australian owls. Carer Phil Pane uses Sooty for educational purposes, taking her to conservation functions and schools, so that others can experience her beauty in person. Appreciating that it's hard to be motivated to protect a species you've never met, Phil allows people to get up close to Sooty, and I've personally witnessed the delight she brings to people, young and old, and how that joyous experience translates to genuine care for wildlife.

Lesser sooty owls were once considered to be a subspecies of their close cousins the sooty owls, but some taxonomists now recognize them as a distinct species. They are considered by many to be the prettiest representative of the genus *Tyto* (owls that have the divided heart-shaped facial disk). They live in the tropical rain forests of northeast Queensland. Unable to build a true nest, they depend on tree crevices for roosting. They have the most amazing call, which has been described as resembling the sound of a falling bomb.

133
Darcy
Brown falcon
Falco berigora

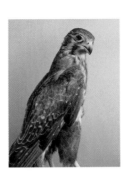

When I was a child I was enamored with animals and saw them as people. I thought of them as my friends and imagined they could talk to me. As an adult, I sometimes have an encounter during my portrait work that takes me back to those childhood memories. Meeting Darcy was one of those experiences.

Darcy is such a dramatic bird. I pictured him as a world-renowned thespian, a lover of Shakespeare. I was on the edge of my seat as the curtain was drawn, revealing Darcy onstage, spotlight shining on his tailcoat, cravat, and pocket watch. He delivered a monologue and dazzled the audience with his electrifying performance. The real world disappeared, and he had us in the palm of his . . . claws.

Brown falcons are a small- to medium-sized raptor with a characteristic tear stripe below the eye. They can be found throughout Australia, with variations in their plumage colors depending on where they are found. They like open grassland and agricultural areas with scattered trees, and can often be seen perched on top of a utility pole.

Brown falcons eat rabbits, reptiles, insects, or smaller birds, and they kill their prey with a bite to the spine. When nesting, these falcons usually use the abandoned nest of another bird, although they have been known to build their own too.

135
Pepper
Southern boobook
Ninox boobook

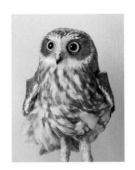

Paul Mander runs Broadwings, a raptor-training and rehabilitation center in Queensland. Rescued as a chick and hand-raised by a caring vet, Pepper, the little southern boobook, is now in Paul's care, and is simply the cutest owl in town.

The southern boobook is Australia's smallest and most common owl, and can be found in a variety of habitats, from dense forests to open country. Closely related species can be found in New Zealand, New Guinea, and Indonesia. The nocturnal bird feeds on insects and small mammals, which it either catches in flight or pounces on from its perch. The owl's common name is derived from the sound of its call, "boobook," which it hoots through the night.

We weren't sure how Pepper would handle being photographed, and at first she wasn't sure either. She kept flying off her perch, preferring to be on the ground. But after Paul reassured and comforted her, with the little bird nuzzling into his chest, the transformation in her was astounding. Her confidence grew so much that she stood up tall on her beautiful little legs, and it ended up being a wonderful portrait session.

Paul has tried to release Pepper three times, but she keeps coming back. We know she will eventually be brave enough to leave home.

List of Works

136
Soren
Wedge-tailed eagle
Aquila audax

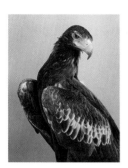

With a wingspan of just over 7 feet (2 meters), "wedgies" are Australia's largest bird of prey and are very commanding creatures. My initial meeting with Soren was an intimidating experience. During our first photo shoot, he got up to fly, and the gust of wind produced by his wingbeat almost bowled me over. As I spent time with him over the course of a year, I discovered that he's a gentle giant with a comical swagger and bounce when he walks.

Soren has a very important job, as he is used as part of a conservation program to deter other bird species from destroying property (the lovable sulphur-crested cockatoo is a common offender) and to kick a sugar addiction that has come about from nectarivores, such as lorikeets, raiding sugar packets left on balconies in hotels (the sugar is very hard for their little livers to process). Soren's job is to approach a flock with a camera attached to his back. He never harms them, but his presence alone is enough to deter them. Knowing such an intimidating predator is in town, the offending flock moves on.

Wedge-tailed eagles have been seriously persecuted through trapping, shooting, and poisoning for more than one hundred years. Farmers claim that wedge-tailed eagles steal their livestock, but studies show that only 3 percent of their diet is from livestock. They live primarily off carrion, which actually helps to prevent the spread of disease. Fortunately, the younger farming generation is starting to learn more about these birds and appreciate the important environmental role they play.

137
Dexter
White-bellied sea eagle
Haliaeetus leucogaster

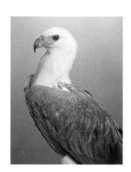

Dexter was a distinguished nine-year-old gentleman when I met him. He lives at Broadwings, on Australia's Gold Coast, and had been given to his carer, Paul Mander, by someone who found him to be of "strong character" and consequently "difficult to handle." Paul worked with him, and his deportment lessons paid off. Dexter was so impeccably groomed and his manners so faultless that I found it hard to believe he once had wild ways.

The most common habitat of white-bellied sea eagles is along coastlines, but they can also be found along large rivers farther inland in Australia and around freshwater swamps and lakes. The eagles are also found throughout Asia, reaching as far north as China and as far west as India. They breed and hunt only near water, feeding mainly on aquatic animals, such as fish, turtles, and sea snakes, which they catch within their talons after a shallow dive.

Little is known about their complete breeding cycle, from building their impressive giant nests to fledging their young, but BirdLife Australia is working to solve these mysteries. Since 2009, BirdLife Australia volunteers have run Sea-EagleCAM, a live video stream and diary. It's the best kind of reality TV, as anyone can click on the remote feed to see what the eagles are doing. The stars are a pair of Parramatta River sea eagles who can be followed through the highs and lows of life in the wetlands near Sydney Olympic Park. The couple has raised young for many years, although last year they failed to breed, which caused much concern. In 2015, they laid two eggs. One little chick emerged, but the other failed to hatch. On top of that, they've also had to contend with wild weather conditions. Watching the high-stakes drama unfold can be mesmerizing.

139
Cleo
Peregrine falcon
Falco peregrinus

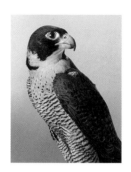

If ever there was a raptor supermodel, a peregrine falcon would be it. Cleo captivated me on our first meeting. Her long, sleek, muscular body and intricately patterned feathers, topped off by her air of refinement, made me feel like an ugly duckling in her presence. But Cleo is so much more than just a beauty. She could represent Australia at the Olympics, as peregrine falcons are the fastest animal on Earth. When hunting they perform what is called a "stoop"—a free-fall dive from great heights that has been tracked as reaching just over 240 miles (390 kilometers) per hour.

The peregrine falcon's story is all the more remarkable considering that not long ago they were almost extinct in some places. When extensive pesticide use (particularly DDT) in North America made its way into the food chain, falcon populations dived, and the species became critically endangered in the 1970s. Being a top predator, these birds absorbed so much of the pesticide that their eggshells thinned and the young died before they could hatch.

Scientists lobbied the government, and DDT was finally banned in North America in 1972, but it took until 1987 to ban it in Australia. DDT takes years to disappear completely from the environment, so an enormous conservation effort was mounted to ensure falcon eggs hatched successfully. One method involved scaling high cliffs where the birds nested, taking the eggs from the nest, and replacing them with warming ceramic eggs to keep the parents happy. The real egg was then hatched in an incubator brooder so that no weight was placed on the thinning shell. With the use of hand puppets and vocal mimicry, the chicks were fed and then returned to the nest for the parents to raise. Thanks to these elaborate conservation efforts, the peregrine falcon is now off the endangered list in the United States, and we can still admire supermodels like Cleo in the wild.

141
Jeda
Greater sooty owl
Tyto tenebricosa

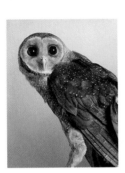

Jeda is one of the residents at Broadwings on Queensland's Gold Coast. She came in with an eye injury and has been deemed nonreleasable, so she is now in permanent care. For a nocturnal creature, Jeda surprised me by being a bundle of energy. Generally speaking, owls tend not to move around much, but Jeda was very active, always on the prowl and facing different directions. She was very alert, and listened to me talking to her as I took her portrait.

Sooty owls have a wide range of calls. One that took me by surprise was so pretty—a soft chirping trill. Although listed as vulnerable or threatened in some states of Australia, sooty owls are found in small populations throughout southern Queensland, coastal New South Wales, and down to Victoria, living in temperate rain forests and eucalyptus forests. They can live for many decades, and mate for the life of a partner.

The owls often hunt in drier areas and prey on other birds and land mammals of up to a surprisingly large size. The female stays in her nesting site for several weeks before she lays her clutch of up to two eggs; commonly only one chick survives. The male brings her food, as she rarely leaves the nest, and the chicks are completely dependent on their parents for an extended period after fledging and can fly at three months old.

143
Fenrick
Black kite
Milvus migrans

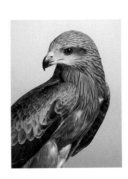

Meeting a black kite up close is quite extraordinary—they are beautiful birds. Fenrick is nine years old, so his feathers are fully matured and at their most striking. The thin, dramatic black feathers were woven into his coat like a tapestry, creating an effect so delicate that he looked like an illustration. I observed the lovely dark brown feathers around his eyes, which resembled a pair of sunglasses he never loses. This luscious eye band is a result of evolution, an adaptation to stop the sun reflecting into his eyes when he is gliding on thermals as he searches for food. You might have seen American football players with black paint under their eyes—black kites thought of it first.

While the black kite appears to be black when viewed from a distance, it is in fact various shades of brown. The birds are opportunistic hunters that often scavenge and eat carrion. It is also common for the birds to gather around bushfires, waiting to pounce on fleeing animals. Usually, the birds hunt alone or in small family groups. However, they are also known to form huge flocks of many thousands of birds, quite unlike any other Australian bird of prey.

Black kites are one of the most numerous raptors in the world and can be found across Australia, and in Asia, Africa, and Europe. The bird lives in almost any habitat, from open plains to timbered watercourses. The bird has a ritualized courtship aerial display, which both sexes take part in.

145
Mulga
Black-breasted buzzard
Hamirostra melanosternon

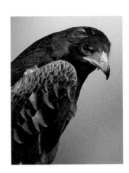

Mulga was very shy when we first met. He was crouched low, looking over his shoulder, surveying the surroundings, and totally ignoring me. It was a time of observation, with his carer, Paul Mander, curious to see if he would relax and connect with me so I could take his portrait.

With time, however, Mulga became familiar with the strange photographic gear, his composure shifting from uncertain and distracted to suddenly very focused—on me. It's an exhilarating feeling when a bird makes this transition and we begin to communicate silently as we study each other. The intelligence of this bird was profound, and I wished I could read his thoughts—or perhaps not, as I wonder if he was thinking about how tasty I might be.

Mulga is eight years old and has found ways to solve complicated problems in order to survive—for instance, how to break open an emu egg when the shell is so strong it can't be pierced with his beak. His solution is to find suitable rocks to hurl onto the egg until it cracks open and he can treat himself to the yolk inside. So many animals use tools—humans really need to come up with a new way to feel special.

Buzzards are found mainly in the north and semi-arid or arid regions of Australia, and are rarely seen in coastal areas. They are partially migratory in northern Australia and more sedentary in the southeast. These raptors glide low in search of prey, which most commonly consists of rabbits, ground birds and their eggs, lizards, and dead animals—particularly roadkill. Identifying a buzzard is a little easier than with other birds of prey because in flight they reveal bright white feathers under their wings, which are known as "windows."

146
Trinity (young)
Brown goshawk
Accipiter fasciatus

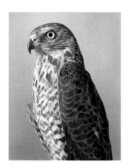

147
Trinity (mature)
Brown goshawk
Accipiter fasciatus

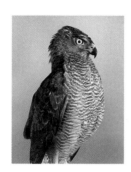

149
Yule
Barking owl
Ninox connivens

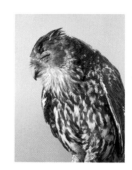

When I first met Trinity she was not quite twelve months old. She came into care with Paul Mander from Broadwings in Queensland after losing her home. When the Australian government allows developers to clear bushland for housing, a spotter catcher attempts to catch and remove animals before the bush is cleared. Trinity was just a little chick in a nest with her brother when her habitat was cleared for development, and she was not spotted. The goshawk chicks' nest fell, and she and her brother sustained injuries but were fortunately found. Her brother had a broken leg that became infected, and sadly, he was put down, as he was too sick to survive. Trinity recovered, and after learning of her difficult start in life I felt enormous respect for this tough little lady.

The first time I photographed Trinity she was wearing little love-heart patterns on her chest, but a year later they had changed into stripes. I couldn't believe how much feather patterns could change, and realized that this is why it can be so hard to identify birds of prey. Every time I met Trinity she was a confident bird and comfortable in front of the camera, and I enjoyed getting to know her and watching her grow over the course of a year.

Brown goshawks like to build their nest on the tallest tree available, and line it with fresh eucalyptus leaves—they must be such lovely smelling homes! Couples will stay in the same area and often reuse the same nest year after year. The offspring eventually leave the nest and disperse widely, sometimes traveling more than 550 miles (900 kilometers) to establish their own breeding territory.

Yule, the barking owl, glided into the room with his characteristic "woof, woof." He was particularly chatty, and the conversation flowed freely, mainly with him talking and me laughing. As well as their barks, these owls have a famous call that apparently sounds like a human scream—perhaps not the most relaxing sound to stumble across at night in the bush. All the excitement wore Yule out, and as I was taking his portrait he started to get sleepy. Being nocturnal, it really was his bedtime, but I liked the fact he was so relaxed in my company.

Barking owls, which belong to a group known as hawk owls, are found across Australia, but they are unable to survive in arid, treeless, or heavily forested regions, instead preferring open woodlands. They only nest in an open hollow in a tree trunk, which they make comfortable by lining it loosely with sticks and wood debris. The owls are known for their silent flight, and hunt either from the air or from an exposed perch, using their keen eyesight to spot prey at dawn or dusk, although they are occasionally spotted hunting during the day.

Unfortunately, in some parts of Australia their numbers are rapidly dwindling due to habitat loss, as well as competition for roosting sites from introduced species such as honeybees. They also compete with foxes and cats for food. I have been reading about some of the recovery plans currently in place, and I desperately hope they work so that we can continue to hear these owls' wonderful barking call.

Wounded Warriors

153
Forrest
Great horned owl
Bubo virginianus

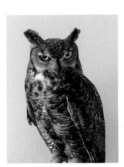

154
Kira
American kestrel
Falco sparverius

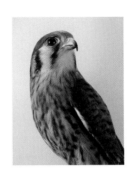

155
Bob
American kestrel
Falco sparverius

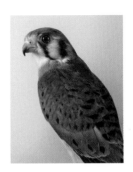

Wounded Warriors seemed an appropriate title for my series of portraits of birds in care at the Ojai Raptor Center in California. Not all the birds' injuries are physical, though; some are psychological, as a result of losing their homes or becoming separated from their parents at too young an age.

I did not have high expectations for a strong portrait of Forrest, the great horned owl, as I was warned she is a very strong-willed little lady. I couldn't have been more wrong. Like a professional actor, she stayed exactly on her mark and, with a raised brow, followed my eyes closely. I found it very hard not to laugh—to me she looked like a superheroine from a cartoon.

With its horn-shaped ear tufts, it's easy to see how the great horned owl came to get its name. The poster child of the owl world, it is widely recognized both for its appearance and what we think of as the typical owl hoot: "Hooo, hoo-hoo, hooo, hooo." It is found in the Americas, and is an adaptable bird that can find its home in any habitat, from the Arctic region down to South America. Like other owls, they are able to turn their head 270 degrees and use their great eyesight and acute hearing to locate their prey. They are large, powerful birds, which means their prey ranges from mammals and birds that are bigger than them in size to smaller prey such as scorpions and frogs. The species is nocturnal, and hunts at night, but is also crepuscular, hunting at dawn or dusk, especially in winter. Great horned owls nest in the hollow of a tree or in the abandoned nests of other birds. They form monogamous pairs in which both birds incubate the eggs, and the male also supplies the food. Despite this companionship, outside of breeding season it is common for the pair to roost separately.

Kira and Bob's story is a common one. They are thought to have been found as chicks by members of the public. Rather than being handed over to an experienced rehabilitator, they were hand-raised, then released. It's often well intentioned, but such birds are raised without the skills to survive in the wild and become "imprints." This is a social disorder (which is very preventable) where a bird no longer recognizes its own species and loses the ability to hunt.

Kira and Bob were found underweight and in trouble, but were fortunately taken to the Ojai Raptor Center in California. They have now bonded for life, and although they cannot be freed, they are champion surrogate parents. They have raised more than thirty young kestrels who remain wild.

American kestrels are solitary for most of the year, but form monogamous pairs in their breeding season and, like other kestrels, use the nests of other birds or holes in trees for their nests. They lay up to seven eggs, which they incubate for about a month, and then the chicks are fledged after another month and are ready to breed at one year old. These birds have a life expectancy of ten years.

What I loved about meeting these American kestrels was observing the differences from Australian kestrels, the most noticeable difference being the wonderful slate-blue wing on Bob and the splash of the same color on both their heads. It's like a painter has applied a beautiful brushstroke to give them their unique markings.

The American kestrel is widespread across the Americas, and while it can flourish in many different habitats, from tropical lowlands to deserts, they are most abundant in open country. The kestrel is the smallest falcon and has a quick, buoyant flight. Due to its size, this predator also finds itself the prey of other, larger birds and even some snakes. This bird prefers to hunt from a tall perch, using its acute eyesight to spot its prey. However, it is also known to catch prey in flight and hover above the ground to locate its meal. Their diet mainly consists of larger insects and rodents and, depending on their habitat, lizards. These birds of prey are known to either consume their catch straightaway, or take it back to their perch to eat or even store away for a later time when food is sparse.

List of Works

157
Drifter No. 1
Broad-winged hawk
Buteo platypterus

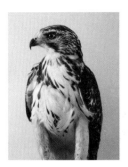

Drifter is a migratory broad-winged hawk who was found on the streets of Santa Barbara, California, with a coracoid fracture. These hawks are found across North America, but due to their long-distance migration, they are seen as far south as Central and South America in winter months. They form large flocks of thousands of birds, also known as kettles. As they tend to cover many miles, they conserve their energy by flying in thermal or mountain updrafts. Wherever they finish their migration, the hawks find forested or wooded areas to stay in. It was Drifter's first migration, and although he didn't make it to his intended destination, he was very fortunate to be taken to the Ojai Raptor Center, where he has received the best care.

159
Drifter No. 2
Broad-winged hawk
Buteo platypterus

Drifter had also broken his tail feathers, and unlike songbirds, which have an auto-release mechanism for dropping and regrowing tail feathers fast (an evolutionary trait that helps them escape birds of prey), birds like Drifter cannot quickly regrow tail feathers and therefore lose their steering mechanism used for flight. Kim Stroud, the center manager, used a falconry technique, called imping, that goes back thousands of years to replace his missing feathers. The center keeps a bank of feathers from deceased birds, and using thin but strong cactus thorns and Cooper's hawk tail feathers (the closest match she could find to a broad-winged hawk's tail feathers), she put substitute feathers in for Drifter until his proper feathers grew back. It is a technique she has employed on many rescued birds, enabling them to have a second chance in the wild.

This feather pattern will change greatly as Drifter grows, but I was so pleased to meet him in his current outfit. His soft, billowy feathers reminded me of a ruffled pirate shirt, and he was such a composed bird that he seemed so much older than his young age. He was a pleasure to work with.

161
Shytan
Golden eagle
Aquila chrysaetos

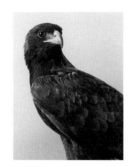

Shytan gave off an air of supreme confidence. His colors were beautiful, especially the gold on the back of his head, which shimmered in the light. He is twenty-four years old, and is in permanent care at the Ojai Raptor Center in California due to a wing injury from flying into a power line. He is an eagle ambassador and education bird for the center.

The magnificent golden eagle is found across the Northern Hemisphere in open, particularly mountainous areas. They are often seen gliding or soaring alone or in pairs with their wings held in a shallow V shape as they search for prey below. While their ability to move quickly and deftly ensures they are skilled at catching ground-dwelling prey such as rabbits, foxes, and rodents, they are also known to eat carrion, and are occasionally seen following other scavengers to a meal.

I was told that Shytan is a very dangerous bird and it would take an experienced handler wearing double gloves to manage him. Raptors initiate a kill with their feet, and if you are grabbed by a raptor's foot, moving will make the bird grip harder. Resistance is futile! Knowing this, I felt a mix of awe and fear. But mostly awe.

In the breeding season, golden eagles begin their lifelong relationships with an aerial courtship display where both birds perform plunging and looping flights. They are also known to take part in aerial play, where they drop objects from a height and race to retrieve them. Together, the pair builds a huge nest or eyrie—usually 5–6 feet (1–2 meters) wide—on cliff edges or in tall trees. This nest is used year after year and, if it stands the test of time, by successive generations as well.

163
Ava
Western barn owl chick
Tyto alba

164
Riley No. 1
Eastern screech owl
Megascops asio

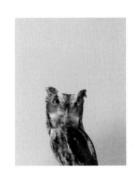

165
Riley No. 2
Eastern screech owl
Megascops asio

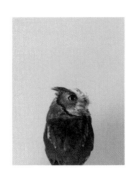

Photographing this little owl was a wonderful surprise. It wasn't part of the plan for the day, but she and her brother were handed into the Ojai Raptor Center while I was there. Kim Stroud, the manager, placed her in front of my camera, and I quickly took a couple of portraits before she was whisked away for assessment.

Both chicks had fallen out of their nest in high winds. Due to deforestation and a resulting lack of suitable nest hollows, the owls in California are trying to nest in the introduced palm trees, which look pretty to humans, but make poor nest sites because there are no deep hollows to protect the birds from the weather. The chicks fell 70 feet (21 meters), but fortunately they sustained only minor injuries. Now they will be placed with a resident barn owl couple who, due to injury, can't be released. What is wonderful is that the parents are given the opportunity to raise young as surrogates. The female keeps laying unfertile eggs, and the center swaps those eggs for orphaned chicks, which are then raised by both adults. Once the chicks are ready to fledge, they are released back into the wild.

The ghostly barn owl is one of the world's most widely dispersed birds, being found on all continents except Antarctica. The bird prefers to inhabit open country or lightly wooded forests, and hunts prey such as small rodents, frogs, and smaller birds. Using its exceptional, acute hearing, the bird locates its prey while soaring silently and slowly aboveground or while sitting on a high perch. With the ability to rotate its head almost completely, the owl can determine the exact position of prey without disturbing it. During their breeding seasons, which can take place more than once a year, the female lays up to six eggs at intervals. The laying process can take several days, and during this time the male brings her food.

When I look at this bird up close, I'm amazed at how beautiful she is, as well as strange and prehistoric looking. To me, I can see the evolutionary line showing there is still a bit of dinosaur in her.

Looking at Riley, the rusty-colored eastern screech owl, for the first time, I could see the most gorgeous small owl with little pointed ear tufts, but trying to focus on individual parts of him was like looking into a fog, because he has the most confusing feather pattern. There are bands and spots and mottled marks, and feathers that go straight while others ripple. It made it difficult for me to find my focal point, as it was hard to know when he was in and out of focus. I had to be guided by his beautiful eyes, which were his one clearly defined feature. He was wonderful to work with and gave me many different poses.

The eastern screech owl can be found most commonly on the eastern side of the United States, anywhere between Canada and Mexico. They prefer wooded habitats, although they don't seem to be bothered by the type of tree. True to their name, they are most easily recognized by their characteristic whinnying or trilling call, which is described as a haunting screech. They are also known, however, to make other noises, such as rasps, hoots, and barks. Similar to most owls, the eastern screech owl is most active at night, which is why they are usually heard, not seen.

Eastern screech owls are hunters and have been called feathered wildcats! They prey on insects, amphibians, and reptiles, as well as small birds and rodents. During the breeding season they prepare a nest in the hollow of a tree or a stump, which the male finds and "advertises" to females during courtship. They lay a clutch of up to four eggs, and the young remain within the care of their parents for up to ten weeks after they hatch.

Riley was struck by a car in Kentucky, and unfortunately sustained a permanent injury to his right eye. He's a bit deaf too, but he's accustomed to people now and spends his time as an education ambassador for the Ojai Raptor Center in California.

List of Works

167
Handsome
Turkey vulture
Cathartes aura

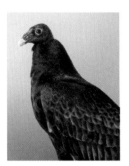

169
Wonder
Turkey vulture
Cathartes aura

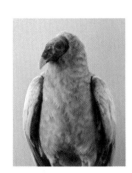

171
Pixie
Northern pygmy owl
Glaucidium gnoma

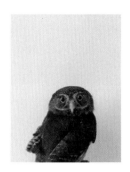

It's always a thrill when I meet a new species, because I uncover such treasures. Both Handsome and Wonder (see right) were incredibly inquisitive and observant. I've often unscientifically felt that the intensity of eye contact with a subject may reflect a higher level of intelligence, and both these birds—more than any I photographed for this series—stared straight into my eyes and held their gaze. They were at all times astute observers of everything that was going on, and I imagined they would most certainly beat me at a game of chess. I am partly correct, as turkey vultures have been shown to be total brainiacs.

Handsome was quite intimidating. He came in to the Ojai Raptor Center as a young chick, and his assertive nature meant he quickly earned a reputation for himself among the carers. I felt like I needed to keep a close eye on him at all times, as the power that comes from his confidence is awe-inspiring. Handsome's presence is magnetic.

Vultures are the ultimate environmentalists. They eat carrion, living off what is normally discarded. A highly developed sense of smell enables them to easily locate a carcass and ensures that they arrive at their meal first, before other, larger birds come and drive them away. They rarely kill for food—although they do eat insects—but if need be, the bird will take down an injured or dying animal. By cleaning up the dead, they also prevent the spread of disease, playing a pivotal role in the health of an environment. We need vultures.

There are so many things I love about them. You can probably guess why they have bald heads, given where they have to stick them. While they clean themselves a lot, they can't clean their heads—hence, a bald head is very sanitary. They can't sing; they grunt. Just looking at them makes me laugh.

Wonder is a very rare albino turkey vulture who doesn't have the best eyesight and is afraid of his own shadow. He was found facedown in the snow in Michigan during his first migration and is now in permanent care at the Ojai Raptor Center. There is a gentleness to him that makes me melt.

The turkey vulture often starts its day perching with its wings outstretched in the morning sun. It is believed that they are drying their wings for flight. This graceful flier has an extremely broad range of habitats and is found throughout the Americas, in coastal deserts, rain forests, grasslands, and savannas. During the breeding season, these birds don't provide nesting material, but lay their two eggs straight onto the ground or into a shallow cave or hollow tree stump. The eggs are sat on for well over a month, and the chicks are then brooded for a further seventy days.

I have a preconceived idea of what a bird's size should be when I go to photograph it, as usually I will have met many similar species. So when I traveled to the United States to photograph native owls, I couldn't quite comprehend that an owl could be so small! Pixie, the northern pygmy owl, is a mere 5 inches (13 centimeters) tall and has a cuteness that is immeasurable. She was just as sweet as she looks, and photographing her was such a special experience, being that she's the smallest owl I have ever met.

Northern pygmy owls have what appear to be false eyes on the back of their head, in their feather pattern. One theory for this evolutionary trait is that not only does it confuse the predator, but if they are attacked their false eyes can take the brunt of it, keeping their real eyes safe and alert and looking for ways to escape.

Although it may be one of the smallest owl species, the northern pygmy owl is known for being a fierce and bold hunter, often taking down birds and mammals far larger than itself. However, they most commonly hunt small songbirds and insects. As a defensive measure, songbirds sometimes gather in mobs to harass the pygmy owl by screeching loudly. When pygmy owls have a surplus of food, they cache it in tree cavities, as they need to feed often.

Pygmy owls are unlike other owls in many ways, particularly because they hunt during the day. This means they do not have asymmetrically placed ears and have not developed the great hearing, silent flight, and exceptional night vision that is characteristic of their cousins. They are found in wooded forests where they wait quietly and patiently to surprise their prey.

The pygmies form monogamous pairs and lay their eggs in the bottom of tree crevices created by another bird or from natural decay.

175
Chicken
Australasian gannet
Morus serrator

I am astounded by seabirds because of the great distances they fly. Their migration routes are mind-boggling, with many species circumnavigating the world each year, and distances recorded as high as 55,000 miles (90,000 kilometers). Not only do they have huge distances to travel, but these birds have to compete with us for their fish dinner and contend with marine pollution we have created.

Chicken is an Australasian gannet that was migrating from New Zealand to Australia and got caught up in a storm, ending up on the Sunshine Coast, Queensland. It's a beautiful place to be lost, and fortunately for Chicken, he was taken in by twin sisters Paula and Bridgette Powers, who run Twinnies Pelican and Seabird Rescue there.

You never really know how a bird will behave in front of the camera, so it is a thrill when a bird like Chicken comes along. He was so at ease that he spent most of the time preening, and I had to work hard to win his attention so that he would look up at me every now and then. Toward the end of the shoot, he even started showing off by lifting up his foot and balancing. It was pretty gorgeous. His weight is now back to normal and his muscle strength has built up, and come migration time the Twinnies will release him so that he can return to the seas.

The conspicuous Australasian gannet is a seabird with a wingspan of about 6 feet (2 meters) and is found in coastal areas in both Australia and New Zealand. These birds are occasionally seen in small flocks, soaring above the ocean, but more commonly in their breeding colonies, where they gather in large numbers. In the breeding season, the male gannets return to the colonies first, to prepare and defend their nesting site. The females can only lay one egg in each breeding season, but if their first attempt is unsuccessful, they will try again. Their young do not reach breeding maturity until they are at least six or seven years old. To feed, the clever hunters herd fish into dense shoals by flying about 30 feet (9 meters) above the surface of the water. They then fold their wings back and do a spectacular dive into the water. They can stay underwater for about ten seconds, but the fish is usually swallowed before the bird resurfaces.

When I met Chicken I fell head over heels in love with him, and now this portrait of him will form the beginning of a new series on seabirds. This is usually what happens when I decide to start a new series. A bird floors me, and I become completely engrossed in its story, wanting to know more about it and other birds of its type. Now that I've met Chicken and heard his story, I want to seek out more seabirds and discover their evolutionary uniqueness and the different characters that exist among them. For me, it begins all over again.

Organizations

Many of the birds featured in this book were photographed at the rehabilitation, breeding, and rescue centers listed below. They are all located in Australia, apart from the Ojai Raptor Center in California, where I had the pleasure of photographing American birds of prey. I've also mentioned some other important Australian organizations that are working hard to monitor and protect Australian bird species.

Adelaide Zoo
SA, Australia
adelaidezoo.com.au
This is where I photographed beautiful Seisa, the palm cockatoo (she hatched there on October 5, 2010). Australia's second-oldest zoo, it's the country's only major metropolitan zoo to be owned and operated on a nonprofit basis.

BirdLife Australia
birdlife.org.au
Australia's largest nonprofit bird conservation organization, BirdLife Australia protects native birds and their habitats. They run research, education, and conservation programs Australia-wide. Just a few of their many projects include Birds in Backyards, which addresses and aims to reverse the decline of wild bird species in environments populated by people, and the Atlas of Australian birds, where many thousands of "atlassers" collect data on birds to help the organization map bird activity and monitor change. Check out the organization's extensive website, which also includes an encyclopedic Find a Bird database where you can look up comprehensive information on many Australian birds. Bird lovers can support the organization by becoming a member for around $1.50 per week, volunteering for one of its amazing projects, or making a donation.

Birdwork
NSW, Australia
birdwork.com.au
Josh Cook is a volunteer wildlife carer who also runs a business called Birdwork. Aware of how people crave contact with birds, but struggle with the idea of caging or clipping their wings, Josh teaches owners a different way of keeping birds, called free flight, which is a bit like training them to become like homing pigeons. The birds are allowed to fly around their neighborhood and get their exercise. I've accompanied Josh on walks along the beach, and it's the most glorious thing to see his blue and gold macaws, Mango and Crush, soar on ahead, often flying to beaches several miles away.

BRASEA
Australia
budgerigarrare.com
Warren Wilson introduced me to the world of people who love and are obsessed with budgerigars. He is the president of BRASEA (Budgerigar Rare and Specialist Exhibitors of Australasia), and the knowledge held within this organization gives you a real insight into this humble little bird. They welcome new members.

Broadwings
QLD, Australia
For my *Prey* series, I spent a couple of years visiting master falconer and licensed raptor trainer Paul Mander in Queensland. Paul rescues, rehabilitates, and releases birds of prey. He also makes his living using his falconry techniques to train birds of prey in a no-kill conservation-management program to help deal with overabundant species.

Christmas Island Seabird Project
Christmas Island, Indian Ocean, Australia
seabirdproject.cx
Dr. Janos Hennicke works hard running this important study that aims to protect endangered seabird species endemic to Christmas Island, including the Abbott's booby and the Christmas Island frigatebird. Financial assistance is desperately needed, and all funds go directly and entirely toward the project.

Eagles Heritage
WA, Australia
eaglesheritage.com.au
Phil Pane runs Eagles Heritage and is such a gentle, lovely man. He started off rescuing and releasing birds of prey, eventually opening his facility to the public. These places need visitors because the entry fee pays for the food and the vets who look after these beautiful birds.

Featherdale Wildlife Park
NSW, Australia
featherdale.com.au
This is where I met Commander and Mrs. Skyring, the gang-gang cockatoos. If you want to get up close to these animals, this is a great park to visit. You can learn so much about Australian wildlife here.

Finch Society of Australia
Australia
finchsociety.org
The Finch Society of Australia brings together those with a keen interest in finches. They enthusiastically share their knowledge to ensure that the birds are given a good quality of life. The very experienced members also breed vulnerable species of finches in case their numbers decrease in the wild. They have branches throughout New South Wales, but welcome members from across the country.

Foundation for National Parks & Wildlife

Australia

fnpw.org.au

Among its many other projects, the Foundation for National Parks and Wildlife acquires high conservation land for national parks and nature reserves. Since 1970 it has added more than 1.2 million acres (half a million hectares) to Australia's publicly accessible and permanently protected areas. It also delivers high-quality environmental education to transform suburban backyards into healthy habitats and to inspire the next generation of conservationists. It provides greatly needed grants to scientists, individuals, and groups across the country, and relies on donations to continue its amazing work.

Friends of the Orange-Bellied Parrot (Wildcare Inc.)

Australia

wildcaretas.org.au/branches/friends-of-the-obp

A bird couldn't ask for a kinder bunch of friends. They care so much about saving this species, and are often in the field observing, planting, and trying to raise funds so they can do more.

John Morony Correctional Complex

NSW, Australia

Another impressive facility is the Wildlife Care Center at the John Morony Correctional Complex in Berkshire Park, New South Wales, which looks after injured animals prior to their release, as well as those in permanent care. This is a correctional facility for female offenders, who, as part of their rehabilitation, are given the opportunity to work with animals at the massive center on prison grounds. I have visited this center—the largest of its kind in New South Wales—several times now to take photographs of the animals, and am very impressed at the extraordinary setup. There are wallabies, emus, kangaroos, possums, bats, snakes, lizards, and, of course, a wide variety of birds, including birds of prey. In meeting some of the female offenders, I saw firsthand how the animals bonded with them. This helps give the women a purpose during their incarceration, while the animals are cared for and given a chance to recover.

Moonlit Sanctuary

VIC, Australia

moonlitsanctuary.com.au

There are often moments when I stop and realize how important sanctuaries are for connecting people with wildlife, and Moonlit is one of those places. I walked the sanctuary's immaculate 25 acres (10 hectares) of bushland near Mornington Peninsula, Victoria, where wallabies and kangaroos amble past the public. Sitting quietly in the morning sun was a keeper bottle-feeding a young joey kangaroo; inside, where I was to work, a quoll was happily chewing away on a treat and a turtle was sleeping. The sanctuary is one of the few places where you can see an orange-bellied parrot, and it holds lantern-lit tours at nighttime, when the nocturnal animals wake and the bush comes alive.

Ojai Raptor Center

CA, USA

ojairaptorcenter.org

The Ojai Raptor Center in California cares for an astonishing number of birds, approximately one thousand per year. They are dedicated to professionally rescuing, rehabilitating, and releasing native North American wildlife, as well as educating the public about the plight of wildlife. The center is in the progressive town of Ojai, in California, and relies on donations from the public. The center is open to the public twice a year and is well worth a visit.

Sydney Wildlife

NSW, Australia

sydneywildlife.org.au

As its name suggests, Sydney Wildlife focuses on rescuing wildlife in the Greater Sydney Metropolitan Region. It's an organization that is completely run by volunteers.

Twinnies Pelican and Seabird Rescue

QLD, Australia

twinnies.com.au

Identical twins Paula and Bridgette Powers, known as the "Twinnies," see injured and sick birds at their rescue center on the Sunshine Coast every day. I was struck by their gentle natures and their unique "twin" way of talking, where one chimes in to finish the other's sentence. They want people to stop leaving fishing lines lying around, which entangle birds, and also to get serious about plastic waste left at the beach and street litter that enters the oceans via storm drains during rainy periods—seabirds mistake it for prey and eat it. I have seen firsthand what happens when seabirds ingest discarded plastic, and once you see this, you'll never look at a plastic bag, plastic straw, plastic beach toy, or plastic lid the same way. The Twinnies do important work and rely on donations to keep their center operating.

WIRES

NSW, Australia

wires.org.au

So many of the birds I've met have been in the homes of wonderful WIRES (NSW Wildlife Information, Rescue, and Education Service) volunteers. There are different branches in my home state of New South Wales. People call WIRES if they find injured wildlife, and carers rescue the animal and rehabilitate it, where possible, before releasing it. You can volunteer (they offer training courses), which is wonderfully rewarding, or make a donation.

The following organizations also do important work conserving, rehabilitating, and researching bird life. Visit their websites to learn more about what you can do to support bird species in your country.

International

International Wildlife Rehabilitation Council
theiwrc.org

The Nature Conservancy
nature.org/ourinitiatives/urgentissues/migratorybirds

World Wildlife Fund (WWF)
worldwildlife.org

British Isles

British Trust for Ornithology
bto.org

Manx BirdLife
manxbirdlife.im

Manx Wildlife Trust
manxwt.org.uk

The Royal Society for the Protection of Birds (RSPB)
rspb.org.uk

The Wildfowl and Wetlands Trust (WWT) Wetland Centers
wwt.org.uk

The Wildlife Trusts
wildlifetrusts.org

USA

American Bird Conservancy
abcbirds.org

California Foundation for Birds of Prey
rescue-birds-of-prey.org/raptor-rehabilitation

Cascades Raptor Center
eraptors.org

National Audubon Society
audubon.org

Partners in Flight—US
partnersinflight.org

Raptor Research Foundation
raptorresearchfoundation.org

Acknowledgments

This book began long before its publication, and the ten years it has taken to complete it makes it impossible to thank everyone who has helped by encouraging me, seeing my exhibitions, and acquiring my work, but please know I am very grateful to all of you.

My heartfelt thanks go to the following:

Ruth Hobday and Geoff Blackwell from PQ Blackwell, who wholeheartedly put their trust in me to make this book, and thank you also to Rachel Clare, Abby Aitcheson, and Ellie Kyrke-Smith, for your eagle eyes and peregrine speed.

Bianca Chang, for her creative vision in designing this book and for her endless encouragement. Jacob Ring, for his postproduction work and unrivaled professionalism. Thank you both for your terrific support.

Sarah Engledow, for writing such beautiful words that make me laugh and feel teary at the same time.

Kirsty Bruce, for her friendship and the unwavering professional advice that she has given me through the years.

The photographers I have met over the years, especially Simon Davidson, Cameron Bloom, Steven Chee, Duncan Killick, Jason Hamilton, Brent Pottinger, Ben Saunders, Anita Beaney, Nicole Rowntree, Tara Johns, Brock McFadzean, Bo Wong, Wayne Fogden, Darren Clements, and James Moffat, who have all been instrumental in helping me.

Andrea Black and Tiffany Bakker, for their ideas and for being my sounding board. Melanie Williams and Ben McMillen, for loaning me their car and providing meals and a bed for my trips to Perth. Todd Sheldrick, for starting the whole book concept with me.

My galleries and the staff that have supported me, particularly Tim, Rex, Anna, Katrina, and Brett from Olsen Irwin gallery in Sydney; Rebecca, Nicole, and Rosie at Purdy Hicks Gallery in London; and Mandy at the Cat Street Gallery in Hong Kong. Thanks also to Bruce Ashley and to Angie Dawson and Kerry Ratcliffe from Koru, and to Jonathan, Ben, and Chris at Jonathan Adler.

Of course, there are the unsung people who dedicate their time to saving wildlife, and the scientists, ornithologists, biologists, and bird lovers who have helped me. Special thanks go to Tim Low, Mark Holdsworth, Janos Hennicke, Kimberly Stroud, Josh Cook, Daphne Turner, Angela Robertson-Buchanan, Lisa Tuthill and Michael Johnson, Paul and Robyn Mander, Phil Pane, the Twinnies and their mother, Helen, Warren Wilson, Sam Davis, Simon Degenhard, Paul Henry, Anthony Catt, Christopher Brett, Michael Baker, Joe Gaffa, Fiona Oosthoek, and Mark Wilson.

Finally, James Roden, my sometimes neglected husband, whose humor, help, and love enabled me to finish this book (but who can be a very back-chatty photographic assistant). My son, Vincent, who thinks that I'm always right and who takes the time to pat every animal he passes on the way to the park. My mother, Mona, for her enduring love, enthusiasm, and support, and for never saying no to a last-minute babysitting request. Ros Roden (James's mum), for always starting a sentence with "Now how can I help you?" My brother, Bruce, and his family—Cath, Ayesha, and Rahni—for having me over every week to talk about how things are going and for being the most inspiring people I know.

Me and my brother, Bruce, on Penguin Island, Western Australia, 1980.
Image by Richard Jeffreys

Overleaf: Cap Rock, Joshua Tree National Park, CA, USA.
Image by Simon Davidson

For Abrams:
Editor: Laura Dozier
Production Manager: Kathleen Gaffney

For PQ Blackwell:
Publisher: Geoff Blackwell
Editor in chief: Ruth Hobday
Editor: Rachel Clare
Additional editorial: Abby Aitcheson, Ellie Kyrke-Smith
Book design: Bianca Chang

Library of Congress Control Number: 2015932699
ISBN 978-1-4197-1845-8

First edition published in 2015 by Abrams
Concept and design copyright © 2015 PQ Blackwell Limited
Images and text copyright © 2015 Leila Jeffreys, www.leilajeffreys.com
Introduction copyright © 2015 Sarah Engledow

Printed by 1010 Printing International Limited
Responsibly printed and bound in China
10 9 8 7 6 5 4 3 2 1

Abrams books are available at special discounts when purchased in quantity
for premiums and promotions as well as fundraising or educational use.
Special editions can also be created to specification. For details, contact
specialsales@abramsbooks.com or the address below.

This book is made with FSC®-certified paper products and is printed with soy
vegetable inks. The Forest Stewardship Council® (FSC) is a global, not-for-profit
organization dedicated to the promotion of responsible forest management
worldwide to meet the social, ecological, and economic rights and needs of
the present generation without compromising those of future generations.

THE ART OF BOOKS SINCE 1949
115 West 18th Street
New York, NY 10011
www.abramsbooks.com